THE CASCADES

Happy Birthday 1984

to a lovely sister who
has lots of lovely qualities,
talents & great things
going for her.

Ross & Doris

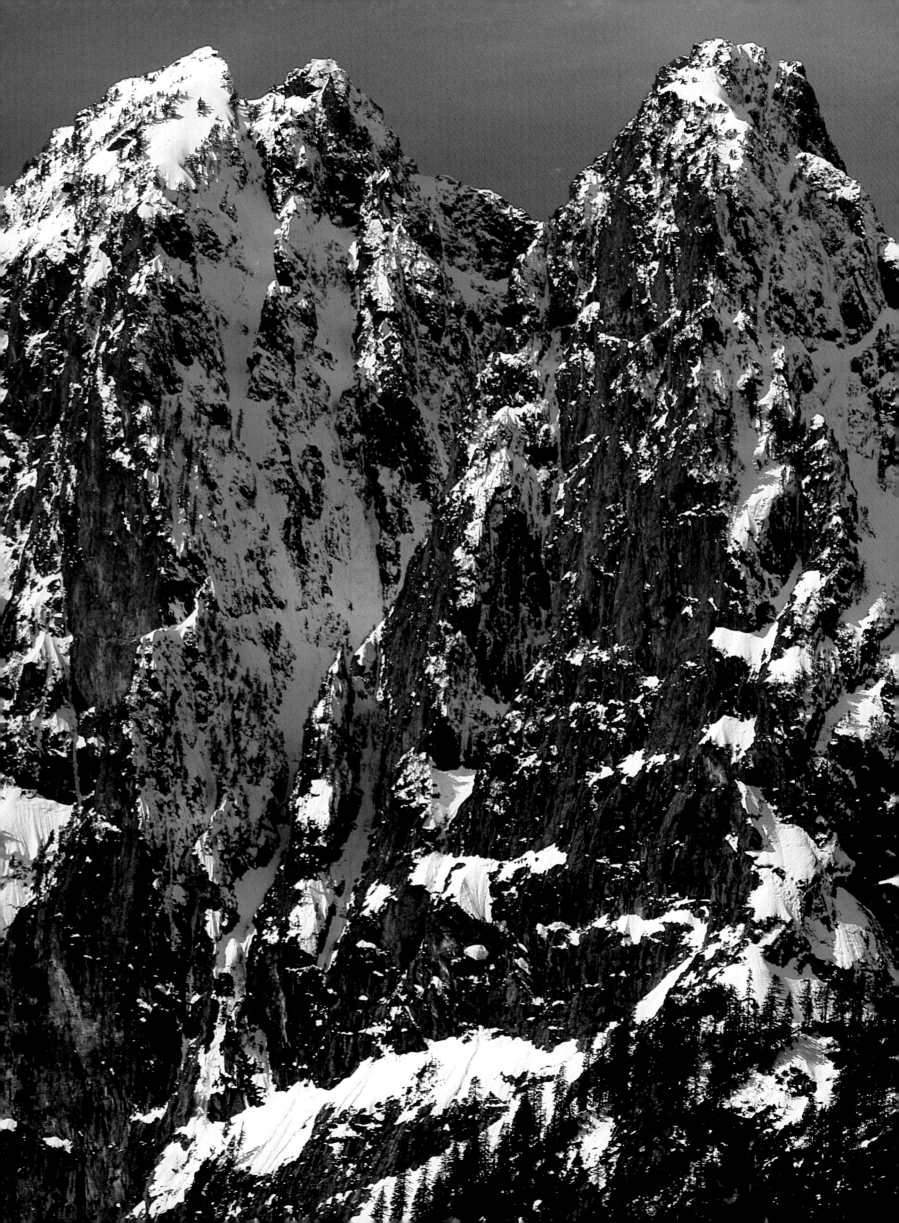

THE CASCADES

PHOTOGRAPHY BY RUSSELL LAMB
TEXT BY FRED BECKEY

GRAPHIC ARTS CENTER PUBLISHING COMPANY
PORTLAND, OREGON

To My Wife and Children
And To All Who Love the Mountains
Russell Lamb

International Standard Book Number 0-912856-78-5
Library of Congress Catalog Card Number 81-86041
Copyright © 1982 by Graphic Arts Center Publishing Company
P.O. Box 10306 • Portland, Oregon 97210 • 503/224-7777
Designer • Robert Reynolds
Typesetter • Paul O. Geisey/Adcrafters
Printer • Graphic Arts Center
Bindery • Lincoln and Allen
Printed in the United States of America

Page 2: Their turrets of metavolcanic rock adorned with winter snow, the frontal peaks of Mount Index tower in grandeur above the Skykomish Valley.

Facing page: Lupines, Indian paintbrush, and other luxuriant wildflowers brighten the meadows of Edith Creek Basin near Mount Rainier's Paradise Park. The grand volcano rises some 8,500 feet higher to its summit icecap.

Overleaf: "From all the more elevated points, Mount Shasta is a most sublime object," wrote scientist William H. Brewer in 1862. Shasta often evokes a mystical response. The volcano's snowfields and glaciers are a dazzling contrast to the dry shrubland north.

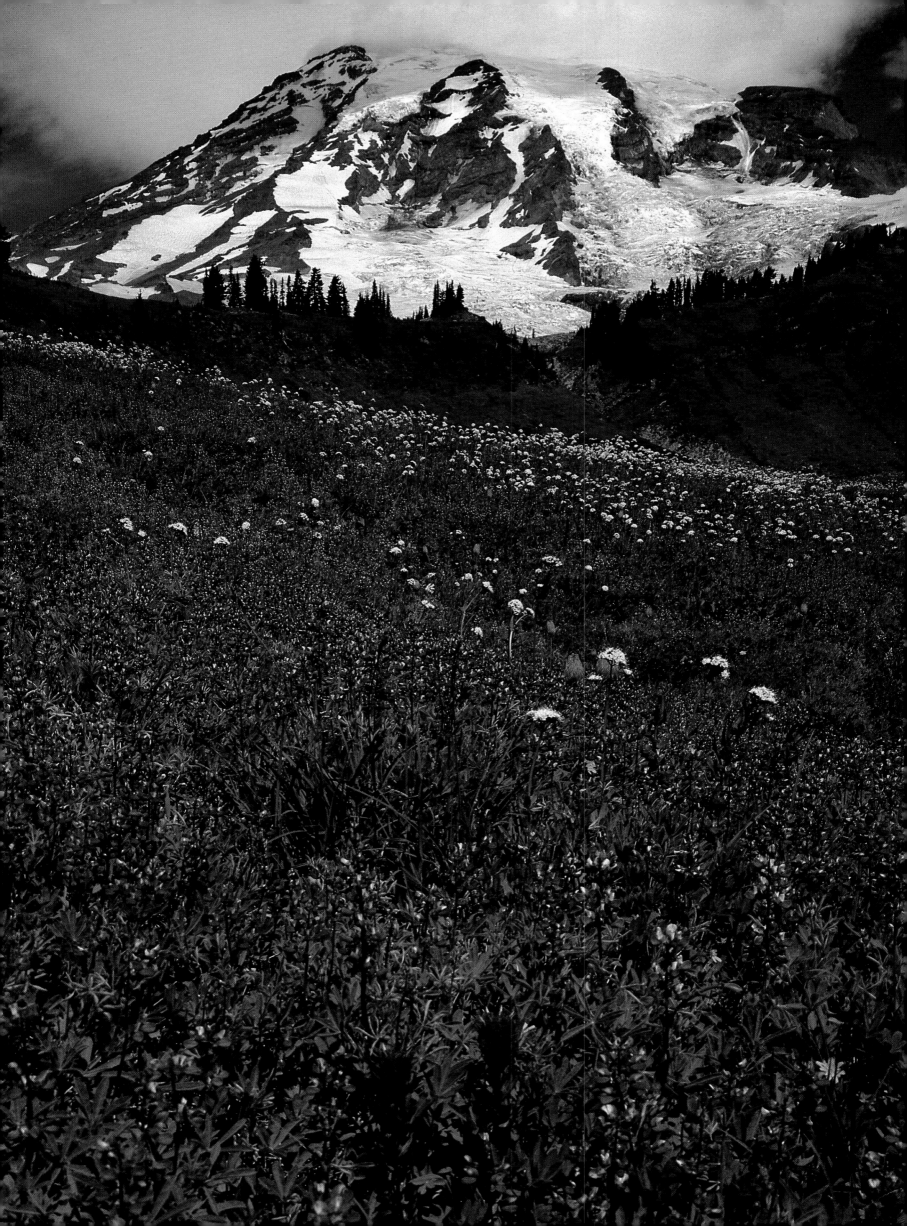

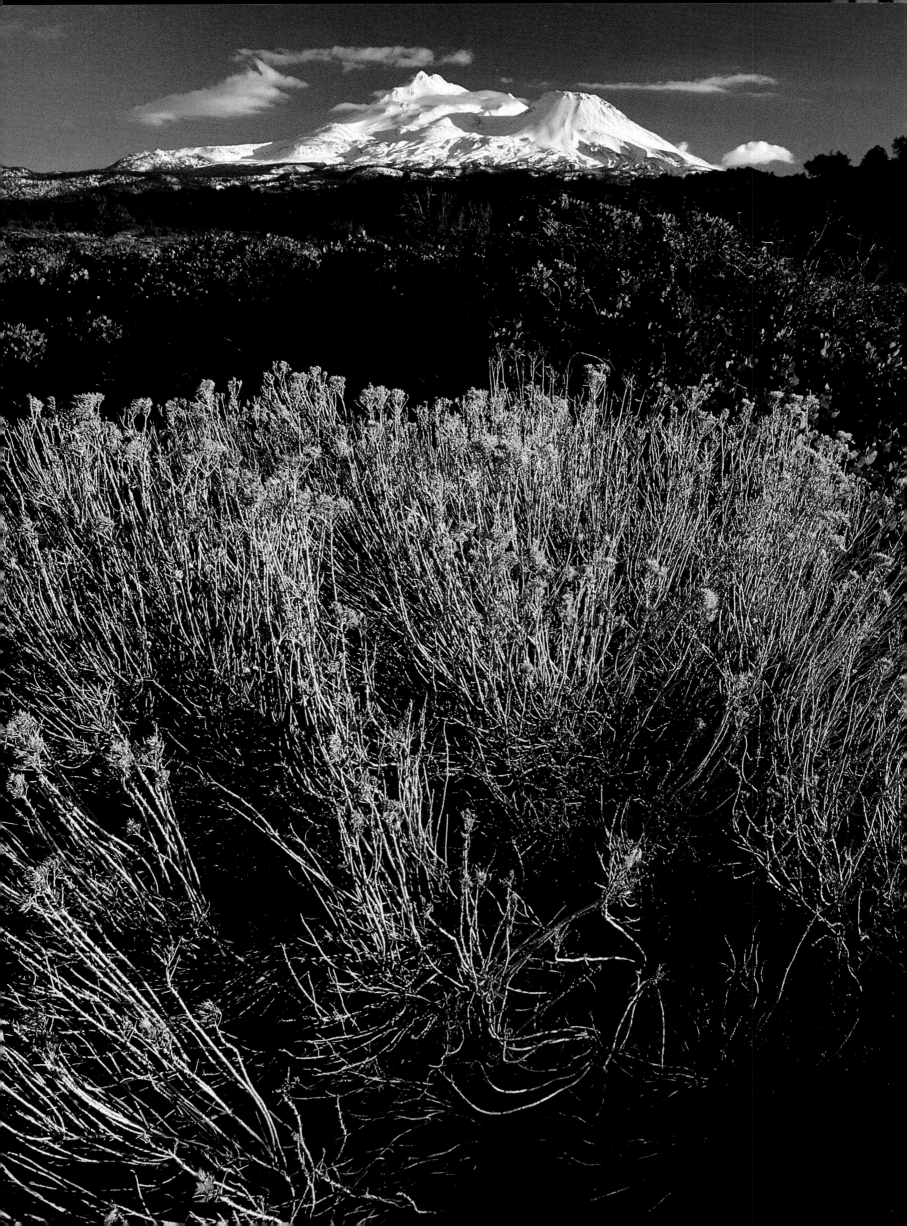

THE CASCADES

WHEN THE Pacific Northwest was first explored by sea and land, the Cascade Range was sighted and named in fragments. In 1792, two years after Manuel Quimper had mapped them "Sierras Madres de S. Antonio," Captain George Vancouver of the Royal Navy called the mountains he saw from Puget Sound the "eastern snowy range." In the early nineteenth century, Lewis and Clark, exploring the Columbia River, described the range as "mountains covered with snow." But it was botanist David Douglas who, needing a specific name, called them the "Cascade Mountains" in his Journal of 1826-1827. Just a decade later the seal was set: the Wilkes Expedition, on behalf of the United States Government, identified the mountains on both sides of the Columbia as the Cascade Range, and the terminology quickly spread south and north, ultimately encompassing Lassen Peak and a prong of rugged country reaching into British Columbia.

For many years after the Louisiana Purchase of 1803, the Far West was a great reach of barely understood, unmapped wilderness. At first, the entry of explorers and settlers into exclusively Indian domain had resulted in an acceptable mingling: the fur trade stimulated friendship and barter. When the Astorians traveled up the Okanogan River in 1811, David Stuart found the Indians "by no means ferocious or cruel, either in look, habits or dispositions." But wherever European civilization established dominance over areas occupied by peoples of a less complex culture, the native populations declined and their ways of life disintegrated. In the Cascade Range their decline is especially unfortunate, for the Indians sought only renewable resources in the mountains.

When settlements were established in the Willamette Valley and the Puget Sound Basin, it was discovered that the lumber of the immense Douglas fir was superior to California's ponderosa pine. The principal reason for the region's rich timber heritage is a maritime-dominated climate characterized by moderate temperatures, cloudiness, and moisture. Winds sweeping in from the west are forced upward, and as air masses push over the crest of the mountains, they cool and condense in the form of rain or snow. Often a stratum of cloud hovers against the shoulder of the range like a thick ring of Saturn. Blanketing western mountain slopes with precipitation, cloud cover abruptly ends on the lee or eastern slopes.

Oceans heat and cool more slowly than land, so temperatures both day and night, winter and summer, vary less in the maritime areas west of the Cascades than in more continental climates. Due to climate and the topography which affects climate, great environmental contrasts in the range occur within short distances; in less than fifty miles lush evergreen forest gives way to sageland. With abundant precipitation a deluge of rushing water constantly seeks the level of the sea. As rainfall drains downslope and meets streams laden with abrasive debris, the land's erosion is hastened, but this water is a blessing to life both in and away from the mountains, and is a necessity to civilization in the Pacific Northwest.

The Cascade Range is an awesome spectacle of natural forces and transcendent beauty invading the sky. Sparkling with snow, the ice-capped summits of the Cascades ride above a green base of coniferous forest. Despite some structural dissimilarities, peaks are linked like a great wall built inland from the Pacific Ocean. The newest mountains — contemporary uplifts built on an already rugged range — are the volcanos. Stationed like sentinels at regular intervals, they make this chain different from every other American range. Their volcanic activity—akin to the volcanism which brought about our waters and atmosphere and permitted life to arise — made the Pacific Northwest both beautiful and soil-rich. The intriguing Cascade landforms result from Pacific winds and moisture, carving by ice and water, and the interaction of complex geologic forces. Today's Cascades reflect a geologically recent uplift, which within the past ten million years has raised ancient rocks to the skies.

The Cascade Range contributes to the physical identity of three American states and one Canadian province, provides vast material resources, supports a rich variety of flora and fauna, and offers great recreational opportunities. To millions of people living nearby, this diverse mountain chain provides the background splendor of the Swiss Alps. Few people would hesitate to compare the Cascades with any of the earth's other mountain wonders.

Mountains spur man's curiosity: they urge exploration. Like no other natural feature, they coax the eye. But to truly understand the grandeur of the mountains—their vistas, their changing shades of light—it is necessary to enter their fastness and to see them from within. One must view their valleys and ridges, study their forests and wild streams, and imagine the energy of vast geological forces, which heaved the earth's crust high.

One day, standing high on Mount Fury in the North Cascades' Picket Range, I contemplated the convolutions of rock, which required hundreds of millions of years to form, and the recent appearance of man. These mountains did not always exist, nor will they remain until the end of time. The illusion that mountains are permanent is derived not only from the brevity of human memory, but from the brevity of human history. Some day, the incessant forces of erosion will tear down the Picket Range, just as compressive forces and uplift built the range from ancient roots long ago.

The Cascade Range is a natural museum close to an enterprising humanity. A living laboratory, it displays examples of the best forests, flowers, birds, fish and mammals our earth offers. To enjoy this museum we must pursue our needs gently and with

Thick pine forests surround
Odell Lake in Oregon's
High Cascades. Behind,
8,744-foot Diamond Peak
juts into the skyline.

understanding. This land is our treasury. It must be preserved.

* * * * *

THE GREAT naturalist and conservationist John Muir said that in California, "Mountains are ever in sight, charming and glorifying every landscape." His description evokes the southern extremity of the Cascade Range as well, for while the Sierra Nevada fades into northern California's mountain upland, the domelike, volcanic cone of Lassen Peak rises, and another great chain of mountains begins.

In the spring of 1914, not many years after immigrants first passed through Sacramento Valley and west of Lassen Peak, the 10,457-foot volcano awakened and a surge of ash columns rose 12,000 feet above the mountain's crater. After a thick mist of ashes fell on the village of Mineral, a party of brave climbers investigated the summit of the peak and found that a new crater had formed. Meanwhile a large explosion peppered the men with sharp rocks, one flying missile breaking an explorer's collarbone. The men were fortunate to escape. Observers at the mountain's base reported that a cloud of smoke "black as night" issued from the summit.

May, 1915 brought other spectacular eruptions. In the words of one witness, "The whole rim of the crater facing us was marked by a bright-red fiery line which wavered for an instant and then, in a deep-red sheet, broke over the lowest part of the lip." Peter Lassen, the pioneer guide for whom the mountain was named, saw a glowing red lava column rise in the crater and send mudflows eighteen miles into the valleys of Lost and Hat creeks. Three days later, Lassen Peak blew its summit into the heavens, sending a great ash umbrella 30,000 feet into the sky. The violent explosion was seen by thousands of persons throughout northern California. After this climactic event, intermittent volcanic activity lasted until 1917.

Lassen Peak is a young fire-volcano, the satellite of an ancient and larger parent, which geologists have called Mount Tehama. This eminence was in ruins when Lassen Peak was born about eleven thousand years ago. During a brief eruptive episode, violent gas pressures thrust a single mass of viscous dacite lava through an old vent. Exposed to the air, the surface rocks cooled and hardened rapidly and Lassen Peak emerged. The solidified core of Lassen is the largest plug dome in the Cascades and one of the largest in the world.

The slopes of the lava dome are too recent for glaciers to have formed, although ice did scoop out the Lake Helen basin on the south flank. During winter, Lassen turns gleaming white and beckons the adventurer in search of sublime beauty. On my first trek, it was spring and I skied across miles of sparkling snow to a frozen Lake Helen. Planting my touring skis at the base of the long southern slopes, I chose a direct route, kicking endless steps in the frozen snow surface to reach the highest portion of

the volcano, which holds four snow-filled craters.

On the rim of the eastern crater lies the true summit, a rocky crag. From there I identified Mount Diablo and Mount St. Helena, and glimpsed San Francisco Bay. Mount Rose in Nevada showed faintly, and in the opposite direction, Mount Shasta was more than conspicuous. Three hundred thousand years ago 11,000-foot Mount Tehama stood only two miles away. Later I would recall the words of geologist William Brewer, who made the climb in 1863: "As we gaze in rapture, the sun comes on the scene, and as it rises, its disk flattened by atmospheric refraction, it gilds the peaks one after another."

These splendid vistas and volcanic curiosities south of the mountain led to the establishment of Lassen Volcanic National Park in 1916. The largest and showiest exhibit in the preserve is Bumpass Hell, where roaring hot springs and boiling mudpools — the result of ground-water percolating down to hot magma feeders—produce a small, gurgling, muddy volcano. In this fuming hydrothermal area, near-molten rock lies just below the surface. According to a park naturalist, hydrogen sulfide accounts for the odor, which must attract visitors, for the trail to Bumpass Hell is the Park's most popular. Tourists are warned not to burn themselves, as trapper Bumpass did when he scalded his feet in boiling mud.

The scratchy manzanita, which hugs the ground beneath pines and white firs, is more likely to injure the explorer. The woody shrub's berries attract birds and animals — especially golden-mantled ground squirrels. Above a scattering of whitebark pine and mountain hemlock, one enters the alpine realm. Among lingering snowpatches in early summer one admires the lupine, penstemon, and cream bushes, a hint of what the lush meadows of the Cascade Range bring to life.

* * * * *

NORTH OF Lassen Peak, the Cascade Range is dominated by snow-mantled Mount Shasta — one of the world's largest stratovolcanos. Each time I drive Interstate 5, the concrete ribbonway which flanks the Cascade sentinels, the overwhelming bulk of 14,162-foot Shasta mocks puny man. I always seek out the granite battlements of Castle Crags near Dunsmuir on the drive northward out of the Sacramento River Valley, but these rock forms are not of Shasta's size. In the opposite direction, the Medicine Lake Highland perseveres as an eastern promontory, but the eye and mind revert to Shasta.

Over a century ago there were no freeways, but there were men whose thoughts and ambitions dwelt on the great volcano. Captain E. D. Pearce and eight men made the first successful ascent on August 14, 1854. On the summit, Pearce and his men jubilantly "unfurled the Stars and Stripes." Their hurried descent was later described as a frolic: "We set ourselves down on our unmentionables, feet foremost, to regulate our speed, and

The damming of the
upper Sacramento River
in northern California
has created Shasta Lake, a
four-fingered reservoir
with 370 miles of
shoreline.

our walking sticks for rudders. At the word, off we sped inside of 2:40, and the like I never saw before in the shape of coasting. Some unshipped their rudders before reaching a little pile at the foot of the snow, gasping for breath. After examining a little, we found that some were minus hats, some boots, some pants, and others had their shins bruised, and other little et ceteras too numerous to mention. No one knew what time we made the four miles in"

Radiometric dating methods, which measure the disintegration of radioactive elements, indicate that the volcano did not exist before the Ice Age. But there are a number of local devotees who disbelieve the geologic story and contend the volcano is a holy place, that its inside is hollow and a residence for secretive and mysterious groups. Some of the believers who feel Shasta is a magic mountain have provided bewildering stories of encounters with divine beings on the slopes. The best known legend depicts Shasta as the home of civilized refugees from the ancient lost kingdom of Mu. UFO reports, perhaps inspired by the lenticular clouds that often form over the summit dome, are not uncommon.

Strangely, early mountaineers and scientists from the California Geological Survey did not confirm the existence of any of the five glaciers until the historic ascent in September, 1870 by the indomitable Clarence King. From the top of the high western satellite cone of Shastina, King had the first view of the large ice mass now known as the Whitney Glacier. He and his survey party spent a night on the true summit and became intoxicated with the majestic aura of a dreamlike night under the starry heavens.

Because of Mount Shasta's volcanic origin, future eruptions are a concern, but its lava flows would be less dangerous than those erupting from Mount St. Helens, because Mount Shasta's molten material is viscous, which usually moves slowly. Still, such lava can destroy everything in its path. To date, Shasta has not abused mankind, but mankind has abused the mountain.

The ruggedness of mountains and the hardiness of their flora and fauna belie their fragility. Their vulnerable environments have only a meager ability to rebound and heal after outside damage. The rate of restoration after disturbance is slow because of climatic extremes, the shortness of the growing season, low productivity, lack of nutrients, and the islandlike character of the locale. Like a living species, once destroyed, mountain habitats are gone forever. We need mountains like Shasta preserved for their spiritual resources and their majesty, for their ecological diversity and the variety of their biota, and for their richness as a genetic reservoir. In the end, damage to the uplands finds it way to the lowlands.

In traditional Old World cultures men damaged mountain slopes by grazing, by cutting and burning forests, and by modifying the landscape with functional structures. But the impact was small until population increased and modern technology brought changes in transportation networks and forest-cutting methods. While the Shasta region has its share of road systems, it is the damming of its river valleys which has affected it most.

Water projects have proliferated due to the West's endless demand for water. Bonneville, Ross, Hetch Hetchy, Boulder, Shasta, and other dams which produce electricity and store water directly affect valley systems. Nearby commercial development, with all of its potential for environmental damage, is a common sequel. The Shasta Dam and its huge reservoir continue to irreversibly alter the character of mountain valleys. The 30,000-acre lake, the largest man-made in California, reaches back into the canyons of the Sacramento, McCloud, and Pit rivers.

* * * * *

THE ROLLING upland of southern Oregon lacks the alpine thrust of Mount Shasta and the above-timberline vistas that characterize the Cascades farther north. Man's activities have imprinted the land with roads and small towns. Here a person can reside in all seasons, make a home, and turn forest resources into a living. Amid this upland, east of Medford, stands the orphan of the Cascades, the 9,495-foot Mount McLoughlin. Symmetrical and pointed, its lonely positon hardly confirms it is part of a continuous mountain range.

Named for the Dr. John McLoughlin of Oregon's pioneer history, the volcano has been in existence for perhaps one hundred thousands years and probably marked the southern terminus of the Pleistocene icecap which buried the High Cascades. The volcano's strange history began when it blew out pyroclastics, then quiet streams of lava. Later, lava flowing from the summit crater in thin streams completely encased the original soft cinder cone in a sheet of hard andesite.

But the volcano is not nearly as old as Mount Thielsen, north of Crater Lake, which began as a shield of basalt, then erupted explosively and built a high cone. Eventually, glaciers demolished the cone. Below 9,182-foot Mount Thielsen, at its western foot, glistens Diamond Lake. The placid waters and the pyramidal peak are a combination unmatched in the Cascades.

Higher and more impressive than either Mount McLoughlin or Mount Thielsen, the ancient Mount Mazama once towered perhaps 12,000 feet into the sky. Scientists state that a cataclysmic eruption of Mount Mazama sixty-six hundred years ago ejected volcanic ash into Pacific Northwest states and Canada. It is estimated that fifteen cubic miles of material were expelled during the immediate event. Areas nearby were smothered under one hundred feet of pumice and ash, and glowing avalanches of great force carried large pumice boulders over twenty miles from their source. One hot avalanche filled the valley of the Rogue for forty miles from its source; another

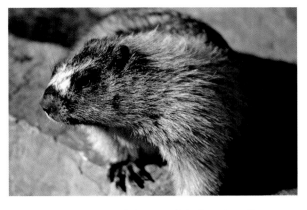

The hoary marmot is the sentinel of the rockslide and meadowland. Its shrill whistle often warns of danger.

pumice hurricane swept across Diamond Lake. In all, some forty cubic miles of pyroclastics which erupted are gone, most as ash carried by the winds.

When Mount Mazama collapsed, its underlying magma chamber emptied, and the mountain, reduced to a hollow shell, caved into the void. Collapse left a caldera six miles wide and 4,000 feet deep. Several thousand years ago, new lava sealed the old vent and the crater slowly filled with water. Jewellike Crater Lake, with walls rising from 500 to nearly 2,000 feet above its surface, is the second deepest lake in North America. From the thirty-three mile Rim Drive, which circles the caldera's edge, one sees Wizard Island, a recent cinder cone built up within the caldera. From The Watchman — a short trail hike — Mount Shasta is visible one hundred miles away.

In Oregon the Cascade Range is divided into two physiographic provinces, the old or Western Cascades and the young or High Cascades. The heavily forested Western Cascades have an average upper elevation of 4,500 feet. They are composed of deeply dissected Tertiary volcanic flows and intrusive rocks which were part of intermittent eruptive activity going back fifty million years. This is the base upon which the younger High Cascades are built. During later Pliocene time, highly fluid basaltic lavas from shield volcanos poured out over much of the High Cascades, then younger stratovolcanos rose to 6,000 feet above their platforms. Cascade volcanos, typical of the nearly continuous "ring of fire" surrounding the Pacific Ocean, are situated along the edge of the North American plate—a "raft" of the earth's crust, where the ocean floor slides deeply under the continental edge.

The term High Cascades has become identified with the lofty part of Oregon. Like the *hochgebirge* of Europe, these mountains are particularly conspicuous. Mount Hood was discovered from the ocean, and Mount Jefferson sighted and named by Lewis and Clark from an inland position. Fur trappers first noticed the unusual and beautiful volcanos now known as the Three Sisters. In 1825, Peter Skene Ogden wrote of "lofty mountains in the form and shape of sugar loaves." An exception to the regular spacing of Cascade volcanos, the Sisters group is a cluster of high cones, craters, and buttes built up near the site of an immense, vanished ancestor called Mount Multnomah, which like Mount Mazama exploded and blew away.

North of La Pine and just outside the main axis of the Cascades lies an area of extensive volcanic activity more recent than that of Mount Mazama. This setting of multiple lava flows and cinder cones provides a foreground to the unique colony of the magnificent Sisters and their cousins. Seven peaks constitute the Sisters group: the South, Middle, and North Sister, Broken Top, Bachelor Butte, The Husband, and The Wife.

The 10,358-foot South Sister is the highest, youngest, and best preserved of the group. The volcano is a massive dome with a young summit crater south of the highest point. Here, during warm summer weather, a small lake forms from snow melt. At various times, vents and fissures released lava flows which descended the mountain slopes, but glaciers have extensively modified the lava which built the Sisters. Seventeen glaciers still survive, and eleven of them lie within a north-south limit of seven miles. The preponderance of so much ice prompted Ira A. Williams of the Oregon Bureau of Mines and Geology to write in 1916: "No other area in the United States so small, and withal so accessible, surrounds so many glaciers as the Three Sisters region."

These glaciers may provide good summit routes, but they can prove hazardous to the mountaineer. And there may be another danger. During an outing of the Mazamas in 1916 it was reported that, "lightning flashes grew closer and sharper, the thunder become more violent....Suddenly we experienced a most astounding sensation. The rocks gave forth a hissing sound from every edge and corner, the alpenstocks cracked and hummed and one felt a peculiar sensation from the finger tips and the hair." This phenomenon lasted seconds and ended as suddenly as it began. On the descent, great hailstones pelted the climbers, who were also met by wind-driven sheets of rain.

From the summit of South Sister one can see Mount Shasta and Mount Rainier and, much closer, the Middle and North Sisters. The Middle Sister, the least prominent of the group at 10,047-feet, is a peaked cone that did not develop until the geologically recent Pleistocene epoch. Of a more interesting character is the older, more eroded 10,085-foot North Sister. The original slope of the cone, which probably reached a thousand feet higher, has vanished without a trace. During the ice ages, glaciers developed and spilled down to an altitude of 1,500 feet on the west slope and 4,000 feet on the east slope.

To many mountaineers, the North Sister has an evil aspect. Climbers have rated the ascent "one of the most difficult and dangerous climbs in the entire range." In 1916 geologist Warren D. Smith wrote: "The North Sister reminded me of Medusa of old with her wild snaky locks — death lurked there in each of these jagged points." Little snow and ice clings to the slopes of the North Sister and the disintegrating and sloughing process is very marked. In 1922 mountaineer John A. Lee wrote that, "The whole mass [is] composed of black, rapidly disintegrating lava, each face with a precipice so steep that neither snow nor talus can find lodgement on it, with the ice stream of Collier Glacier sweeping about its base. The North Sister may well be styled the *bête noire*, the black beast of the Cascades."

In an issue of *Mazama*, John D. Scott recalled an ascent of the summit's pinnacle: "All of us were knocking out loose rock as we advanced and a long spire of shale about the level of my knees barred further progress. With both feet solidly set and a good handhold overhead for my left hand, I gave the projecting

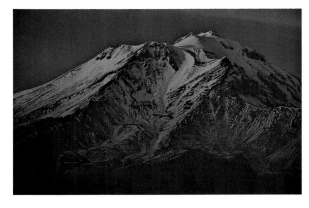

Evening alpenglow lights Mount Shasta, one of the loftiest summits in California. Scoured by snow, Avalanche Gulch is visible on the volcano's southern flank.

spire a push with the point of my ice axe. Instantly there was a roaring crash as the rock under my feet went out.... But for the handhold I would have gone down with the rocks."

Broken Top, a 9,175-foot craggy volcanic remnant of Mount Multnomah located between the Three Sisters and Bachelor Butte, may have experienced an eruption similar to that of Mount St. Helens. Of special interest is its colorful stack of layered volcanic deposits. Nearby, 9,065-foot Bachelor Butte is the southernmost member of the Sisters family. Young and symmetrical, renowned for its skiing, it may have risen less than ten thousand years ago. Glaciers have never formed on its slopes.

The magnificent Three Sisters Wilderness Area, stretching south from the old McKenzie Highway, is now traversed by a popular section of the Pacific Crest Trail. This grand portion of the Deschutes National Forest is generally reached by car from the Cascade Lakes Highway, which loops from Bend to Bachelor Butte, then south to Crane Prairie Reservoir before making a circuit to La Pine. Even while motoring one may see an osprey nesting along the snags of the reservoir, as the birds find wooden outposts a safe spot from predators. South and west of the Three Sisters lie three dozen alpine lakes, many of them well-stocked with brook and rainbow trout. Fishermen delight in these, as well as in cutthroat, coho and kokanee.

While fish may be plentiful, trappers and hunters have taken their toll. Wolves, long considered a menace, still ranged as individuals or in small packs in the early 1900s, but they are now an example of an endangered species, along with the bald eagle, peregrine falcon, and Columbia white-tailed deer. Not only wildlife, but a moonscape of dacite domes, chaotic blocks, and obsidian-flecked pumice on the south flank of South Sister is in danger. The United States Pumice Company, which bought ten claims in 1962, before the Wilderness was established, has threatened to mine Rock Mesa for its pumice. Despite overwhelming public opinion against mining, weaknesses in the Mining Law of 1872 allow exploration and mining on public lands not specifically withdrawn from mining activity.

Perhaps least affected by the hand of man are the birds, which have survived well in the Oregon mountains. The jays, their greed for food and plunder well known, are usually the first to discover a campsite. In the timberline forests, Clark's nutcracker, which feeds on pine cones when it cannot find camp tidbits, is noisy and conspicuous. Higher, in arctic haunts, flies the rosy finch, which makes its home on lava ledges.

In southern Oregon alpine vegetation is most developed and timberline reaches highest in the Three Sisters area, where the numerous peaks join to form a high and large land mass. Plant growth is favorably affected by a continental-type climate of hot summers and cold winters, a distinct contrast to the maritime environment of the western slope with its high percentage of cloud cover. Saxifrage, cinquefoil, mountain sorrel,

false hellebore, blue lupine, penstemon, Indian paintbrush, and fireweed are found among the higher rocks. Personnel of the Forest Service and a local sawmill are protecting an endemic penstemon, which may receive a "threatened status" designation. In the Deschutes Forest, man's impact on sixty-seven different trees, shrubs, and wildflowers is under review.

North of the Three Sisters is the superb McKenzie River Recreation Area. The highway traverses great lava beds, and cinder cones less than three thousand years old rise nearby. Lava flows blocked the ancient McKenzie bed to create Clear Lake; the waters filled behind the lava barrier and killed a forest, whose snags are still visible. Along the McKenzie, the dams above Blue River provide popular boating. The reservoirs are noted for their coho salmon, rainbow trout, kokanee, and cutthroat. Those who fish in the streams are likely to see the amazing water ouzel, which walks about the wet rocks with a droll dip. In 1916, Florence Bailey described this "dipper" in the McKenzie's cold waters: "When the ouzel started to swim, it would put its head under the water as if locating something, and then, quivering its wings, disappear altogether, coming up soon after with a long, black-shelled caddice fly larva." Then the bird would shake the long shell until it broke open, "pulling out the yellowish brown larva..."

* * * * *

THE MAZAMAS, the first mountaineering club organized in the Pacific Northwest, have called picturesque, 10,497-foot Mount Jefferson "The Matterhorn of the Pacific Northwest," and consider it "one of nature's brilliant gems." While canoeing up the Columbia River on their eastward return in 1806, Lewis and Clark named Mount Jefferson. Captain Clark's journal entry for April 7 reads: "Mt. Jefferson we can plainly see from the entrance of Multnomah from which place it bears S.E. this [sic] is a regular cone and is covered with eturnial snow." The most imposing topographic feature in its portion of the High Cascades, Mount Jefferson began as a highly explosive vent and erected a high, fragmented cone. Since then, glaciers and erosion have removed lava and ashes to expose the old conduit, destroying at least one-third of the original cone.

There were various early summit claims, but the first complete ascent was made by E.C. Cross and Ray L. Farmer on August 12, 1888. The ascent can be perilous by any route. In 1916 William E. Stone commented, "With only two of us, the utmost care was necessary to avoid an accident from falling stones." An entry in the register for 1926 described the thrill of climbing to the summit: "Have just climbed the north side. Boy, oh boy, what a climb! Rocks? I'll dream about them for the rest of my life."

During a Mazama outing in 1925, John D. Scott descended a chimney on the mountain's east face at the head of the White-

Ice age glaciers once carved the deep canyon of Lake Chelan, viewed here with Wapato Point near its southern end.

water Glacier. Rocks began to roll behind him: When he jumped to avoid them he landed on a film of snow atop ice and shot downward with great speed—"the speed of a toboggan for a hundred yards." Scott disappeared into a crevasse, and others on the mountain were uncertain for some moments that the moving body had been a man. Luckily, Scott landed on a fallen snow bridge, and this saved him from plunging to the bottom. Jefferson's east face was not climbed until 1922. On its icy wall, three climbers slipped to their death ten years later.

To find firm snow conditions covering the loose rock, I made a winter ascent. Weeks of superb weather had firmly crusted the snow surface so that my companion and I were able to dispense with snowshoes on the approach. Climbing with ice axes and crampons on the steep summit pinnacle, we moved with care and safety to the pointed top under a brilliant blue sky on the type of crisp, perfect day one dreams about. On such days the effect of the sun becomes very distinct with the increase in altitude and thinner air. The combination of high ultraviolet energy and high snow reflectivity can cause a quick sunburn. But when the sun vanishes behind a cloud, the air, unable to hold heat because of the low air pressure and the scarcity of water vapor, rapidly cools.

The Mount Jefferson portion of the High Cascades is a sportsman's paradise. In the 99,600-acre Mount Jefferson Wilderness (one of six in Oregon), which contains 36 miles of Oregon's 420-mile section of the Pacific Crest Trail, there are some one hundred and fifty lakes. North of the mountain, Jefferson Park is especially beautiful. Avalanche lilies and Indian paintbrush are very evident in this park where ancient glaciers dug out a large basin. During the ice ages, both Mount Jefferson and its northern neighbor, Mount Hood, rose high above an immense icefield which blanketed the Oregon Cascades.

My first view of Mount Hood was as memorable as the last time I saw it tipping a white cone above thick cloud cover. Silhouetted against a clear sky, its glaciers reflecting a brilliant white, Mount Hood is a remarkable presence with an air of alpine majesty. As Professor William D. Lyman once reported of this volcano: "Though not the highest, this is the boldest and most picturesque of all."

The illusion of immense height is enhanced by the spearlike mountain's proximity to the Willamette Valley. Various early surveyors and Oregon enthusiasts, including Thomas Dryer, who claimed the first ascent, stated that the mountain was over 18,000 feet in altitude. Actually 11,235-feet high, Mount Hood rises forty-seven miles from the city of Portland and twenty-four miles from the Columbia River. When storm clouds gathered over the mountain and aerial forces shrieked with reckless fury, is it any wonder that the Indians felt the mountain was part of a spectacle of war? To them, Mount Hood was Wy'East, legendary god of the high peaks.

Indian myths and dreams have long expressed the eloquence of mountains. The Indians must have felt the magic that lingered in a land permeated with the mystique of the volcanos and violent creation. Sighting Mount Hood and Mount Jefferson in 1843, John Charles Frémont wrote: "The Indian superstition has peopled these lofty peaks with evil spirits, and they have never yet known the tread of a human foot."

The white pioneers at first avoided the mountains, which they did not always regard with worship and respect. Mountains were impediments to travel and territorial expansion. In early American times many settlers considered it "God's will" to subdue the wilderness. This led to a "frontier mentality" — a belief that resources were infinite and indestructible. We now know differently. As in medieval Europe, a general fear of mountains was felt first. Respect and appreciation came with a few pioneers, but only in the past decades has there been a popular concern for the alpine environment which includes its aesthetic treasures and spiritual resources.

The first view of Mount Hood must have inspired the immigrants following the Barlow Trail, for after arid deserts it symbolized a promised land of valleys and cool evergreen forests. Some pioneers immediately felt the allure of the lofty white cone. One, the Reverend H.K. Hines, believed Mount Hood to be higher than any other mountain in Europe or North America. He made his first attempt on the peak in 1864, but was defeated by wind, snow, and cold.

In 1866, Hines set out again, full of determination. "We selected a place for our camp on a beautiful grassy ridge between one of the main affluents of the Deschutes River and one of the Clackamas. Having erected here a hut of boughs and gathered fuel for a large fire during the night, we spread our blankets on the ground and slept well until morning. We picketed our horses in this place.... The present summit of the mountain is evidently what was long since the northern rim of an immense crater...." Hines noted volcanic activity — the "gases from the pent-up fires below." He reported: "many of the rocks which project upward are so hot that the naked hand cannot be held upon them ... steam and smoke is continually issuing, at times rising and floating away on the wind."

Ascending Mount Hood one observes fumaroles, gas vents, and hot spots at the base of Steel Cliff and in the depression behind Crater Rock. Lavas softened by heat are the source of powerful sulphuric odors. The thought of volcanic eruption, which must enter almost every climber's mind, entered mine when I crossed this area.

The geological history of Mount Hood is recorded in the lava flows and deposits of fragmented lava which make up the mountain and its flanks. Lavas and pyroclastic material slowly built the present high cone near the divide between ancestral Zigzag and Hood rivers. The most accepted theory is that as the

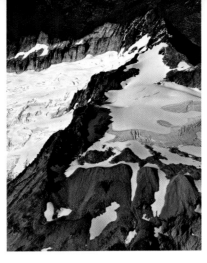

Flanked by North Cascade glaciers, Sahale Peak and pyramidal Boston Peak are viewed from the air above Cascade Pass.

high cone grew, it gradually buried an ancestral volcano. At the onset of Fraser glaciation about twenty-five thousand years ago, Mount Hood may have been as perfectly formed as Fujiyama. Most of the upper 4,000 feet of the cone is built of pyroclastics interbedded with thin lava flows. Soon after volcanic activity ceased, glaciers stripped away much of the mountain's bulk and reduced its 12,000-foot height. The last large glaciers and recent stream activity have cut deeply into the flanks of Mount Hood and exposed many lava sequences. One huge debris flow smoothed out the mountain's south slope about A.D. 300 when a crater blown out of Mount Hood 1,000 feet below the summit emitted a large flow of lava.

Man has adapted this recently formed terrain to his own ends — building the splendidly crafted Timberline Lodge in the 1930s, ski lifts, and most recently the Wy'East day lodge for skiers. But the Skyline Timberline Trail, which encircles the mountain in 37½ miles, is not conspicuous. Following this path the hiker can cross terrain varying from 7,300 feet to 3,000 feet, enter alpine floral meadows and sandy creek ravines, and see beautiful Ramona Falls and the rustic Cloud Cap Inn, built in 1889 near Eliot Glacier.

*　*　*　*　*

EARLY EXPLORERS were impressed not only with lofty Mount Hood, but with the Columbia River as it sliced through the Cascade Range. A topographer on a railroad exploration in 1853 observed that the name Cascades is obvious from the "steep sides of that tremendous chasm through which the gathered waters seek the ocean."

The Columbia is one of America's great rivers, and it was already known as such in the days when the *Cascades* meant five miles of water rushing over an inclined gorge in the heart of the range. During the days of early exploration, fur trapper Joseph Meek said: "The Hudson, which so long has been the pride of America, is but the younger brother of the majestic Columbia." In the argot of geographers, the Columbia is called an antecedent stream — one which existed before the mountains were formed. When general uplift of the range took place, the river kept pace by downcutting and maintained its channel through the mountains. The Klamath, Skagit, and Fraser are other rivers of this type, as are the Indus and Brahmaputra, which originate on the Tibetan Plateau and flow across the highest mountains in the world to reach the sea. Like the Columbia, they have created spectacular valleys.

Considered the nation's greatest water gap, the Columbia Gorge is a remarkable sea-level opening with a biological transition from lush maritime forest to sagebrush desert. An ecotone formed by two climates, it was once a gathering place for diverse Indian tribes, who came here to fish for salmon, and the focal point of Klickitat Indian legends which called Mount St.

Helens "The Mountain of Fire." One legend describes the kindness of the Great Spirit who transformed a homely old woman into a beautiful maiden who wore only white. Two of the Great Spirit's brave warriors were Wy'East and Pah-to, and they fell in love with the maiden, Loo-wit-lat-Kla. As their passion grew, they warred, tossing great boulders from opposite sides of the Columbia. Under this strife, The Bridge of the Gods, which spanned the great river, fell. But the beautiful maiden, Loo-wit-lat-Kla, or Mount St. Helens, stood serene, and each son took form as Mount Hood and Mount Adams.

Because of the great eruption of 1980, Mount St. Helens has become the most famed of the three "Guardians of the Columbia." In October 1843 two Willamette Valley settlers, William Overton and William Johnson, noted in a journal: "Mt. St. Helens, a lofty snowcapped Volcano rises from the plain, and is now burning. Frequently the huge columns of black smoke may be seen, suddenly bursting from its crater, at the distance of thirty or forty miles." The mountain, a juvenile whose visible cone is only twenty-five hundred years old, smoked and burned intermittently until 1857.

A volcano may remain dormant for a great length of time, or, like Mount St. Helens, it may erupt often. In a typical pattern, once activity ceases the lava solidifies and reseals the volcano until enough pressure builds to uncork the cover. Composite volcanos like Vesuvius, St. Helens, Mazama and Katmai are the most dangerous and unpredictable. Like Mount Hood and Fujiyama, they are usually symmetrical and well-proportioned. They are stratified because they are composed of alternate layers of lava and aerially ejected material. The alternation of fluid rock and solidifying debris creates a steep form, and the interleaving of materials brings strength. Silica-rich andesites which are viscous can solidify quickly upon reaching the surface, and this caps the underlying material. When steam and gas cannot escape, pressure builds until a release occurs from a superheated explosion.

The violent eruption of May 18, 1980, which killed sixty-one people and made Mount St. Helens world famous, was both predicted and closely monitored. Until then, most residents living near the Cascades had given little thought to the dangers presented by the great volcanos. Yet, calm as they seem, at least seven Cascade volcanos have been active within the past one hundred and fifty years. They are affected by their location near North America's continental margin: when the heavy, basaltic ocean crust dives under the lighter, continental crust along a subduction zone, the adjoining land terrain rises, and mountains, sometimes volcanos, appear.

For perhaps the past twenty million years, volcanos in the northern part of the West Coast have formed above down-sliding slabs of oceanic crust. Complex physical and chemical reactions, occurring where crustal plates converge, cause rocks

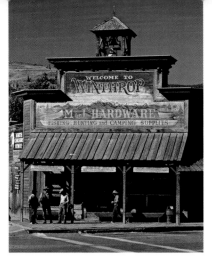

Winthrop, a Methow Valley town, which was once the scenario of Owen Wister's *The Virginian*, faces the world with a vintage western aspect.

to heat and liquify. Magma or molten rock moves upward along areas of weakness in the crust. In the magma chamber, the heavier rock components settle, and the lighter volatiles—such as gases — rise. The degree of explosive volcanic activity is governed in part by the rate at which the thrusting plate plunges under the bordering plate. Near Japan and Indonesia, where the annual subduction rate is two to three times as much as the convergence along North America's Pacific Northwest, there is usually one volcanic eruption per year.

* * * * *

CAPTAIN GEORGE Vancouver probably sighted both Mount St. Helens and Mount Adams on June 8, 1792. Then, for over half a century, various explorers, surveyors, and settlers confused the similar volcanos. Captain William Clark's diary on April 2, 1806 notes "a high humped mountain to the East of Mt. St. Helians," but the Lewis and Clark map of 1814 omits Mount Adams. For all his ability as an observer, Frémont confused the two volcanos, and Lieutenant Charles Wilkes of the U.S. Exploring Expedition erred on their separate identities. Not until the Pacific Railroad Survey of 1853 did confusion end.

Shaped by multiple vents, massive Mount Adams never evoked the pre-1980 elegance of Mount St. Helens. From a distance, its physical character suggests the grim power of Klickitat legends, but from close-vantage alpine meadows and beautiful spurs such as the Ridge of Wonders lure the eye. Professor William D. Lyman described the volcano's wonders: "The rocks of black and red and saffron are seamed with glistening colors of ice, which, descending from the dizzy pinnacles of the summit, join in the gashed and hummocked surface of the great ice river of the Klickitat Glacier."

Lyman climbed Mount Adams with the Mazamas in 1902. On the summit a dismal cloud cap split to reveal the glorious sun: "Every vestige of smoke or fog was gone. We could see the shimmer of the ocean to the west. The glistening bands of Puget Sound and the Columbia. Far eastward the plains of the Inland Empire lay palpitating in the July sun. The whole long line of the great snow-peaks of the Cascades were there revealed, the farthest a mere speck, yet distinctly discernible, two hundred miles distant. One unaccustomed to the mountains would not believe it possible that such an area could be caught within the vision of a single point."

* * * * *

SOME FORTY-SIX miles northeast of Mount St. Helens rises a 14,410-foot, ice-clad volcano, a massive splendor that Northwest Indians considered a physical god. Height places Mount Rainier at the apex of the Cascade Range, but its size is difficult to comprehend without personal experience on its slopes. Where the volcano begins to rise 8,000 feet above surrounding

ridges at the timberline level, it has a circumference of twenty miles. Mount Rainier has been likened to an arctic palace floating on a sea of green trees. A closer look below the level of permanent snow and ice shows that it is textured with a multitude of canyons, cliffs, ridges, lakes, and magnificent floral meadows. Theodore Winthrop, who crossed Naches Pass in 1853, eloquently wrote: "Of all the peaks from California to Frazer's River, this one before me was the royalest."

Climate has created famous displays of flowers and twenty-six named glaciers, the greatest amount of ice on any single mountain in the United States outside of Alaska. Snow, which generally begins by October, may accumulate heavily in lower valleys at the 2,000-foot level. A stormy winter can produce fifty to seventy feet of snowfall, with existing packs of over twenty-five feet at the meadow region, where many drifts remain until July.

While Mount Rainier may appear savage in its elemental ruggedness and stormy cycles, the surface of the volcano is surprisingly fragile. The six glaciers beginning at the summit icecap constantly gnaw at the friable bed and flanks of rock. The greatest sculpturing takes place between the altitudes of 10,000 and 12,000 feet, where frost action and the erosion of cirques will slice the upper portion of the volcano into a triangular shape. A complex of life and land which has developed over millions of years, the mountain is very vulnerable to a recent visitor — man. Roads built to timberline, notably at Paradise and Sunrise parks and traversing the pristine valley of Stevens Creek, scar the subalpine meadowland. Such roads present a visual eyesore, disturb slope drainage, and allow masses of people into formerly isolated places which are damaged easily. Management in the past decade has been responsive to this problem by forming backcountry plans. Regulations limit camping locations, the building of campfires, and improper human waste through zoning and rationing. Camping in "trail corridors" is channeled to specific areas with cross-country and climbing camps designated far from trails.

Opportunities for hiking abound: Van Trump Park, Indian Henry's Hunting Ground, Spray Park, Summerland. One can hike the trail and snowfields to Camp Muir, over 10,000 feet in altitude, on an esthetic but usually crowded route, or hike part or all of the Wonderland Trail below glacier levels. Such a trek provides priceless isolation — one feels beyond the range of civilization, yet there are shelters and points of contact every day or two. In addition to great hiking and scenery, Mount Rainier possesses what naturalists John Muir and Henry David Thoreau loved: great coniferous forests, subalpine parklands, jeweled lakes, changeable and misty weather. It is possible to marvel at a waterfall, hike a path overtopped by hellebore and avalanche lily, then sit by a lake mirroring the icecap of "The Mountain that was God."

The reflective waters of
Diablo Lake, held by a
dam completed in 1930,
flood the tortuous channel
of the Skagit River.

Ever since its discovery by Captain George Vancouver in 1792, the icy monarch has inspired pioneers and visitors. The pristine upland meadows were seen first by Dr. William F. Tolmie, a medical officer in the service of the Hudson's Bay Company, who made a botanizing trek to the mountain in 1833 with Indian companions and three horses. Tolmie was the first white man to come close to the great mountain. By 1857 men felt compelled to test themselves in an ascent. For all practical purposes, the expedition of Lieutenant August V. Kautz and three companions conquered the mountain, and the final triumph of Philemon Van Trump and Hazard Stevens occurred in 1870. Since then, Mount Rainier has become a mecca for the mountaineer. Yearly, seventy-five hundred climbers make an attempt on the summit, and a little more than half are successful. Many are devout pilgrims who summon the stoic virtues of patience and self-denial.

I climbed Mount Rainier by the Liberty Cap Glacier in the 1950s. We slept the night before the ascent in sleeping bags on a rock outcrop surrounded by ice cliffs and black wilderness. At dawn the cold, blue upper mountain overshadowed the land. Only a dark quarter was visible for the sun was on the opposite, eastern slope at that hour. The northwest face was so steep it concealed the summit points and appeared mythic. There was a chill in the July air as I and two companions cramponed up a laced network of steep ice patches. Fearful that an unstable section might loosen and crush us, we followed a series of forbidding, shiny ramps through a mammoth cliff of white ice. The ice cliff — so large it is visible from Puget Sound — is of varying stability. A climber does not linger here, but seeks the crest of Ptarmigan Ridge. What followed was a cheerful, triumphant ascent to Liberty Cap, one of Mount Rainier's summit points.

In historic times we have been fortunate to find Washington state's great young mountain a benevolent volcano. Mount Rainier was formed by repeated extrusions and ejections of lava, ash, and pumice, mostly in the last several hundred thousand years. The volcano grew atop an older upland of the basal range, which is composed of sedimentary and igneous rocks twenty to sixty million years in age. Explosions, collapse, and erosion eventually truncated the highest 2,000 feet of the summit and scooped out a vast crater 1½-miles wide. Almost six thousand years ago, one sliding mass took the top of the mountain through a gap and onto the Winthrop and Emmons glaciers to produce the immense Osceola Mudflow, which traveled some forty miles down the White River valley. Mudflows, or lahars, are destructive aspects of volcanism and have caused extensive damage but no loss of life in the Pacific Northwest until the explosion of Mount St. Helens. Worldwide, mudflows have taken many lives in the last few centuries.

Between prehistoric eruptions, mankind would have found Mount Rainier and its surroundings hostile, as a cooling climate produced ice sheets in the Puget Sound lowland. The last glaciation, called the Fraser, occurred twenty-five to ten thousand years ago when alpine glaciers extended fifteen to forty miles down valleys. The icecap which covered the Cascade divide east of Mount Rainier scoured the landscape, leaving depressions which filled with water when glacial times ended. The most magnificent lakes that formed in these meadow highlands are the Cougar Lakes, which nest in glacier-cut bowls beneath brown and gray rock formations. As the 210,000 acres in Mount Rainier National Park are no longer sufficient for the number of hikers, this superb area between White and Naches passes has been proposed as a high-country wilderness.

* * * *

ONE OF the most magnificent regions in the Washington Cascades is Mount Stuart and the Wenatchee Mountains. Mount Stuart, a crown peak in this portion of the range, has been called "a dizzy horn of rock set in a field of snow." Perhaps the first white man to see the Wenatchee Mountains, which are on the eastern fringe of the Alpine Lakes region, was the great geographer of the North West Company, David Thompson. When Thompson journeyed down the Columbia River in July, 1811, he observed "high rocky mountains to the south-west." Later, during a railroad survey in 1853, Captain George B. McClellan was enchanted by the highest peak: "In front of us the Cascade range extended directly to the river. ... About west-northwest was a handsome snow-peak smaller than Mount Baker; as it is not to be found on any previous map that I know of, and had no name, I called it Mount Stuart."

On Mount Stuart the mountaineer can find the essence of alpine rock climbing. Approaching the great northern rock and ice faces, a climber feels encircled by vast amphitheatres. On one of my latest climbs, I ventured onto the base of the 2,500-foot north buttress. Here was a cleanly sculptured pillar of granite rising from an icefall glacier and tapering to a gendarme-studded crest which leaned against a broad, ice-hung wall. The route proved difficult, slow, and exacting. My companion and I took turns going first for the rope lead, then belaying. We climbed carefully every inch of the way, for an injury would have placed us in a precarious position on a remote mountain facade. The protection of the rope, and the metallic climbing devices called chocks and pitons should hold a climber in the event of a fall, but in an adventure of this type there are secondary factors such as the isolation of the location. Eight hours after we started climbing the apron at the foot of the buttress, our difficulties ended. We stood at the summit cairn with a view westward to the Alpine Lakes region, which seemed spiritual in its timeless beauty.

A curious northern landmark of the Alpine Lakes portion of

Cougar Reservoir in Oregon's Willamette National Forest captures maritime moisture on the flank of the Cascades.

the Cascades is Mount Index. More visible to the motorist than Mount Stuart, the savage, three-pronged fang is formidable despite its diminutive size and flags the beginning of the North Cascades. "Pointing upward like an index finger," this peak has captured the imagination of the public.

Such frontal peaks as Mount Index were hardly affected by ice age glaciers, which capped the Cascade divide and flowed down valleys to the Puget Sound Basin. But glacial action produced wildly picturesque subalpine lakes south of the Wenatchee and Skykomish rivers. There are over seven hundred lakes sheltered by rugged mountain contours, and most of them are less than one hundred miles from the metropolitan areas of Seattle and Everett. Here is a wilderness of jagged peaks, basins cradling small glaciers, and lakes romantically named Enchantment, Venus, Viviane, and Big Heart. In valleys leading to these lakes one observes how glaciers scraped the land: thin soil cover shows bedrock; avalanche scrub like red alder, dwarf willow, black cottonwood, vine maple, crab apple and devil's club grows on open slopes.

* * * * *

THE ALPINE Lakes region is part of the original Washington Forest Reserve established in 1897. Logging of privately owned valley regions expanded into public lands in mountain preserves administered by the federal government. The Forest Service, which is charged with managing these timberlands and has distributed over one hundred million dollars per year to counties in Oregon and Washington, is caught in the middle of a controversy over logging in America's 187 million-acre national forest system. Environmentalists have termed the Gifford Pinchot Forest in southern Washington nothing but a tree farm. In British Columbia, where the boundary region is managed only for timber production, environmentalists claim it will take one hundred and fifty years for high altitude clearcuts to grow back. Throughout the Cascades, deforestation has taken place in areas marginal for tree growth. The dilemma in mountain forestry is that depletion of lower valley forests means higher slopes become more valuable.

Decades of intense logging in the Cascades have laced mountain valleys with all-weather roads and, consequently, hillside blemishes. These roads have made possible the great clearcuts—the removal of all trees in a given tract—which in turn lead to conflicts with recreational users. Both road construction and clearcutting accelerate the process of mass soil movement by destroying the stabilizing influence of vegetative cover and disturbing the natural water drainage. Organic matter, which maintains vital fertility, is destroyed when skidders, bulldozers, and tractors churn the fragile topsoil to mud. Soils in logged areas are lost faster than they are formed, patently violating the sustained yield concept.

While conservationists present evidence that clearcutting is destructive to the land, industry leaders point out that such cutting is both cheaper and more effective than selective cutting or other methods. They assert that the best way to replant Douglas fir seedlings, which need sunlight, is to begin from a cleared tract. But clearcutting in federally owned forests also faces the issue of legality: a circuit court in the East recently upheld an 1897 law which states that only dead or mature trees can be cut on public lands.

After a battle between the forest timber industry and environmental groups, Congress created a 393,000-acre Alpine Lakes Wilderness Area. Meanwhile, mountain defiles such as Snoqualmie Pass have yielded to man's needs. The route across the pass has changed from a gravelled wagon road at the turn of the century to a concrete interstate highway. Over one million people travel the Alpine Lakes region, and it is estimated that a quarter of a million people hike there annually. These visitors, who do not want to see clearcuts, bring tourists dollars.

From the beginning, the wild lands and parks in the Pacific Northwest have been influenced by two factors: increasing pressures from visitors and their automobiles; commercial development and non-park uses. In 1914, prices were low and logging had made few inroads beyond the foothill valleys. A mountaineering group reported that about fifteen pounds of food cost them $2.24 (cheese was twenty-six cents a pound). Just as prices have risen, so has the demand for solitude and recreation territory. The notion that an individual can gain insight and strength through solitary communication is an ancient one: it is an experience the Wilderness Act promotes. As John Muir discovered: "Thousands of tired, nerve-shaken, over-civilized people are beginning to find out that going to the mountains is going home; that wilderness is necessity."

The dilemma is that not everyone desires solitude, and limiting wilderness use may appear to satisfy purists at the expense of the general public. Yet if too much public land is allowed to serve only current economic wishes, it will be impossible to provide for the needs of future generations. Americans have long found it difficult to consider the intrinsic value of wilderness while it was still an adversary. As William Goetzman points out, "Americans have traditionally viewed the settlement of the western frontier as a struggle between the individual and the wilderness environment." But preserving wilderness and its non-renewable resources is in the national interest.

* * * * *

WHEN UNTOUCHED by logging, the lower forests of the Cascades are a sanctuary, sometimes sparkling, sometimes gloomy, always luxuriant. Devil's club and lady fern occupy valley bottom habitats which have luxurious understories.

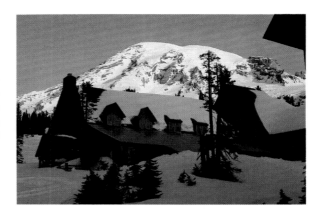

Winter snow coats historic Paradise Inn, its surrounding subalpine meadowlands, and the glacier-draped mass of Mount Rainier.

Many forms of animal and bird life exist, but camouflaged by nature they often are hard to discern. In favorable locations in this lower forest, the western red cedar towers. This tree, which may live a millenium and was once used by Indians to fashion canoes, tapers from a fluted buttress base which may have a circumference of thirty feet.

For quality and abundance the Douglas fir is the most valuable tree. This fir arrived in the Pacific Northwest about one million years ago and thrived in the post-Ice Age climate. Its original range extended much farther north, but glaciers forced the tree southward. The tree became known commercially during the gold boom of 1849, when ships sailed north from California to Puget Sound for lumber. A large, long-lived species, it is the undisputed king of the temperate coniferous forest — a region almost unmatched for tree size and diversity.

The dominance of evergreen conifers and the region's high growth rate is believed to be largely a consequence of the relatively cool, dry summers and warm, wet winters. Due to the proximity of the Pacific Ocean, the climate is mild, equable, and moist. Professor Israel C. Russell, who explored both forests and glaciers in 1898, wrote, "Beneath the deep shade, the boughs ... seem to mingle with the clouds — and during much of the prevailing misty weather this is literally true."

On cross-country ascents in Washington's western hemlock zone, between low valley bottoms and an altitude of about 3,000 feet, I saw old growth forests which are up to seven hundred years old. The hemlock, fir, and cedar needles smothering steep, trailess slopes are thick enough to require the nailed boots loggers wear or an ice axe to help with balance. Pulling up on tree roots and shrub branches, clambering over great windfalls is tiring exercise, requiring more strength than technique. Inspired by thoughts of glorious mountain scenes to come, I would usually try to move up these lower slopes rapidly so as to enjoy the more open Canadian zone where mountain hemlock, Alaska cedar, Pacific silver fir, and subalpine fir predominate.

Subalpine fir — an important pioneer species when a forest develops on inhospitable terrain — is distinguished by its spire-like form and is symbolic of mountain meadows. A wide-ranging conifer in the boreal and mountain regions of western North America, it is common in the Cascades above 4,000 feet. The fir is a conspicuous feature of the Cascade timberline and is often found in groups with white-bark pine and mountain hemlock. The species has few enemies, but the balsam wooly aphid — like the medfly, a pest introduced from Europe — has destroyed certain tracts in the range.

In the parklike mountain meadows, one often hears the whistling sounds of marmots, members of the Rodentia family, who act as sentries in this highland domain. Hikers, usually devout friends of these meadows, have inadvertently hurt the low-growing vegetation communities. Trampling by hundreds of people damages fragile alpine tundra, especially in wet conditions. While alpine plants are relatively durable — they cope with a rigorous environment — they are unable to tolerate much human impact. Once heather and many plants are disturbed, irreversible erosion will remove the soil of an entire area. Impact, of course, is related to improper location of roads, trails, and camping areas.

* * * * *

FORTUNATELY, the Cascades are a long chain with space for hiker mobility. Two days of backpacking along the Pacific Crest Trail northward from the Alpine Lakes area brings one to the loneliest volcano in the Cascade Range — Glacier Peak. This glacier-clad volcano rises like a white eminence above a parade of overlapping foothills, some reaching timberline heights within seventeen miles of Puget Sound.

Volcanos like Glacier Peak are young features built atop an existing mountain range or an older volcano. Cascade volcanos are usually composite cones consisting of thin, alternating layers of pyroclastic debris and lava, mainly andesite. There are four common types of lava: basalt, andesite, dacite, and rhyolite. Each has a different chemical composition and a different viscosity. Basalt, for example, is highly fluid and may flow rapidly over great distances. Dacite is pasty and viscous when molten, and tends to form bulbous, steep-sided domes. Rhyolite is also viscous, and andesite is nearly as fluid as basalt.

Relatively quiet eruptions produce lava flows, but explosive eruptions produce clouds of gas and volcanic ash. The ash is used to date geologic events over wide areas, since bits of carbonized wood found with the ash can be analyzed for age using the Carbon 14 dating method. An eruption of Mount St. Helens one hundred and seventy-five years ago, of Mount Mazama (forming Crater Lake) sixty-six hundred years ago, and of Glacier Peak twelve thousand years ago have been reliably documented. Numerous consecutive eruptions from Glacier Peak deposited a layer of dacite pumice up to twelve feet thick as far as twelve miles downwind from the crater, and deposited lesser amounts of dust and ash over thousands of square miles of Washington, Oregon, Idaho, Montana, and Alberta, Canada. After the major pumice eruption, a glowing avalanche devastated the Whitechuck Valley at the mountain's foot. Since that time, Glacier Peak appears to have been inactive.

* * * * *

ALTHOUGH THE present landscape is young, the complex geology of the North Cascades, which includes the region of the Alpine Lakes and Glacier Peak, goes back over one billion years. Some rocks now constituting the Cascades were slivers of continental shelf. Formed in widely separated places, they

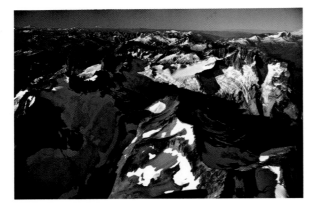

The jagged forms of the Chilliwack peaks, near the International Boundary, and Silver Lake have been shaped by the carving of glacier ice.

were moved northward at different speeds along great faults. The accretion of crustal fragments, which probably formed well south of their present locations, took place over at least one hundred million years. Probably only the youngest rocks and the stratovolcanos were formed in their present positions. The North Cascades were built to their present height by the slow collision of the North American and oceanic plates and the upwelling of molten magma. Rising bedrock eventually pushed the Pacific Ocean westward.

Professor William D. Lyman eloquently captured the image of Glacier Peak when he wrote, "It can be seen in all its snowy vastness, ten thousand feet high, and bearing upon its broad shoulders miles and miles of rivers of ice, the most beautiful and significant of all the poems of nature." The Suiattle River Valley, where, between evergreen trees, a river races across a fan of Glacier Peak mudflows, marks the beginning of a different landscape. Hidden behind a diverse terrain of jagged rock peaks and glacier-covered ridges lies a Shangri-la-like Napeequa Valley. The upper portion of this secluded defile is floored by deep gravels left by glaciers. Its river meanders for six miles through lush grassland, then cascades — Napeequa means "white water" — into a V-shaped canyon.

Also concealed between high flanking ridges, but far more famous, is fifty-mile-long Lake Chelan, which was once occupied by a glacier up to 3,000 feet thick. During the ice ages, glaciers poured over passes north of the Chelan trench, and a great lobe of ice swept around from the Okanogan Valley to block its lower end. Glacial advances and retreats created one of the most beautiful lakes on earth. In 1879, Army explorer Lieutenant Thomas Symons evoked its essence: "The water is of diamond-like clearness and yet in places no sight can penetrate to the bottom of its liquid depths." Strangely, no white man canoed the length of the lake until 1870, although Indians knew its waters and used the lake as a trade route to passes leading to the west side of the range. Railroad surveyors studied the lake for a possible route to these passes, but became discouraged by the steep terrain above the shoreline. A feasible railroad route was not located in this portion of the Cascades.

The mountains surrounding Lake Chelan provide some of the finest examples of towering rock peaks to be found in the North Cascades. Many are armored by great, crevassed glaciers. The view from Sahale Peak, one of the summits near Cascade Pass, has inspired alpinists for over eighty years. Reporting on his experiences during a Mazama outing in 1899, A. S. Pattullo commented: "I have seen the famous view from the Righi in Switzerland, but it does not compare with the view from Mount Sahale in the Cascade Mountains."

So complex is the rugged terrain of the North Cascades that most of the principal rock peaks, and even volcanos like Glacier Peak and Mount Baker, do not mark the watershed boundary. The random jumble of peaks, sometimes moved by ancient faulting into the most complicated of bedrock arrangements, and the deep interlocking valleys between the high massifs obscure any topographic logic. Some of the most spectacular mountains, and those with the greatest relief, are well west of the watershed divide which separates eastern and western drainages. One of these is Johannesburg Mountain, a gigantic rock wedge clad with steeply pitched arrows of hanging ice. Miners prospecting the valley leading to Cascade Pass understood the lethal power of Johannesburg's hanging glaciers. In 1877 a member of a prospecting party described being awakened at night by "thousands of tons of ice." The dangers of this mountain were appreciated by mountaineers, who did not make a first ascent until 1938.

Like Johannesburg, peaks and serrate ridges in the North Cascades are separated by narrow, steep-walled valleys which are generally less than 3,000 feet above sea level. In many valleys, even near their headwaters, elevation increases of 6,000 feet occur in a horizontal distance of less than three miles. Consequently, peaks not as high as those in the Rockies often appear larger. Non-volcanic Bonanza Peak rises to over 9,500 feet west of Lake Chelan, and Mount Goode, a gneissic rock fang, towers near one of the lake's headwater streams.

* * * * *

FROM CASCADE PASS north to the International Boundary, the Cascade range axis — its main chain of summits — is broken by deep lateral valleys and jagged subranges of fingerlike rock peaks. One of the most amazing is the Picket Range. The names of summit points — Mount Challenger, Phantom Peak, Mount Fury, Mount Terror — enliven the nomenclature of maps. What explorer Henry Custer wrote in 1859 about the peaks near the boundary applies: "The sharp, frightful, fantastic outlines of the Cascade Mountains. ... no mortal pen could be found to describe this grand and glorious scenery.

The peaks reveal themselves only incrementally from highways. An automobile provides a parallax view, and gives too much importance to the lesser features of the foreground — the frenetic view of trees, guardrails, river banks, backwoods homes. Its motion distorts the sun and shadow on landforms. To truly see, one must study the mountains afoot.

Deciding to hike into the Picket Range wilderness to seek, as human minds do, a certain order and unity, my brother and I began with a trail ascent to Hannegan Pass. Because the route traversed avalanche-scarred slopes in a gradual ascent, we quickly found a rhythm that continued for two hours. As we climbed higher on the slope, we could see the interrelationships of the deep forest with the slide areas in the slow but sometimes surprisingly visible process of evolution. Thin soil on rocky slopes discouraged forest growth, and large conifers

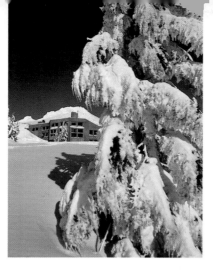

A heavy sheath of new snow decorates a mountain hemlock near the new Wy'East day lodge on the slope of Mount Hood.

tended to crowd in the deep, moist corridors. In deep North Cascade valleys such as the Nooksack, Skagit, and Chilliwack, both western red cedar and Douglas fir grow to record proportions. The cedar, which may grow seventeen feet in diameter and live over one thousand years, was valuable to pioneers because of its durability and usefulness. Indians hollowed out cedar trunks with fire for canoes and wove the roots into baskets.

Beyond Hannegan Pass the trail descends into the valley of the Chilliwack, where we could see impenetrable jungles of prostrate tree trunks, tracts of Alaska cedar, red alder, and devil's club. The words of the Reverend William Spotswood Green, an early explorer of the Selkirk Range in British Columbia, reminded us of the agony of leaving the trail and hiking through the devil's club, "whose thorns, if they penetrate the flesh, produce festering sores."

The thick evergreen forests, the dense understory, the lush alpine meadows, and the snow-decked high ridges—all result from a moist, cloudy climate. The mountain peaks are only visible for an average of about sixty days per year. Yearly precipitation totaling more than one hundred inches produces a heavy winter snowpack: eighteen feet of snow may accumulate at higher altitudes. The precipitation and the glaciers it forms give this region its striking character. As H. B. Ayres reported in 1899: "A climate more favorable to the growth of underbrush or to the starting of young trees would be hard to find." Climate explains the west-east and south-north change in forest growth. Alpine flora of the Three Sisters area shows an affinity to other mountain uplifts of volcanic origin in the southern Cascades, but not to the northern sections.

Our trek took us through U-shaped valleys carved by glaciers. In the Pleistocene, glaciers advanced and readvanced, deepening, widening, sometimes truncating V-shaped river valleys. In the depths of Goodell Creek, polished rock slabs disclose the scraping of glacier ice.

On the high ridges above the Chilliwack River, the timberline zone marks the disappearance of certain trees, but the alpine larch, a deciduous conifer, and stunted subalpine firs continue to grow in clumps. Farther east in the range, trees tend to become smaller, yet the ponderosa pine grows to a height of one hundred and sixty feet in the lower valleys, and along some river courses there are stands of very large, black cottonwoods.

Finally, from a high perch in the Picket Range we discerned the high rolling mountains of what is now the Pasayten Wilderness. In this sparkling region of lakes and meadows the mountain shapes are rounded, unlike the spikes of the more western peaks. Many of the elephantine-shaped peaks lifted high above deep, flanking valleys barely know a timberline. Stockmen have long used grasslands on these high eastern mountains. Although sheep have caused some damage in fragile meadowlands, the impact is minute compared with the damage caused by grazing in semiarid mountains near the Mediterranean.

Some mammals native to the high meadows have caused erosion damage for centuries. Chief among these is the hoary marmot. When not burrowing tunnels in the meadows, the marmot often can be seen perched on a rock searching for intruders. In 1896, mining reporter L. K. Hodge became quite familiar with the marmot: "He is shaped like a small pig, with gray fur stripped with brown and is nimble as a cricket and shy of human society. Instead of being no better than dog meat, as I was led to say in writing about the whistlers of Horseshoe Basin, his flesh is sweet and tender as that of a rabbit."

Smaller creatures, such as ground squirrels and rabbitlike pikas, pay heed to the marmots' warning signals. Despite the damage from alpine rodents, the meadowlands have prospered in the Cascade timberline region. In summer the herbaceous plant communities flourish between the altitudes of 4,500 feet and 7,000 feet, and meadows are a wildflower pageant.

The most adaptable mammal of the North Cascades may be the black bear. Bears share the forest with the mule deer, black-tailed deer, coyote, cougar, beaver, fox, porcupine, weasel, and otter. Playful, and harmless to humans unless surprised with their cubs, they relish the root of the skunk cabbage in moist valley bottoms. They also dine on huckleberries, and do not bother to separate the berries from the leaves, as hikers do. Bears will strip the bark from trees to get at the soft underlying cambium layer, and they savor the sap of the hemlock and Douglas fir. They will sometimes climb a tree and strip its trunk all the way down. Porcupines—who also victimize trees—will girdle trunks and eat the tops of young evergreens.

Animal encounters in the Cascades provide endless campfire stories, most of them amusing. My most surprising bear episode took place in the undergrowth of Agnes Creek early one summer. A group of us were hiking a faint path when a sudden parting of brush revealed a large black bear. Everyone, including the bear, fled in diverse directions. One of our group, who had been behind, chose not to believe the story of this encounter, until only a few moments later a second bear came rambling at high speed down our path.

* * * * *

THE HIGHWAY usually taken to reach Mount Baker flanks its north side. At one time, marathoners starting from Bellingham ran part of this route to the town of Glacier in the valley of the North Fork of Nooksack River, then made a sometimes-hazardous race for the summit of the northernmost volcano in the Cascade Range. Further into the valley, miners once built tent towns known as Shuksan or Hill City, Gold City, and Excelsior. A trail led northward up Swamp Creek to riches discovered by Jack Post, whose claims became the Lone Jack Mine.

In the winter this region is blanketed by heavy snows, and the

A stamp mill with vertical pestles for crushing ore at Mammoth Mine, near Barron in the North Cascades, is a relic from early in the century

miners abandoned their prospecting until the following spring. But today the snow attracts skiers either to the ski area at Heather Meadows or for cross-country adventure. One of my earliest winter tours was a route along Shuksan Arm, the rocky barrier stretching toward Mount Shuksan. There was a chill and unusual darkness in the air that spelled snow. The clouds thickened, Mount Shuksan vanished as if in a mist, and soon the snow ridge ahead lost its depth of field. With the blurred vision of snowfall, trees and slope blended, the snow swirled in uneven gusts, and our group was in the heart of a blizzard. It was time to turn back before our tracks were erased, but the experience provided the tonic of adventure. Wilderness ski tours, like mountaineering and deep-sea sailing, demand commitment.

On this same terrain in summer I hiked across lush meadows. My attention was drawn to lupine and Indian paintbrush, and higher up the alpine phlox grew in low clusters of white flowers, displaying a compact leaf structure that acts as insulation against the cold air. Beyond the floral wonderland towered 9,127-foot Mount Shuksan. Its ice-draped rock walls and soaring, pyramidal summit are the essence of alpine savagery. Not long after the turn of the century, two stalwart climbers — Asahel Curtis and W. M. Price — took leave from a Mazama summer outing to successfully undertake the first ascent. The outdoor group's name is especially fitting in the North Cascades, for in spanish *Mazama* means mountain goat. This rare and beautiful animal leaps about the rocky high country, astounding mountaineers with its ability to scamper rapidly up seemingly sheer cliffs. Soft convex pads on their hooves enable the goats to cling to steep rock, and they have explored many of Shuksan's cliffs and ridges with few mishaps. In the early prospecting days, goats were game *par excellence* to many miners.

The summit of Mount Shuksan offers a good view of regional geologic features. Ancient marine rocks were thrust to high altitudes, and erosion has exposed masses of granitic rocks, once molten magmas deep beneath the crust. Many of the peaks and ridges in view are composed of resistant metamorphic rocks which were once sedimentary or volcanic in composition and were then altered by great pressure and heat. Rocks of differing metamorphic age and location are sometimes juxtaposed by faulting. The distribution of North Cascade bedrock formations is largely controlled by major faults which divide the range into geologically distinct blocks. All these formations have been subject to considerable, recent uplift, making these northern mountains a young range. The present rate of arching may still exceed the rate of erosion.

As these mountains rose, streams cut through weak areas and were followed by the action of glaciers. After the last major glacial period occurred about fifteen thousand years ago in the Puget Sound Basin and Fraser River Valley, the great ice lobe melted and vanished northward. Valley and cirque glaciers within the range itself carved the rock shapes we see today.

Today, about half of the ice in the United States outside Alaska exists in the North Cascades. Some 756 glaciers have been identified, and a few, including the Boston, Chickamin, South Cascade, Deming, and Coleman glaciers, descend below timberline. Most of the glaciers exist in deep north and northeast-facing cirques which are protected from the sun. Typically, prevailing winds sweep winter snow into these cirques and perpetuate the formation of ice.

Melting from both snowpack and glaciers feeds a continual summer streamflow. The importance of these glaciers is critical: nearly two-thirds of the water from glaciers is released during the warmest months of summer, a time when precipitation is generally at a minimum. Also, the greatest ice melt occurs during years that are abnormally warm and dry.

Most mountaineers on Mount Shuksan notice the glacier-mantled cone of Mount Baker. Considerable ice on this conspicuous peak tends to cloak the fact that the Koma Kulshan or "Great White Watcher" of the Indians is a volcano. In recent years, scientists have carefully watched Mount Baker for signs of thermal activity. In August, 1975 ice melted in the summit crater, and vents emitted columns of smoke which rose to a height of 2,000 feet above the crater rim.

But the volcanic activity appears to have subsided — at least for the time being — and it is the sprawl of the thirteen glaciers which has puzzled mankind. Not much over a decade ago, six of these glaciers were in a state of advance, and the largest—the Coleman and Roosevelt—may still be pushing slowly forward. Mount Baker's glaciers have been the scene of numerous, serious accidents. Almost typical is the one which occurred on October 6, 1980: two climbers descending the Coleman Glacier were roped, but they held their rope coils loosely. When one man slipped, both fell into a crevasse, and one did not survive. Collapsing snow bridges and avalanches during warming temperatures or after a heavy snowfall are another source of danger. In one of the worst mountaineering tragedies in the range, a summer avalanche smothered six members of a 1939 college outing on the normal summit route.

* * * * *

BEFORE THE GLACIERS of Mount Baker provided modern recreation for the alpinist, the valleys and ridges of the North Cascades were known only to a few Indian tribes, fur trappers, and surveyors. Prospectors followed in increasing numbers. Uncounted centuries of Indian travel and over one hundred years of exploration beginning in the nineteenth century have created a rich nomenclature. The Indians left their names on valleys like the Skagit, Klesilkwa, Suiattle, and Nooksack, on peaks like Shuksan and Slesse, on towns like Chilliwack. Some British names were applied from the explorations of discovery:

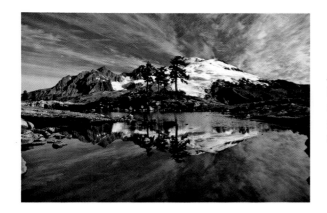

A rock-rimmed tarn on Park Butte vividly contrasts with majestic Mount Baker and displays the Easton Glacier on its southern slope.

Fort Hope, Fort Yale, Fort Langley, and New Westminster all record the passage of the Hudson's Bay Company men. Spanish names like Quimper were retained only along inland waters.

One of the earliest overland adventurers to view the North Cascades was David Thompson, who first saw the Methow River on July 6, 1811 and found an Indian village established close to the Columbia for the traditional salmon catch. Between 1810 and 1825 the fur trade expanded, and Alexander Ross was one of a handful of men who pushed inland by boat and horse, following the valleys of the Columbia and Snake into the Rockies. In the summer of 1814 Ross was probably the first European to penetrate the unmapped North Cascades, but his report is weakened by vagueness, and his route is conjectural. He entered the mountains near the Methow River, and in five days saw a height of land where "we found the water running in the opposite direction." Several days later, Ross came to beaver lodges on a stream he called "West River." Just what river Ross reached is still debated. His map, dated 1855, shows the "Far West Mountains," but no sign of Lake Chelan.

The Hudson's Bay Company, which in 1670 took possession of the territory then called Rupert's Land, eventually explored this region's northern fringe and built Fort Langley on the lower part of the Fraser River. The rival North West Company, formed in 1787, competed for fur until the companies merged in 1821. Fur traders were always seeking new sites for posts and new routes to cross ranges. The traditional annual brigade from interior forts descended the Okanogan River and the lower Columbia to bring loads of furs for shipment until 1846, when it became necessary to locate a brigade route wholly within British territory because the 49th parallel was established as the boundary of the Oregon Territory.

Alexander C. Anderson, an officer of the Hudson's Bay Company, explored several routes, partly in an effort to avoid the difficult and dangerous canyon of the Fraser River. He and others found routes from Fort Hope across the interior plateau and reached Kamloops by Indian trails. In 1860, the Dewdney Trail was built to keep resources from flowing to the United States and to center the British Columbia economy on the Fraser River. After a twenty-five mile mule trail was cut from Yale to Boston Bar, the Royal Engineers began a wagon road in 1861 which became the famous Cariboo Road.

The great Fraser River was first navigated by heroic North West Company men. In 1805 the Company assigned Simon Fraser the task of extending operations into the territory explored earlier by Alexander Mackenzie. In 1808 Fraser undertook to explore the river to tidewater in order to prove a water route to the Pacific Coast and to establish British rights to the entire Fraser-Columbia region. After his successful venture, Fraser admitted: "I have been for a long period in the Rocky Mountains, but have never seen anything like this country. It is so wild that I cannot find words..."

The discovery of placer gold along the Fraser in the early 1850s culminated in the great stampede of 1858, when twenty thousand gold miners poured into the region. During this boom Hope became an important center, and for all practical purposes was the region's capital. The greater region was called simply New Caledonia, but fearful of American annexation, Parliament created the colony of British Columbia in 1858.

Surveying the 49th parallel required extraordinary endurance and field logistics. The International Boundary Survey could only obtain accurate triangulation by placing stations on mountains and marking them with pyramids of stone. The parallel was determined with the help of astronomical observations at these stations. Easy to define on paper, the boundary line is difficult to locate because it follows no natural features. A fair indication of the best contemporary knowledge was given by George Gibbs, a special observer attached to the American party. He noted from near the upper Skagit River that a "sea of mountains stretched in every direction as far as the eye could reach.... To the south and southwest was the great mass of the Cascade range, Mount Baker being distinct among the rest."

When the British survey party arrived from England in 1858, their operations coincided with the Fraser gold rush, which caused serious supply problems. Both American and British parties surveyed and marked the boundary along the 49th parallel between 1857 and 1862. During a second survey, which took place between 1901 and 1908, the field men climbed some of the principal peaks near the boundary. Valley foot trails had vanished during the forty-year interval, so new paths were cut through the thick underbrush. Finally, a joint British-American party inspected each monument. The majesty of the wilderness range awed the men. Gibbs recorded that, "A still grander scene is at the Putlushgohap Lake....the mountain overhangs the water in an almost perpendicular bluff of 1,000 feet; cascades, some of them nearly half that height, fall in spray from its sides; the lake itself towards the end of June was still sheeted in ice and snow, and its outlet was a continuous fall nearly 1,000 feet in half a mile. Above the noise of the stream the roar of avalanches was heard at intervals."

There were other surveys, notably by field parties sent to explore the possibilities of a transcontinental railroad and by government topographic surveyors who made the first accurate maps of the region. United States Geological Survey mapping, begun in 1897, had a marked effect on regional knowledge. One map prepared by the Northern Pacific Railroad in 1867 showed a "Skatchet River" in the position of the Nooksack. Another showed the Skagit originating in a Garden of Eden.

* * * * *

MANY HARDY prospectors needed neither maps nor a

knowledge of geology to find ore prospects. From 1890 to 1937 over five thousand claims were staked in the Mount Baker district. Although gold was discovered in the Skagit River Valley in 1859, the greater Fraser and Cariboo discoveries riveted the attention of most argonauts. But when Jack Rowley and John Sutter found rubies while searching for placer gold in 1872, the name Ruby Creek fanned a Skagit rush. Soon hundreds of miners huddled in streams, swirling sand in pans. In five years the placers sifted out gold with an estimated worth at that time of one hundred thousand dollars. The twenty-mile section of trail from Goodell's — now the site of Newhalem — to the mouth of Ruby Creek, was known as the "Goat Trail." It was famed for a rocky corner known as Devil's Elbow, a crucial spot overhung by a rock wall and overhanging a canyon. Travel here was always hazardous and sometimes impossible.

Some ninety years ago a mining colony with the unlikely name Monte Cristo mushroomed in a narrow mountain draw near the headwaters of the Sauk River, between Glacier Peak and Everett. Monte Cristo is immersed in fable and fact. The dream began when Joseph Pearsall, prospecting on a high ridge in the summer of 1889, studied the walls of a peak to the north. Its streaking red bands suggested the oxidation of rich sulphide ores and indicated wealth. The veins of ore in the mountains above what was to become Monte Cristo were indeed rich. A horse trail was quickly built to the locale, then a wagon road, followed by a railroad. Shafts were dug. Cable tramways as long as ten thousand feet were strung from high rock precipices to the townsite. Even before the forty-two-mile railroad was completed, gold and silver worth three million dollars at the time were taken out of the vale.

A townsite grew to accommodate the onrush of the miners: in addition to hotels and schools there were saloons and dance halls. It was the narrow valleys of the Cascades and the torrential rainfalls of late autumn that spelled Monte Cristo's doom. The year 1897 had been a bonanza, but in late November snowfall turned to rain. As temperatures rose, avalanches thundered into the valleys. The deluge of water from heavy rains raised both the Sauk and Stillaguamish rivers to flood levels. Trestles and bridges were swept away, tunnels were packed by debris, trains were stranded. The mines suffered little damage, but were closed until the railroad was rebuilt, and by then the mining climax had passed. Monte Cristo's scenic fame drew tourists who rode the trains, and for a time gas-operated railroad cars took visitors to the site of the amazing vale deep in the range. Today, hikers can glimpse the old collector site, the yawning hole of the Upper Mystery Mine, the relics of a large cookhouse on a ridge near timberline where meals were once prepared for eighty men.

Above the stream valleys near Monte Cristo, man exploited the mineral wealth in the bedrock. Further north, in the valley of the Skagit River, man exploited water. The great volumes of water in the Cascade Range and the sharp drops in altitude made hydro-power generation very feasible. Federal dam building began on the Columbia River and its tributaries in the 1930s, but Seattle City Light began to develop the Skagit River Valley — first using a wooden crib — in 1924. The large Ross Dam project soon followed in 1937. When the concrete structure was completed in 1950, the dam rose almost six hundred feet above the old river bed.

As good new sites for power generation proved scarce and power demand continued to soar, a higher Ross Dam was proposed. Ten miles of Ross Lake would flood into British Columbia, and five miles would flood into the pristine wilderness valley of Big Beaver Creek. Lands, timber, winter game ranges, and trout spawning grounds would be adversely affected. The State of Washington and the Province of British Columbia have officially opposed the project, which exemplifies the quandries of an expansionist economy.

Today, the Cascade Range stands in the midst of the controversy between exploitation and conservation. Its heritage of rich resources has proved a paradox to man. We have prospered from its great trees, mined its mountains, exploited its valleys and waters, and revered the beauty of its grand forms. Yet until recently we have given little thought to conserving resources which will not replenish themselves for later ages of human existence. We must remember to share these mountains with other forms of life. We must insure the continuity of the great forests and the fragile alpine soils. We must preserve the mountains as a spiritual resource.

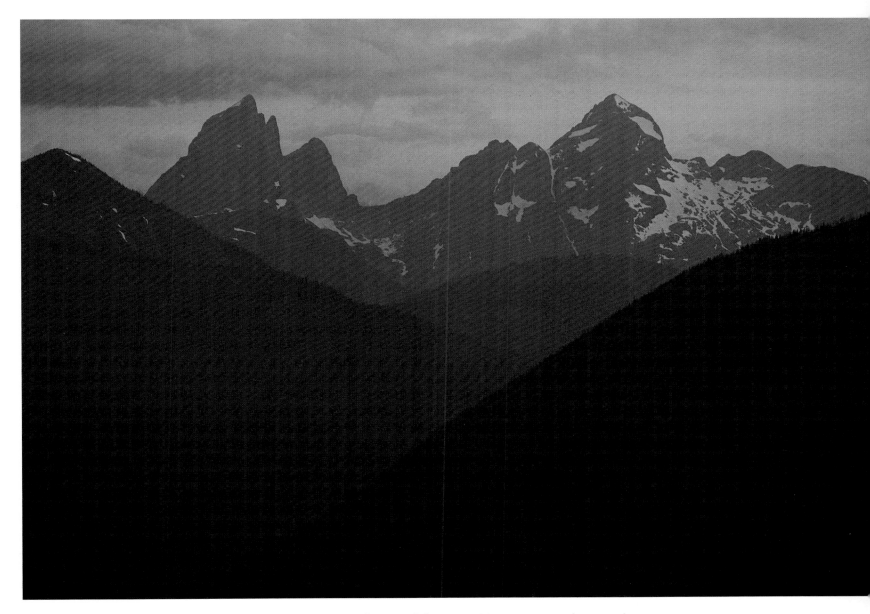

Above: The distinctive twin shapes of the gaunt Hozomeen peaks near the upper Skagit River were an unforgettable landmark to both Indians and early surveyors. *Overleaf:* The northern flank of remote Mount Challenger is covered by one of the largest glaciers in the North Cascades. Its myriad crevasse patterns present a graphic display amid the sharp, gneissic rock peaks of the Picket Range.

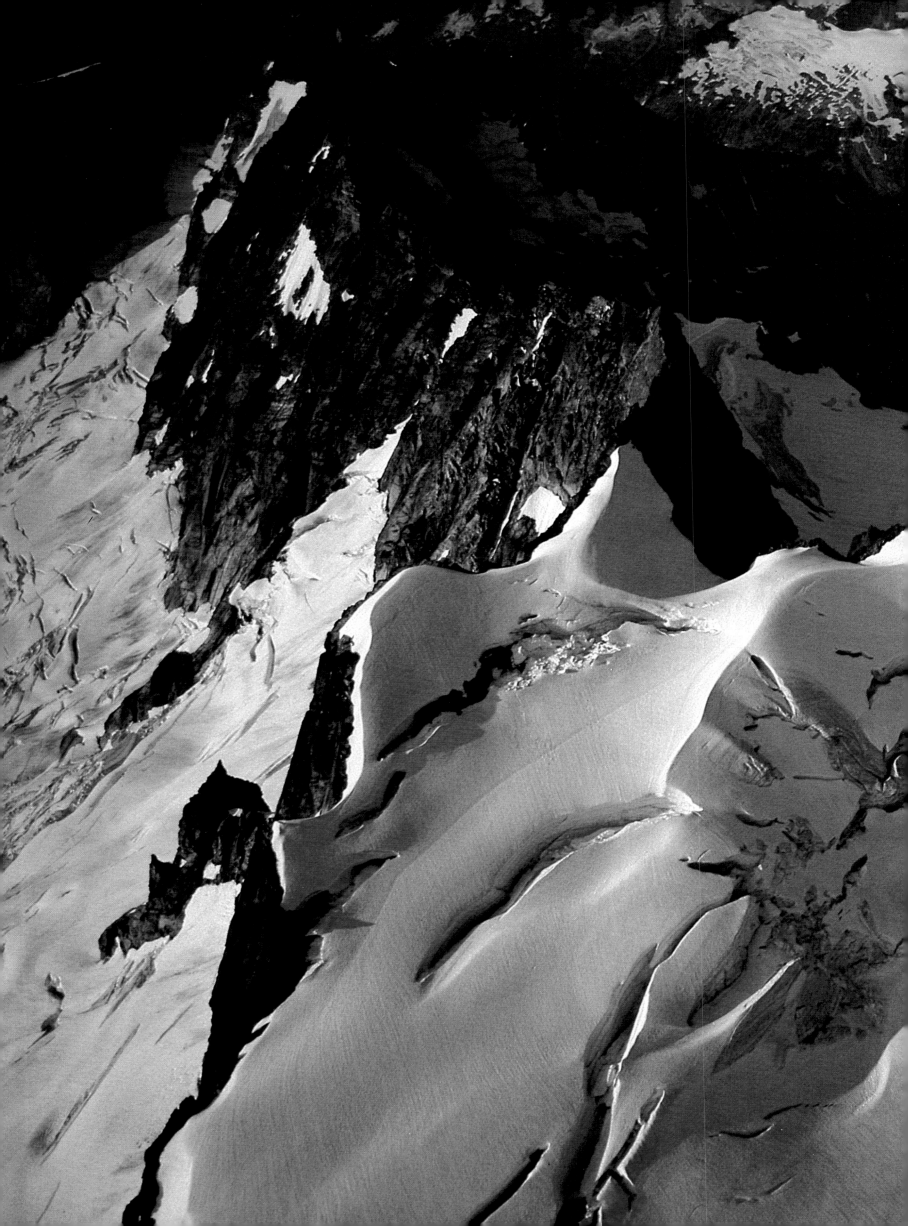

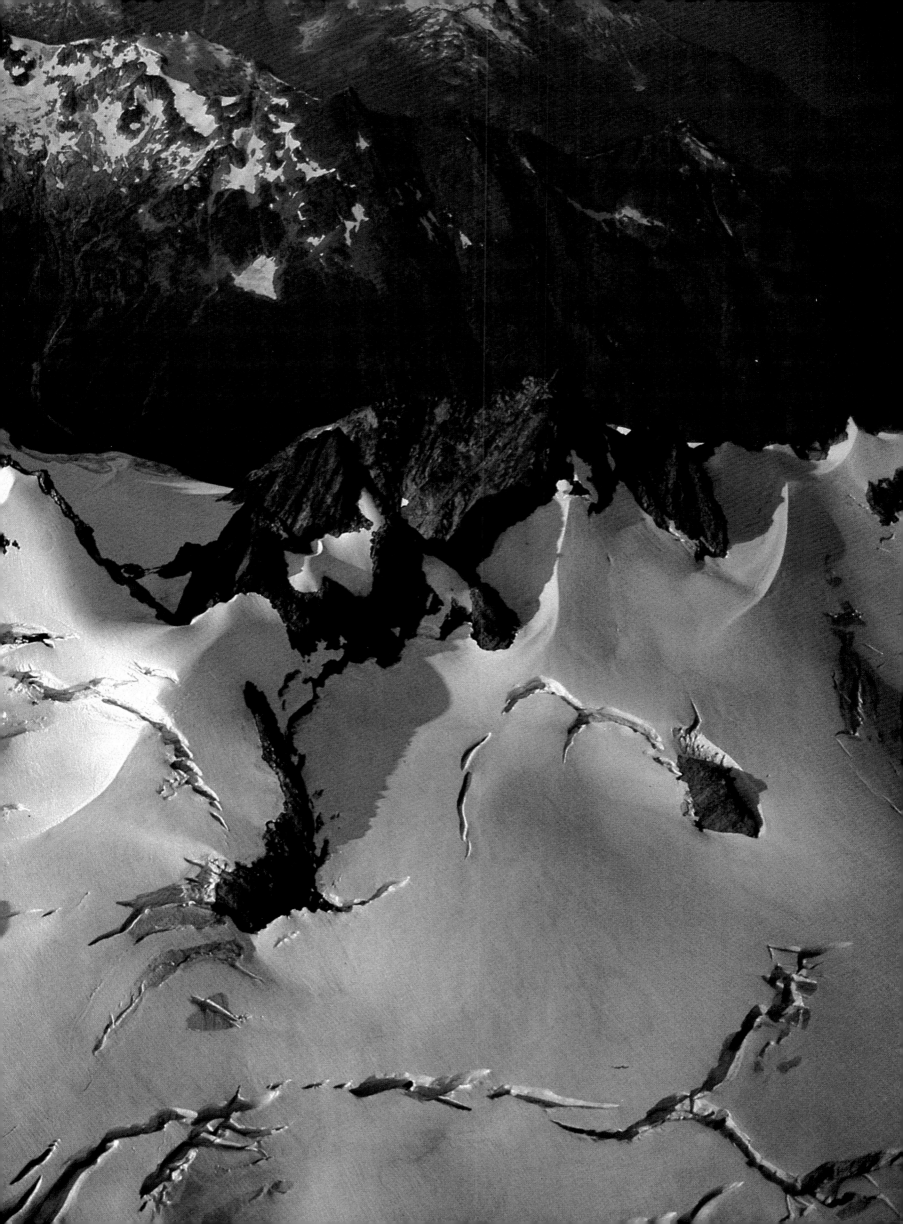

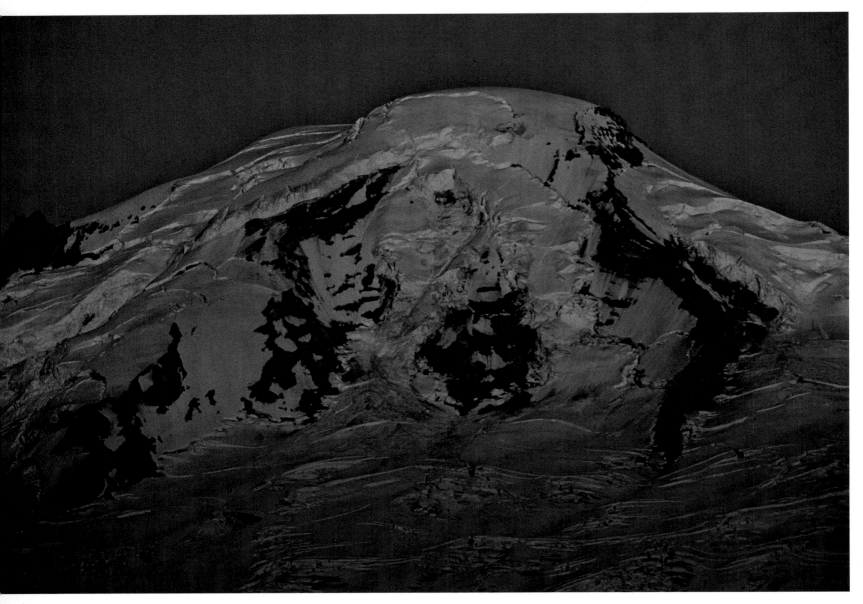

Mt. Baker's steep, crevassed glaciers are tinted red by alpenglow, an atmospheric effect of sunset. The icy mountain is usually climbed by way of the Coleman Glacier (foreground), following the first route pioneered on August 17, 1868 by Edmund T. Coleman, an English artist living in Victoria. He later observed, "As precipices extended downward from our feet, a single false step would have been fatal."

Above: Behind tall firs, British Columbia's deep, mountain-rimmed Chilliwack Lake is the legacy of fluctuating ice-age glaciers. *Overleaf:* The sharply defined character and color of diverse topographic features are the principal characteristics of the convoluted North Cascades. Glacier Peak (upper left), Snowfield Peak (center) and Mt. Rainier (right) are conspicuous in this southward view.

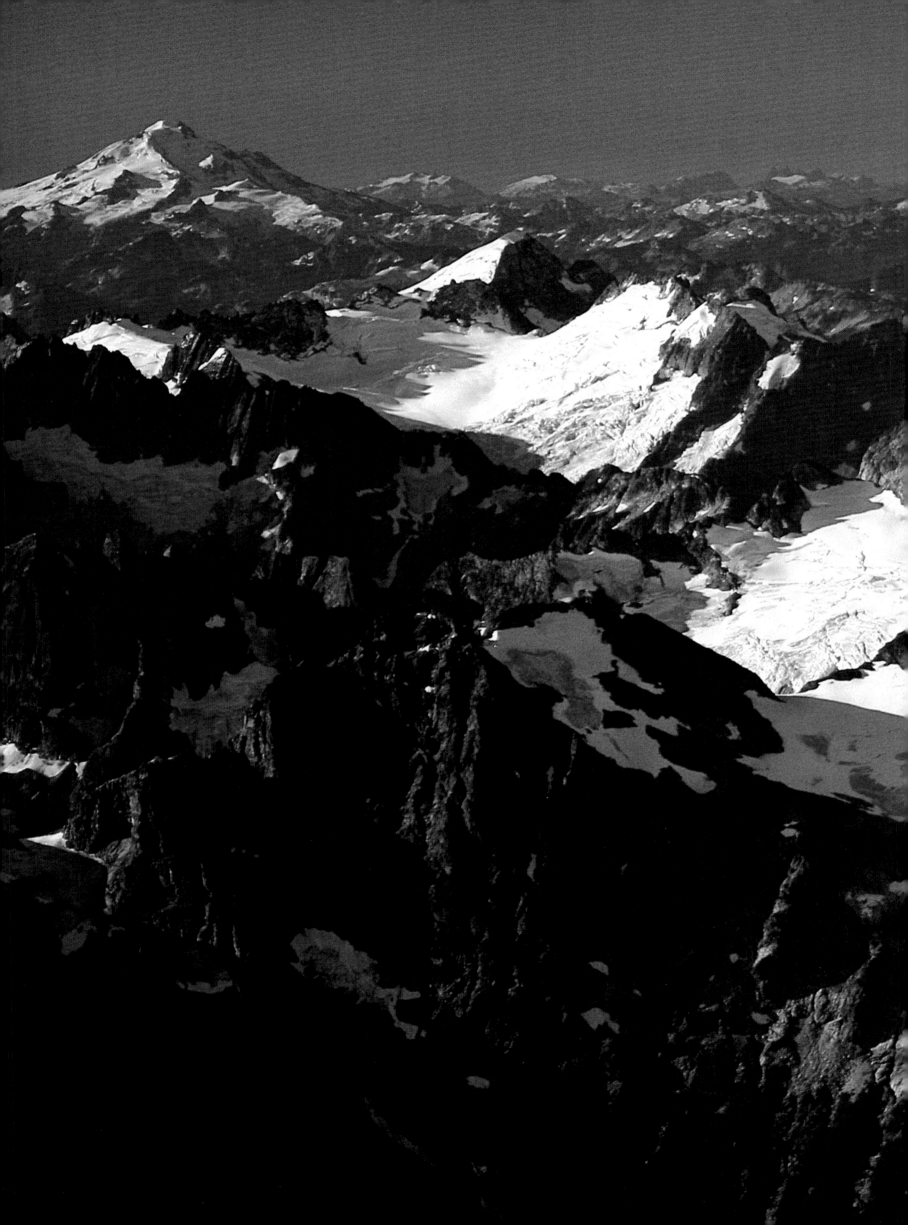

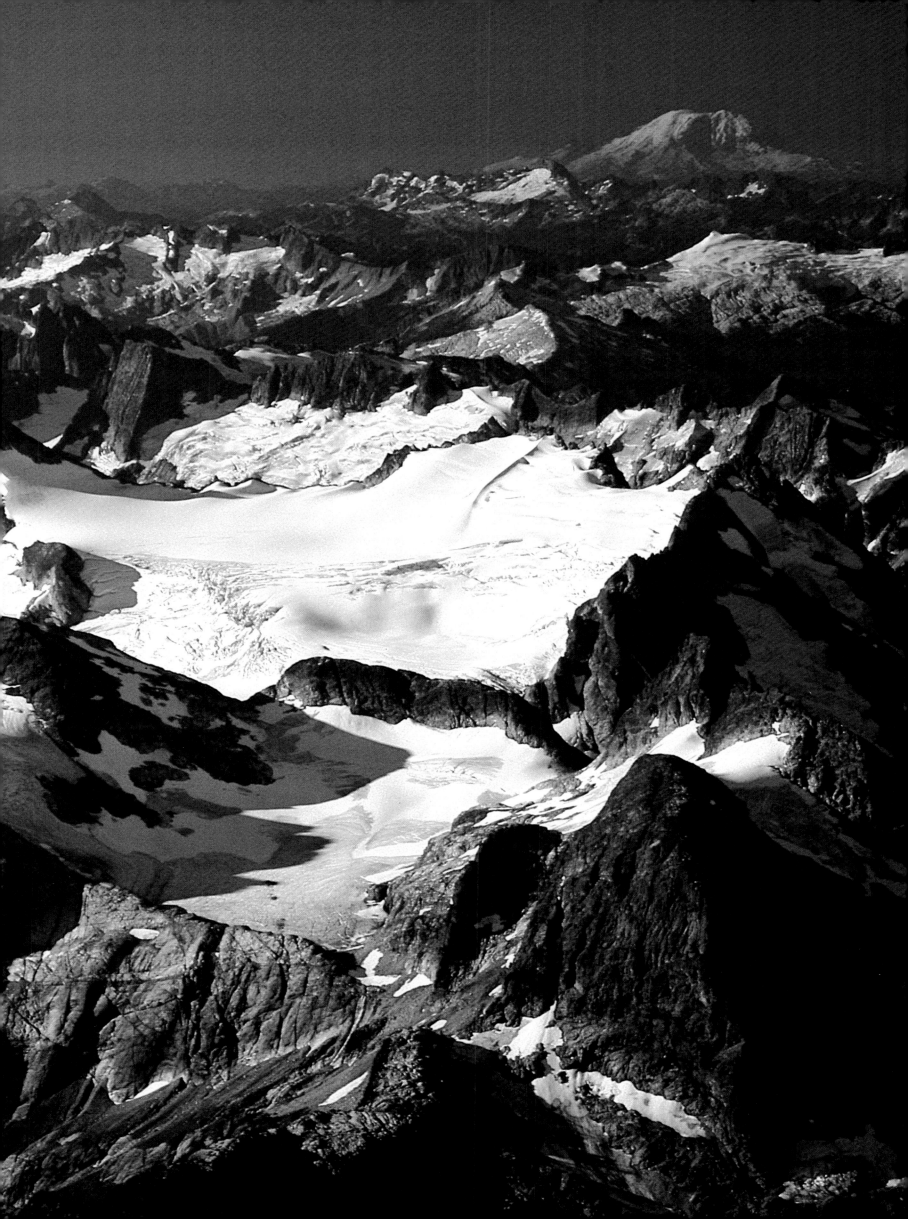

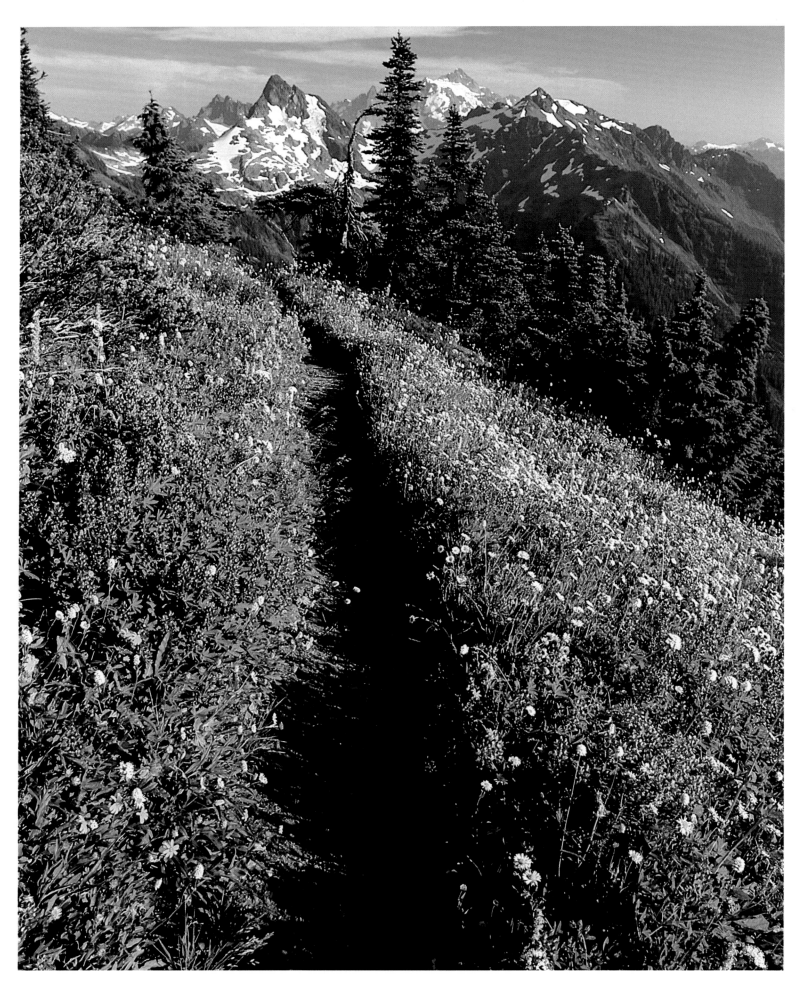

The trail to Winchester Mountain is lined with a riot of lupine, alpine aster, bistort, and valerian. Goat Mountain peeks behind scattered subalpine fir, the spirelike tree of the high mountain region. Now popular with the hiker, this scenic area near the International Boundary and the Gargett and Lone Jack mines was once the domain of prospectors.

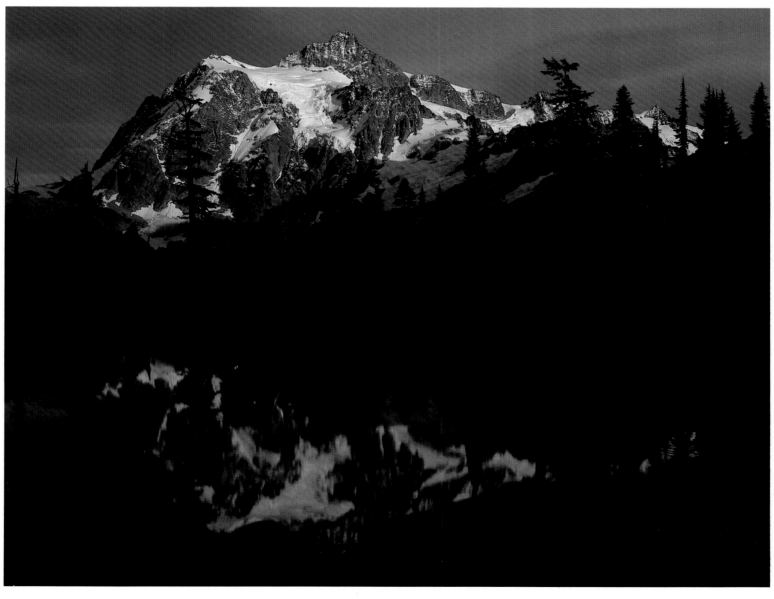

A complex showpiece of alpine architecture, Mount Shuksan is a bastion of dark green schist. Particularly resistant to erosion, schist is a basaltic submarine lava metamorphosed and thrust laterally upward as a sliver. Shuksan's sprawling mass, including five craggy ridges, gives birth to chaotic glaciers; Hanging Glacier, under the summit pyramid, is seen behind the firs of Heather Meadows.

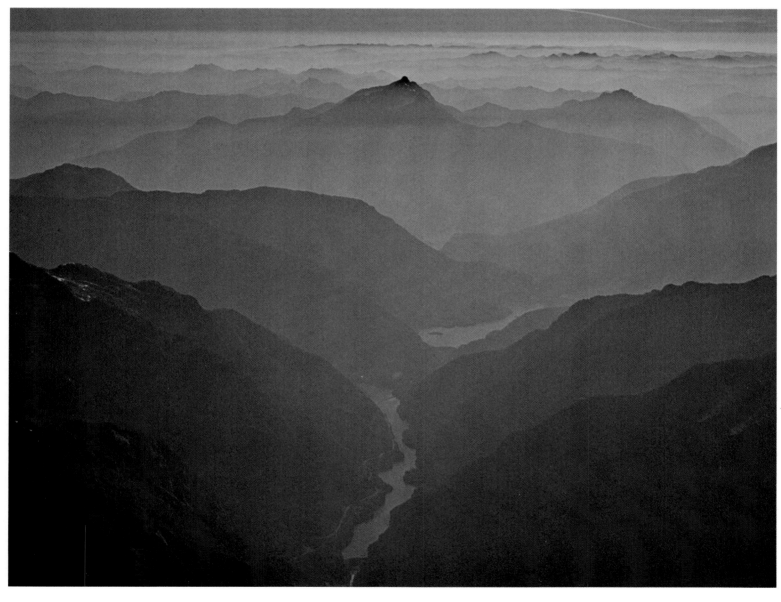

Seen from far above the Skagit River, Jack Mountain—one of Washington's highest non-volcanic peaks — rears above shaded tributary streams and Ross Lake. Three dams, Gorge, Diablo, and Ross, form lakes visible in this mountain heartland, with the North Cascades Highway following the hydroelectric-power-reservoir chain. The perspective of distance belies the size of distant ridges.

Orange agoseris, found in dry mountain meadows of British Columbia's
Manning Provincial Park. The slopes of Three Brothers Mountain and
nearby Mount Outram are credited with the finest assortment of arctic-
alpine flora in the Cascades. The rolling upland's distance from the sea
affects its biological character and ecosystem.

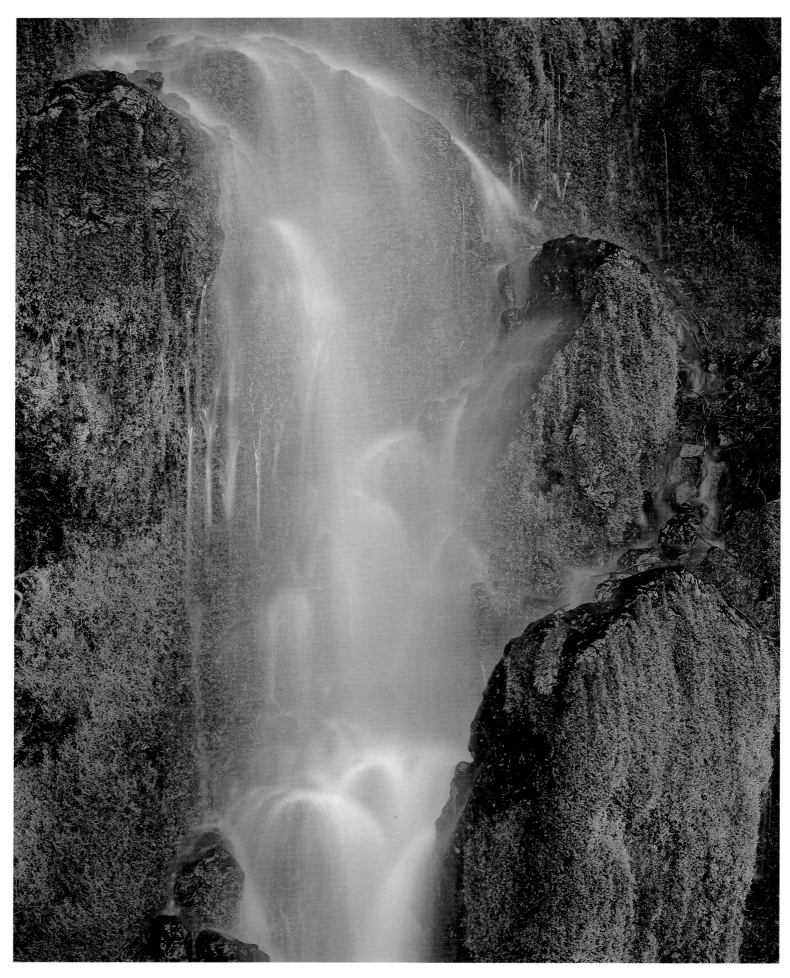

Countless waterfalls and cataracts in the Columbia Gorge and other canyons on the seaward slope of the range inspired the name Cascades. Thundering water tumbles down sheer cliffs, its drifting spray moistening rock surfaces and enhancing the growth of delicate moss and vegetation. Evergreen trees crown the waterways, seeking a tenuous hold at every possible opportunity.

Above: The great yellow flowers of skunk cabbage, massed on a succulent stalk, grow quickly in bogs and wet meadows after snow has left the mountain woodlands. The distinct cabbage aroma attracts insects. *Over-leaf:* The intricate pattern of the Tepeh Towers near Klawatti Peak (between Inspiration Creek and McAllister Creek glaciers) represents millions of years of wedging by frost and carving by ice.

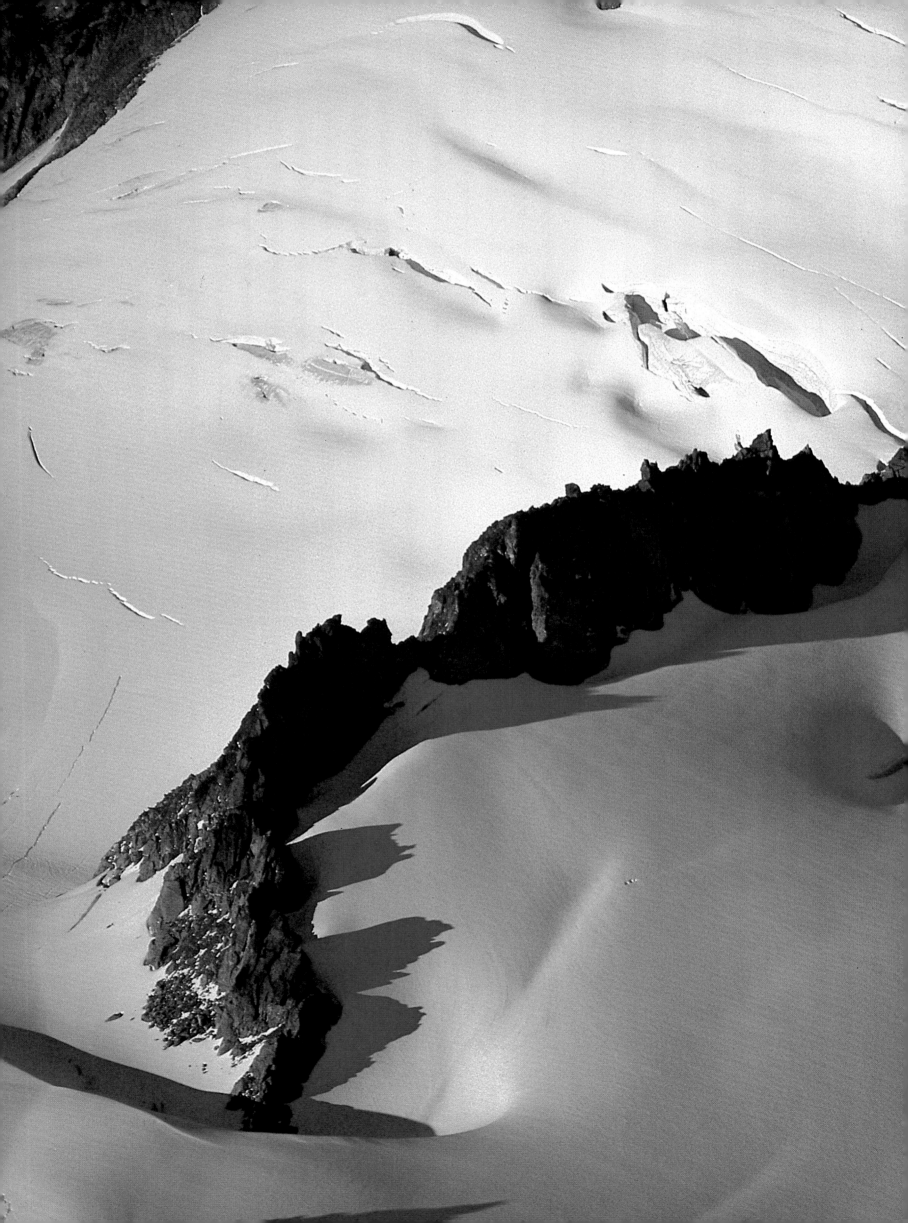

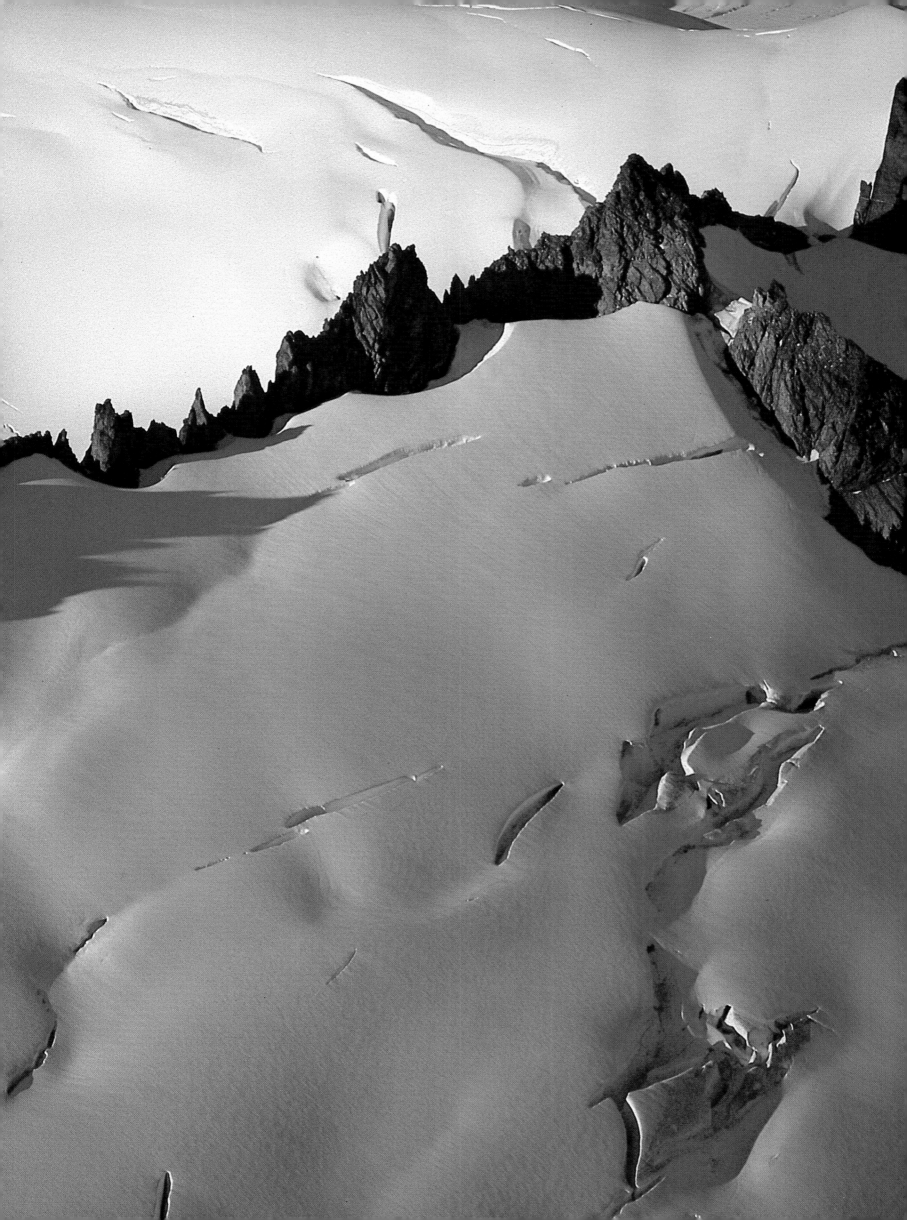

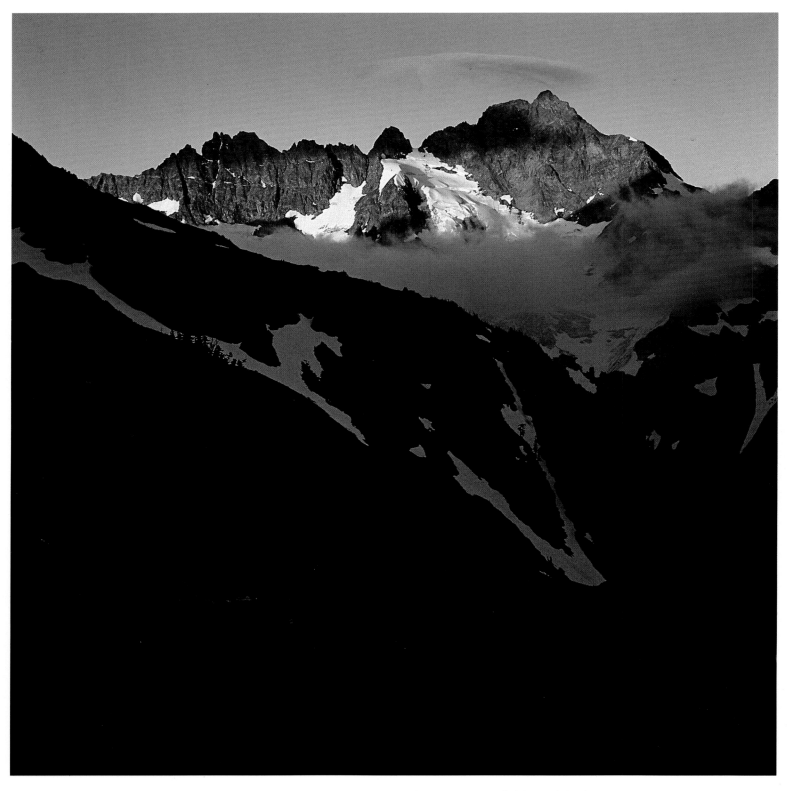

The lenticular cloud above the summit of Mount Formidable and the lower stratus cloud hovering over the glacier may signal deteriorating weather. The formation of a lenticular cloud indicates a strong upper air flow pattern and is typical when moist unstable layers are present in the atmosphere. The cloud condenses on the windward side and evaporates on the leeward.

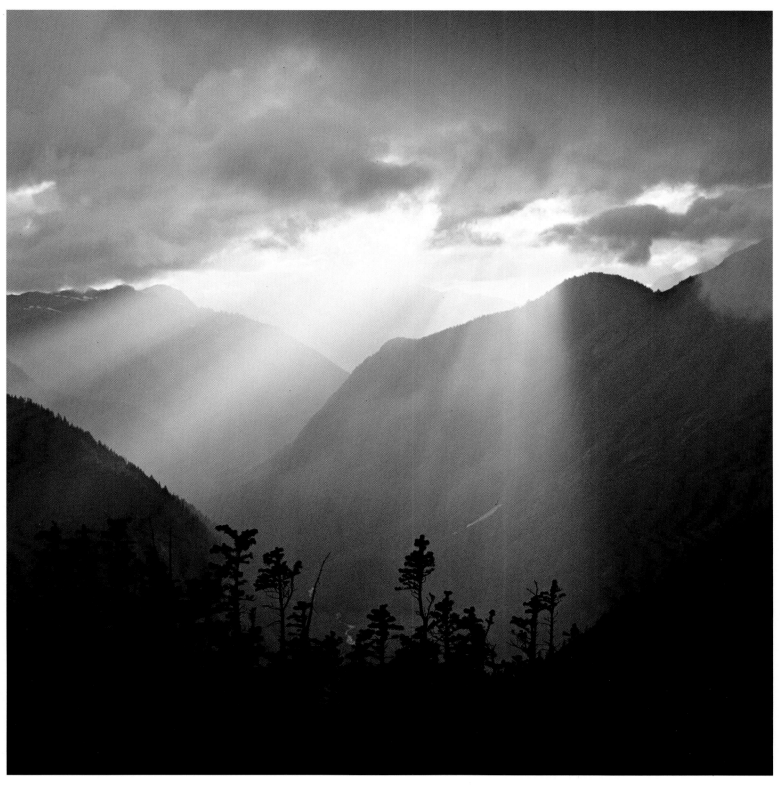

Above: Evening sunbeams streak through a cloud blanket to the deep valley of Cascade River's middle fork. The valley's U-shape is due to the flow of an ancient glacier. *Overleaf:* An aerial view of parallel mountain ridges with great local relief. The scene includes the spectacular spikes of the Picket Range, and, closer, Mounts Despair and Triumph.

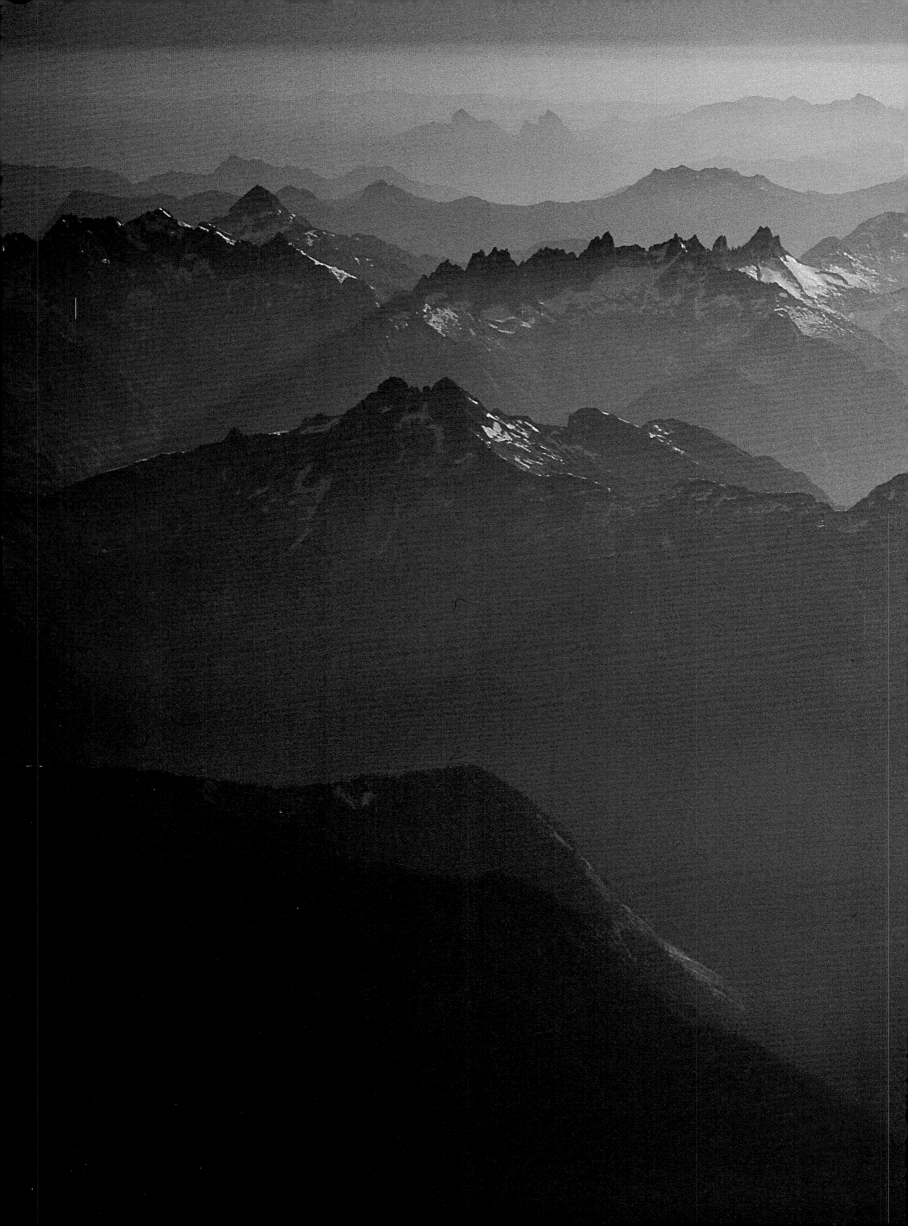

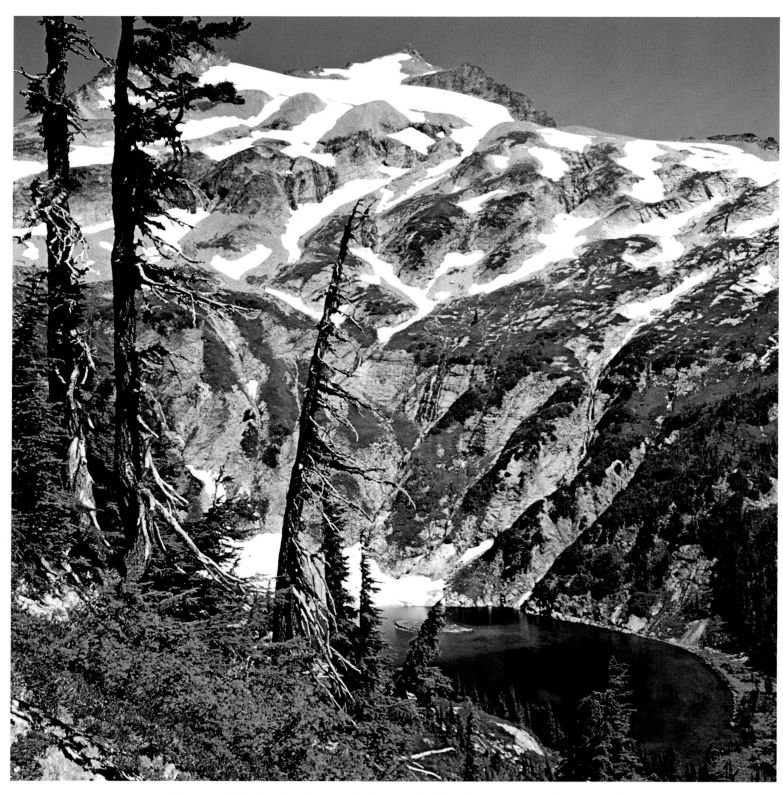

Above: Sahale Peak, above elliptical Doubtful Lake and its rounded glacial cirque. *Right:* The gneissic golden fang of Mount Goode forms the highest summit north of Lake Chelan. The difficult pinnacle was not conquered until 1936. *Overleaf:* Glistening Glacier Peak, its slopes smothered by the Chocolate, Dusty, and other glaciers, last erupted about 12,000 years ago.

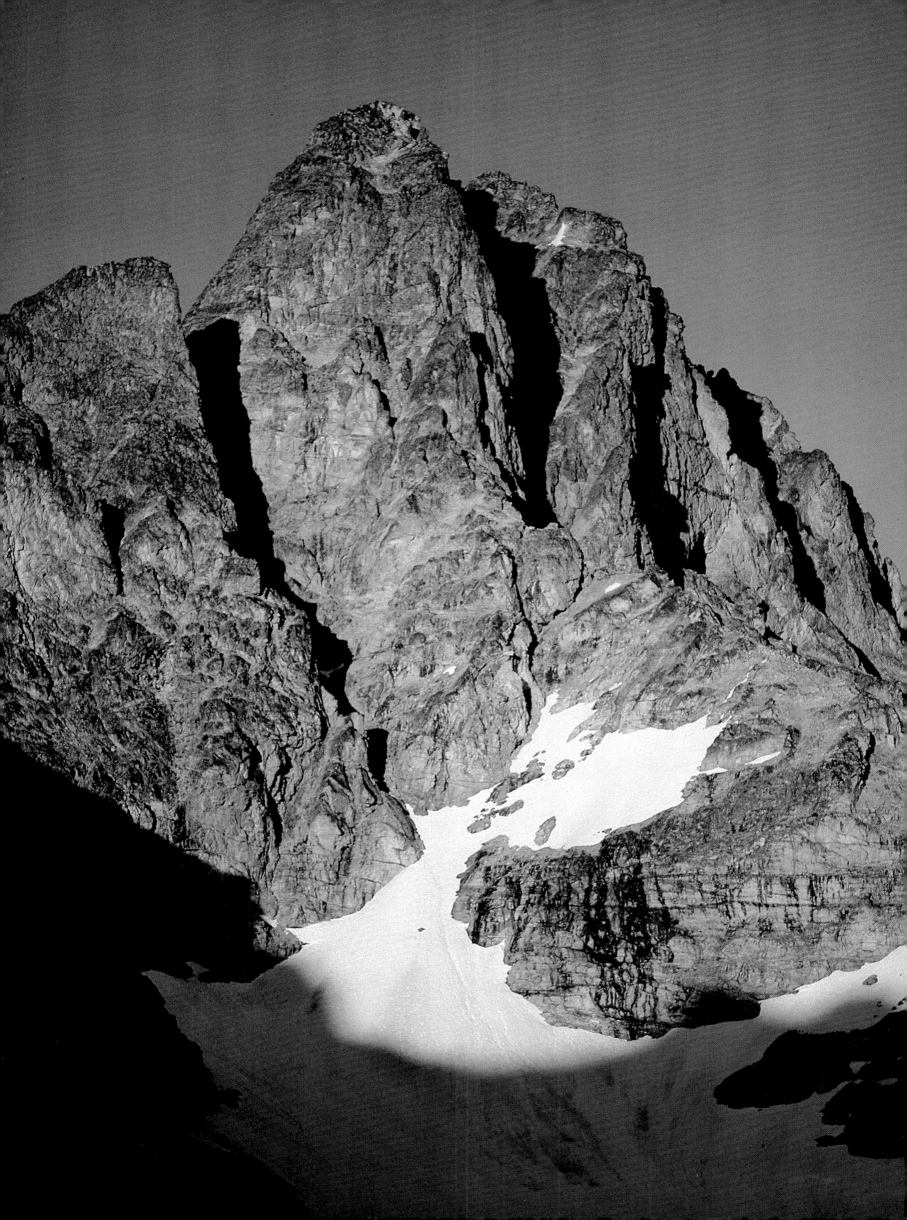

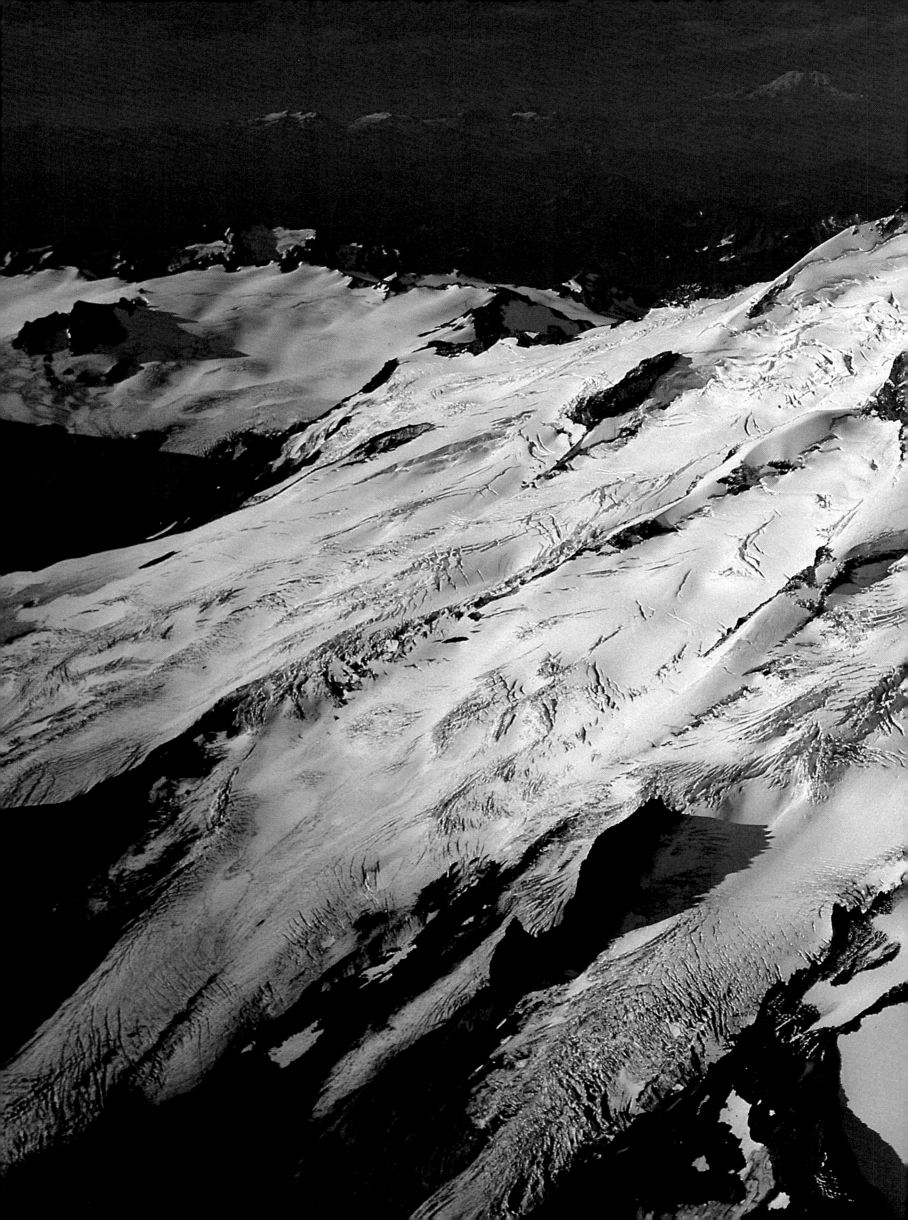

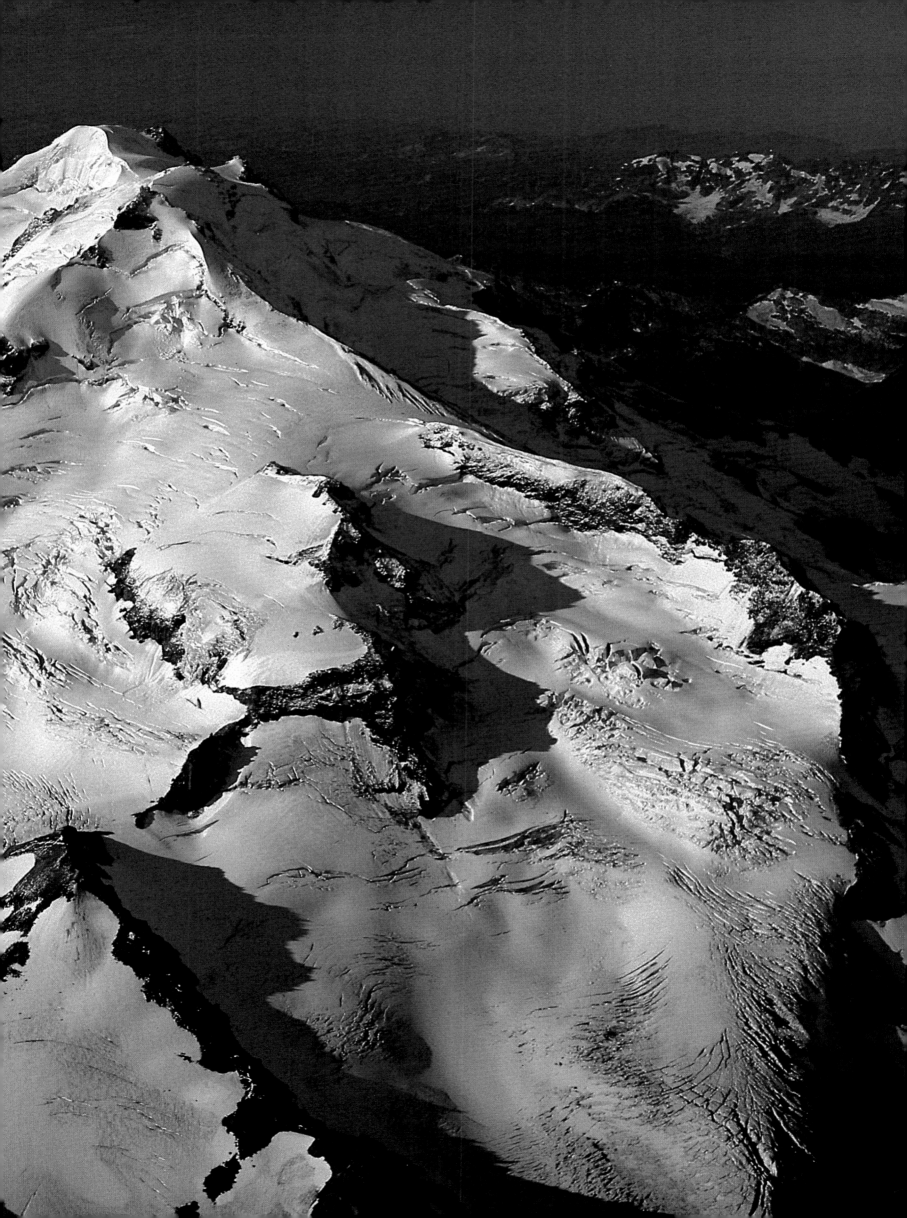

Above: Grass in a shallow alpine lake. *Left:* Western lady fern grows in rich soil in the Cascade's seaward forest floor. Seeking moist ground and open, sunny areas, ferns are ubiquitous along the range. Hikers frequently find their clothes soaked while following trails and crossing logged areas over-grown with ferns, whose long fronds collect the morning dew.

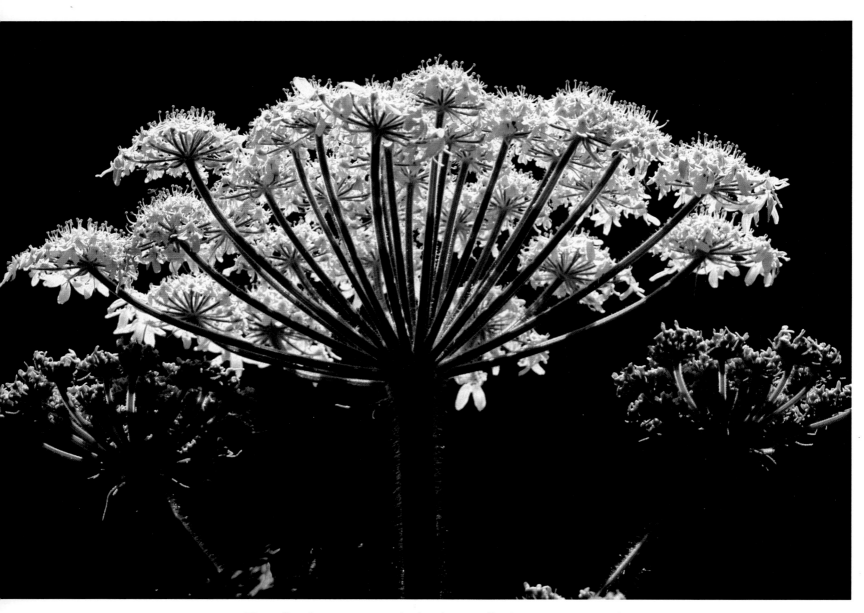

The tall, robust cow parsnip dominates all other specimens in the mountain meadows. Up to twelve inches wide, its umbrella-shaped white flower clusters grow on thick hollow stems up to eight feet high. Considered a delicacy for cattle, deer, and elk, the cow parsnip's geographic range includes the Rockies and western Canada's mountains.

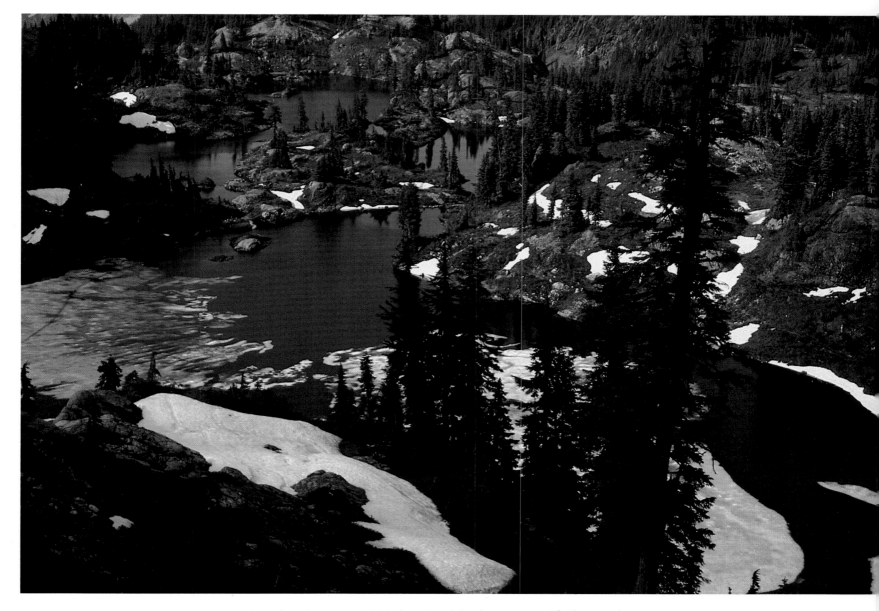

Rampart Lakes, barely over 5,000 feet in altitude, nest amid "heavenly gardens and rock bowls." Seen here with the lingering snow of early summer, the small alpine lakes are rimmed by the resistant Keechelus andesite of Rampart Ridge, east of Snoqualmie Pass. This archipelago of lakes is accessible by an easy day-hike.

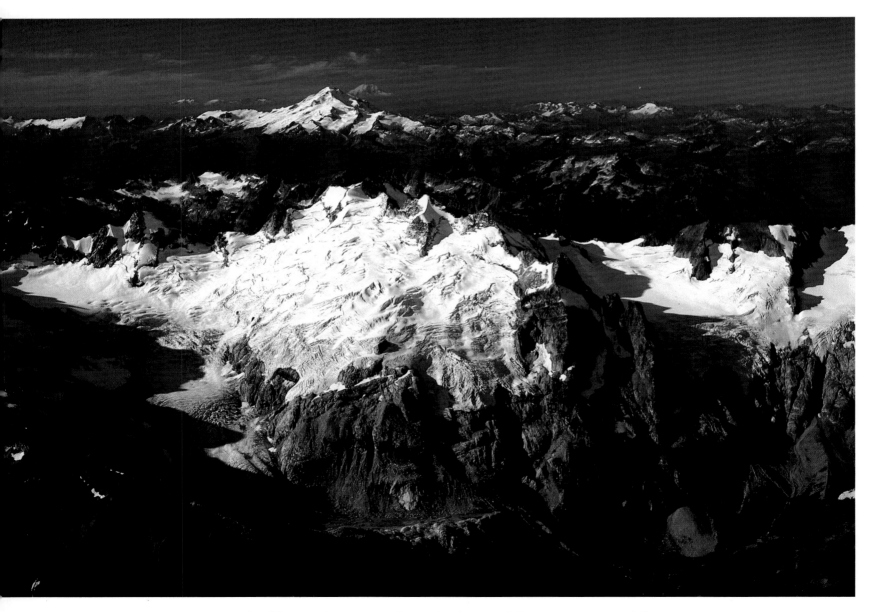

Looking southwest onto Dome Peak, one of the crowning massifs between Suiattle and Cascade passes. The granitic rock of Dome and its satellite peaks forms blocky, monolithic shapes that contrast with the rounded pyramid of volcanic Glacier Peak in the distance. Meltwater from the sprawling Chickamin and Dana glaciers tumbles downward in cascades.

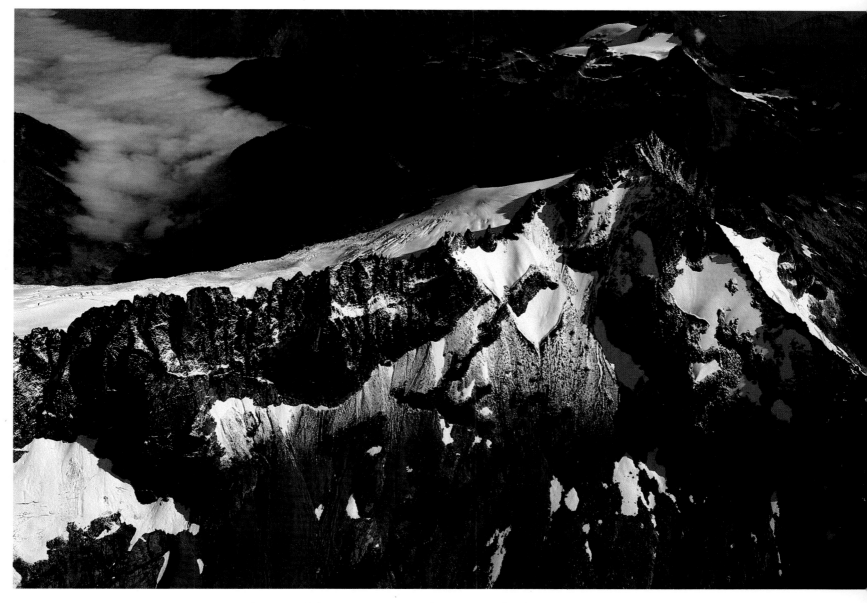

Above: Long barrier of sharp spires, named Ripsaw Ridge by early mountaineers, intersects with the west face of 9,080-foot Mt. Buckner in the southern Skagit area near Cascade Pass. *Overleaf:* Huckleberry shrubs crowd a fog-enshrouded location crowned by subalpine fir and mountain hemlock, a scene typical of the western slope of the Washington Cascades.

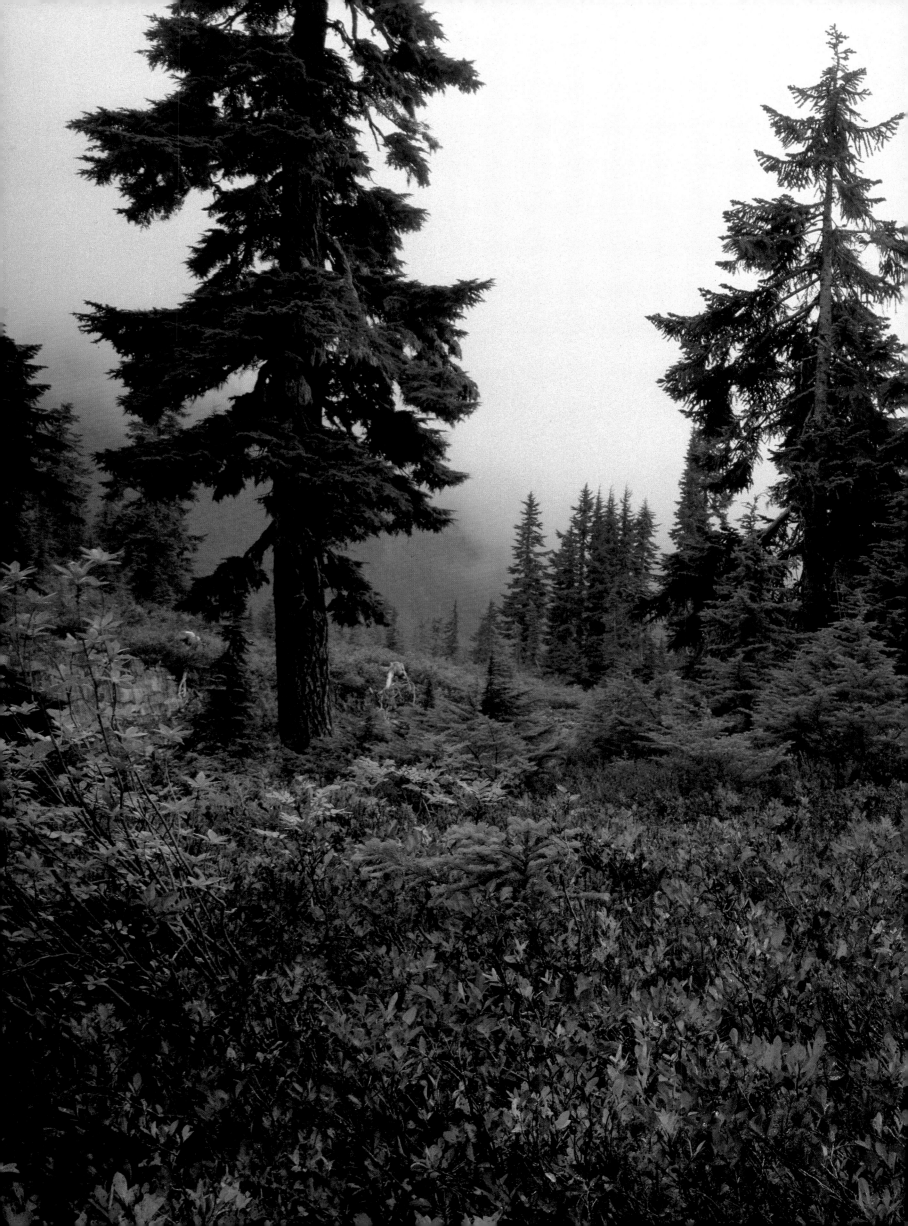

Climbers on the summit dome of Mount Baker. The broad icecap, flat for almost one-quarter mile, feeds five glaciers. In the background, is Sherman Crater, where heat emission in the past two decades melted snow and ice. In the late 1970s, the warming crater held a 250-foot-wide lake, a potential avalanche hazard.

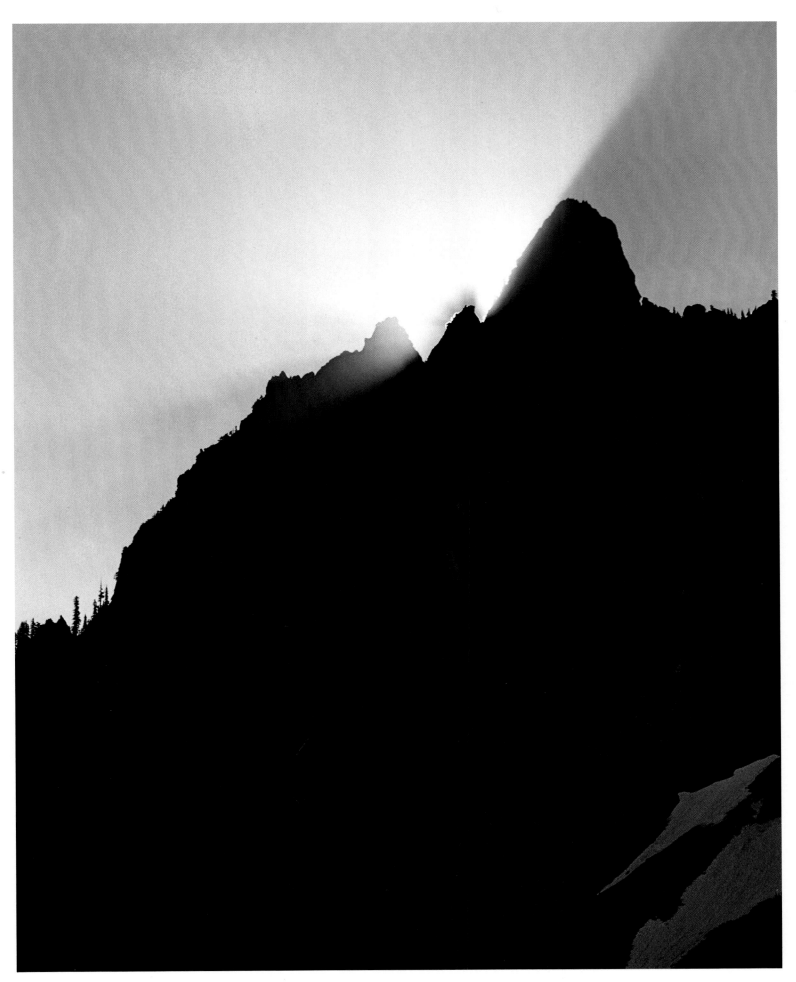

Above: Between Mount Pilchuck and Monte Cristo are dense concentrations of dark, serrate crests. Modest but shapely rock peaks like Morning Star rise above the stunted trees and heather that cling to precipices. *Overleaf:* Foreshortened by the camera's angle, the nearly mile-high north face of Big Four Mountain is a spellbound wintry spectacle found on the route to Monte Cristo.

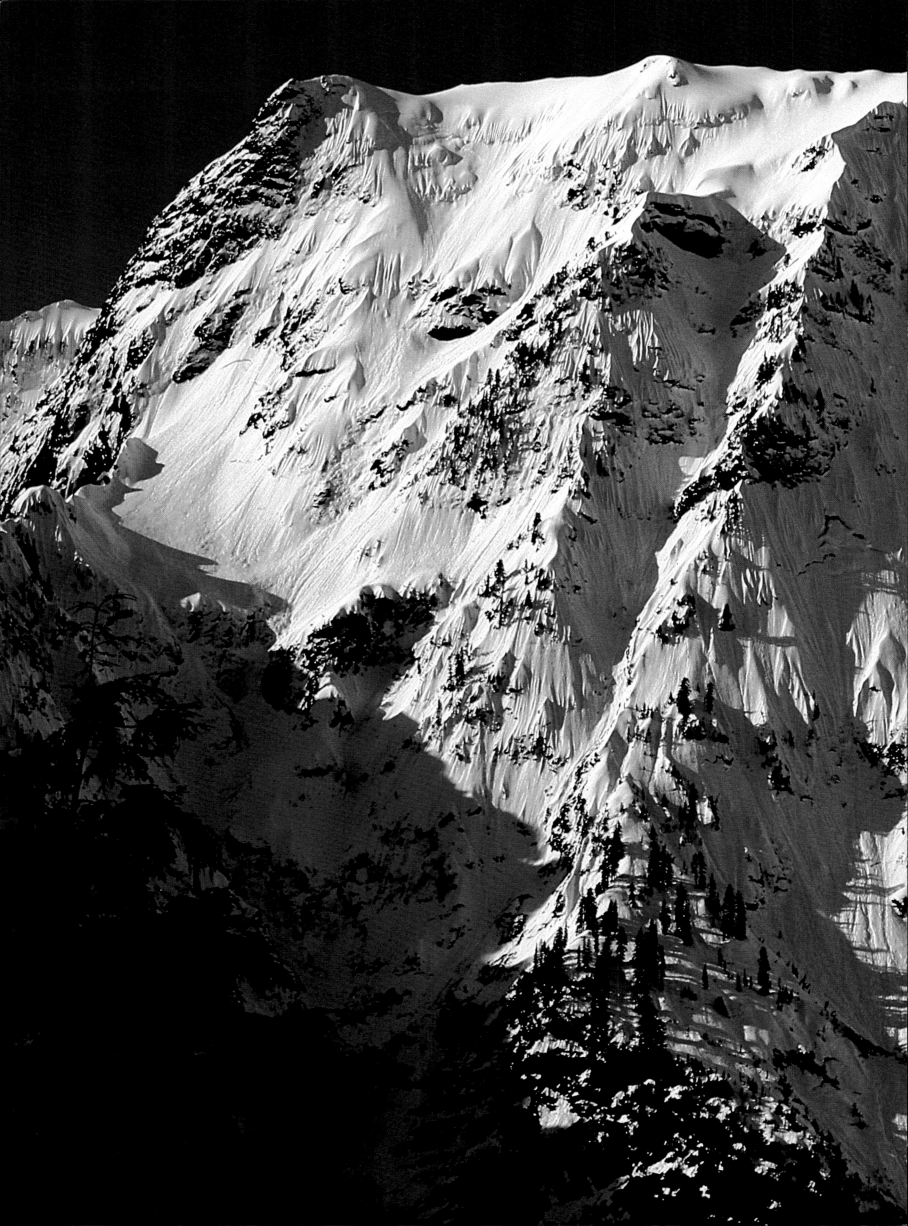

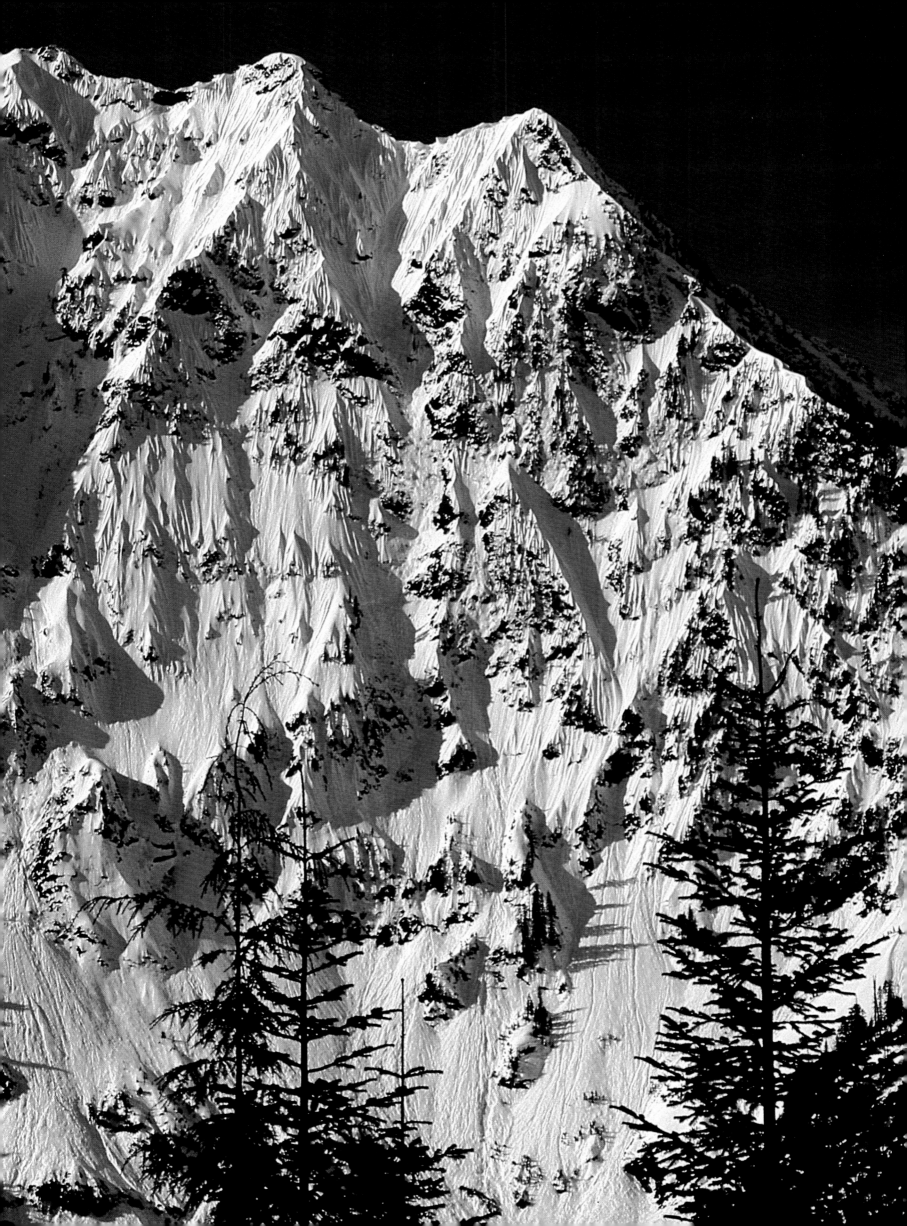

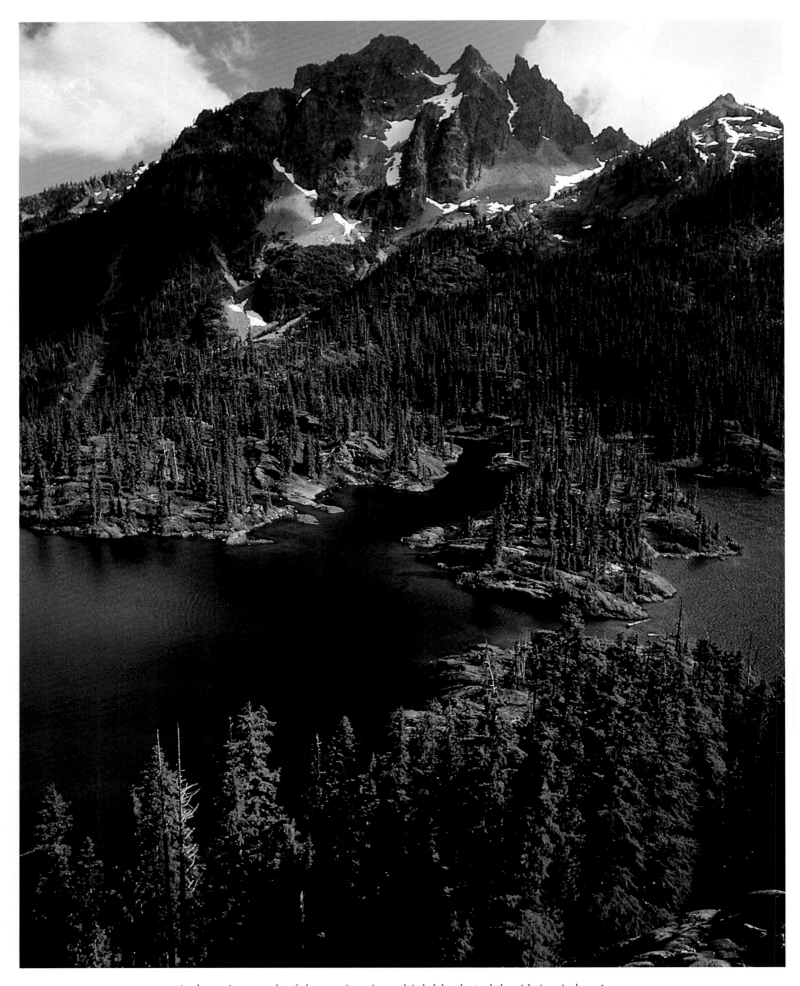

A charming result of the ancient ice which blanketed the Alpine Lakes Area is remarkably shaped Spectacle Lake. Parklands and open coniferous forests vie for existence on the exposed bedrock. The regular intervals of the summit peaks of Three Queens Mountain counterpoint the lake's jeweled waters.

Above: Looking east to the sunrise over the lower Snoqualmie River Valley. Agriculture, dairying, and lumbering activities in the foothill country attest to the diversity of the range. *Overleaf:* Overcast reflects a mysterious spell about the grandiose towers of Lemah Mountain and Chimney Rock near the Alpine Lakes.

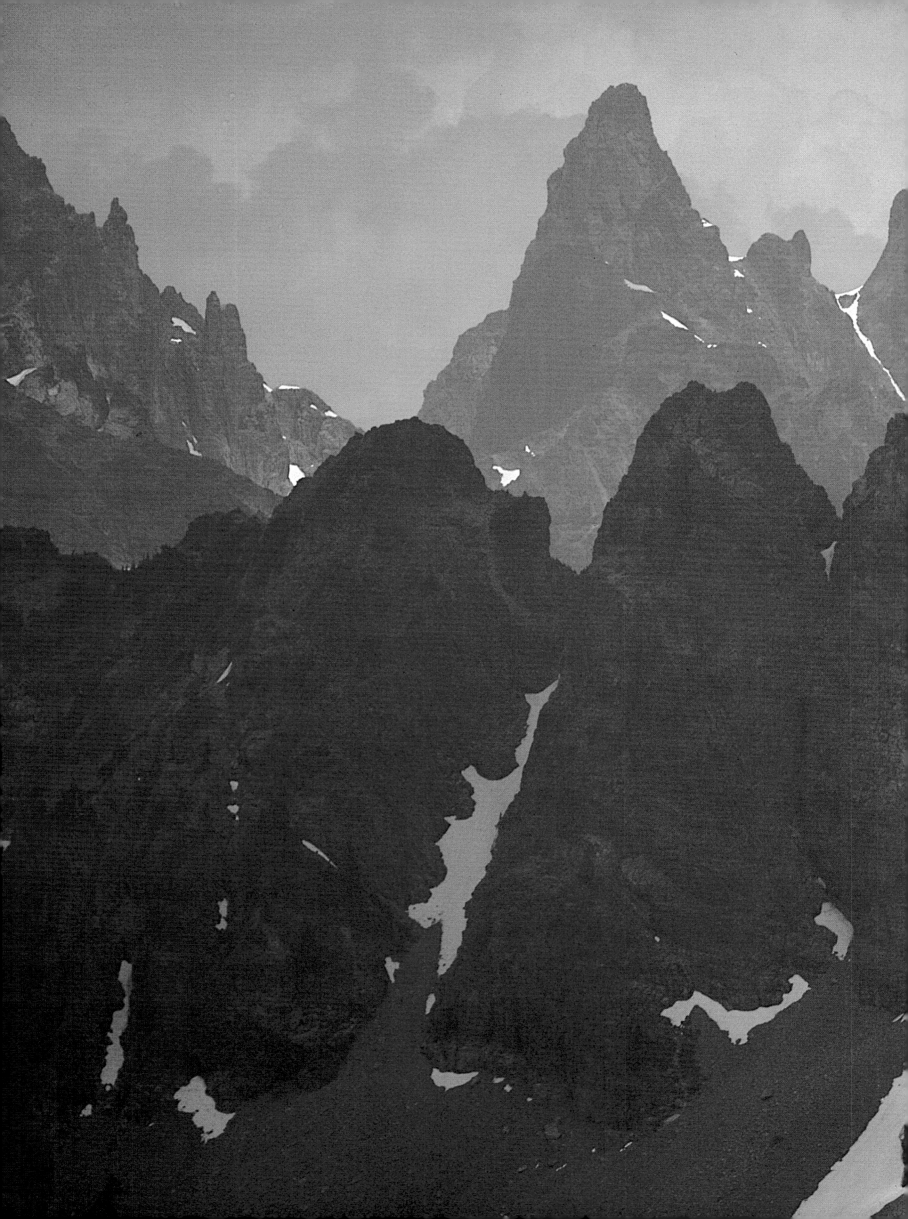

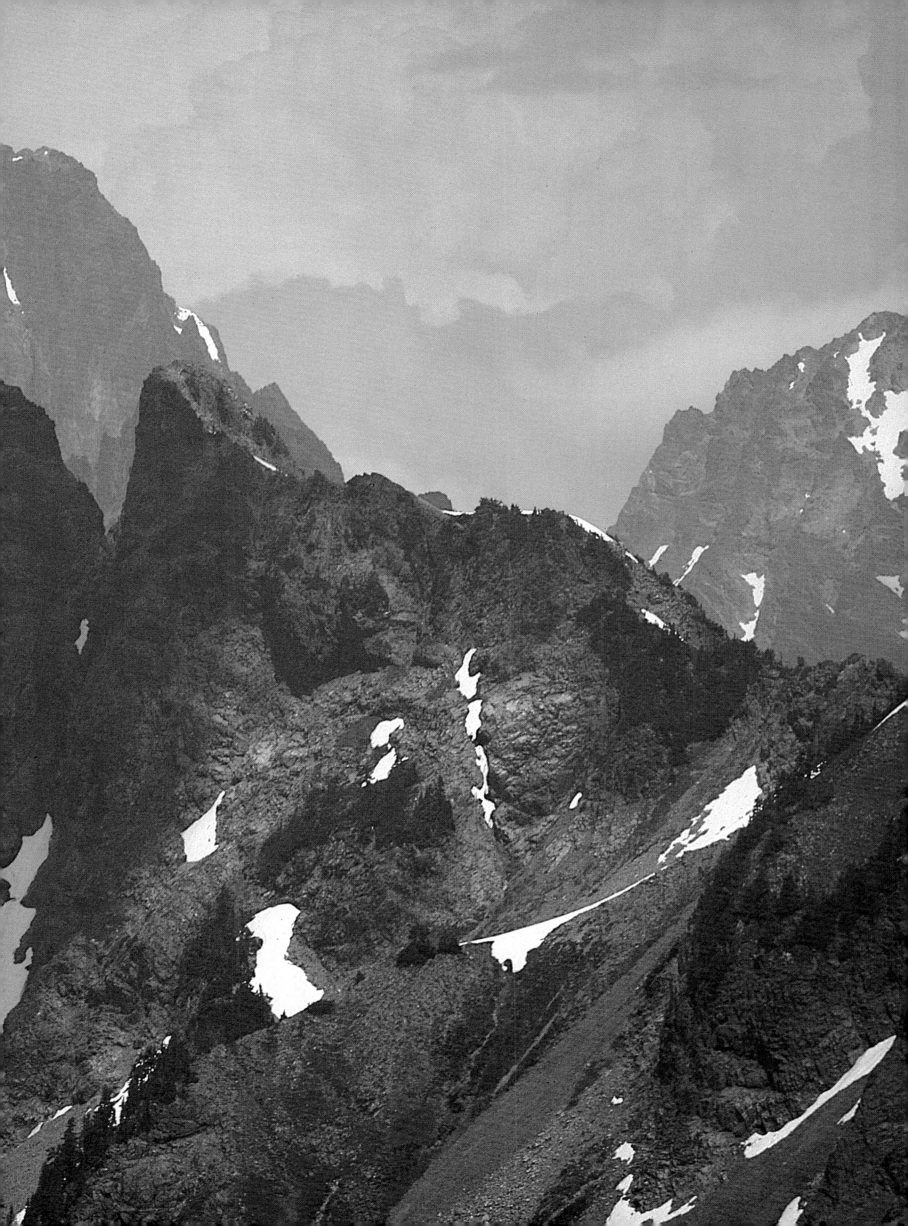

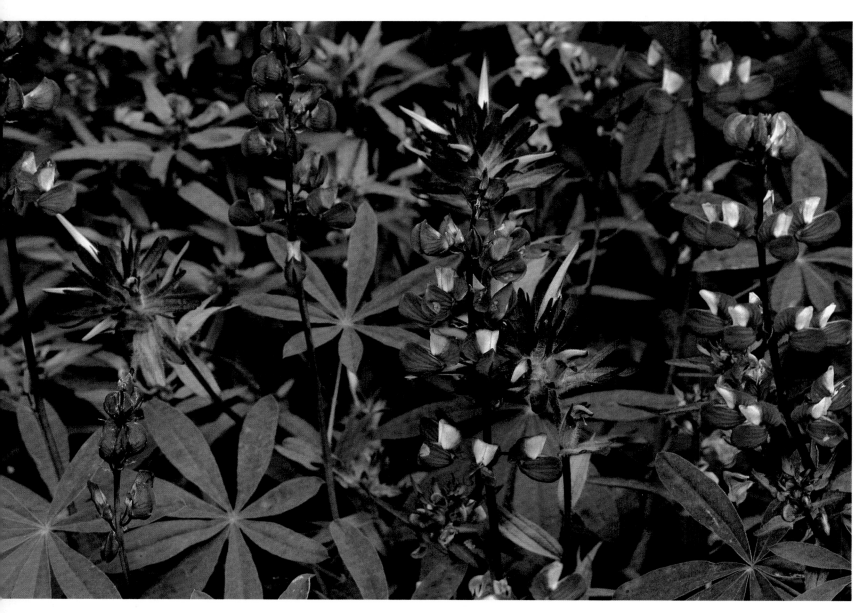

Meadows often are carpeted with the blue and purple of the lupine, a showy member of the pea family which grows from seacoast to timberline. Here lupine plumes mingle with the tall stalks of bright Indian paintbrush.

Fallen trunks of gnarled whitebark pine, the rigorous timberline tree whose broad domain includes the Sierra Nevada and the eastern flank of the Cascades. John Muir once described this tenacious tree as "so well seasoned by storms, that we may tie it in knots like whip-cord."

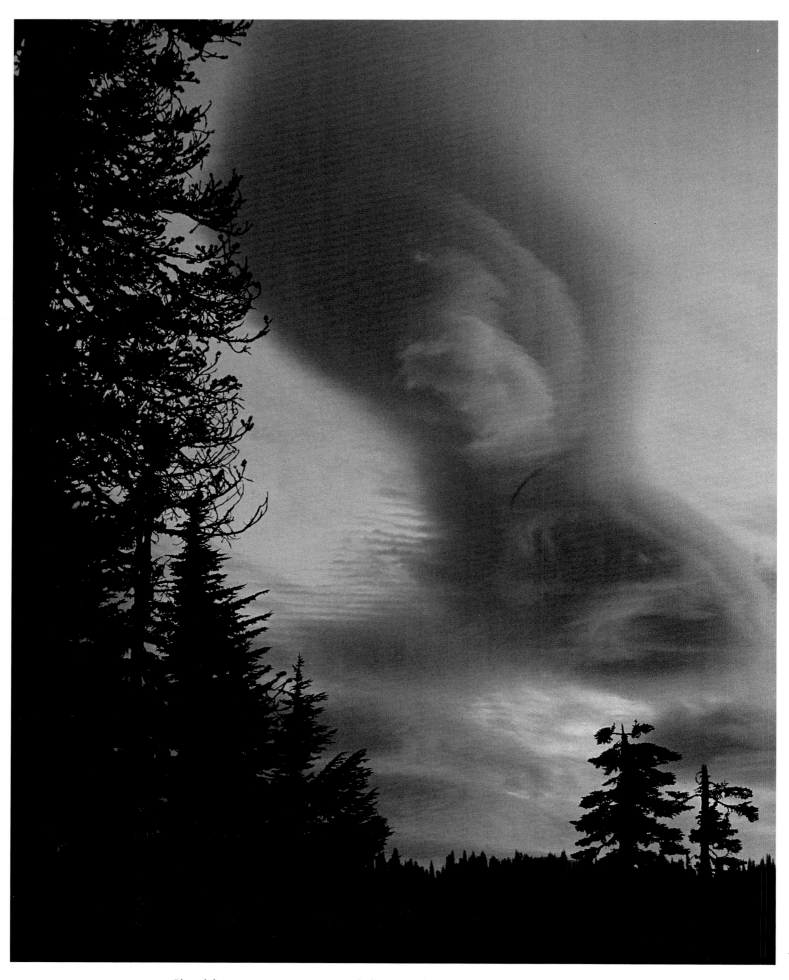

Cloud forms are not a matter of chance. The strong air turbulence or wind action exhibited by this fractocumulus cloud is created by the nearby mountains. Cooling through expansion of humid air during its ascent in the atmosphere may bring rain.

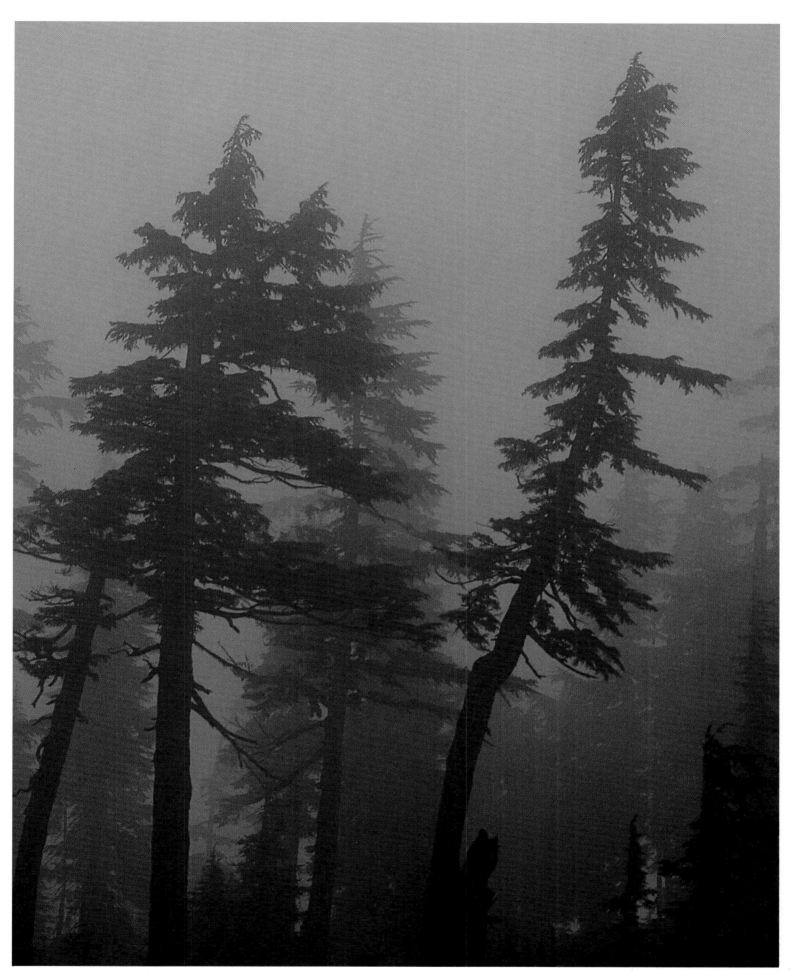

Thick fog envelopes the western hemlock, a rugged conifer of the western Cascade slope whose seeds germinate quickly. Seedlings require a moist rooting medium and can grow in dense shade. The hemlock tends to dominate the Douglas fir because of its tolerance for shade.

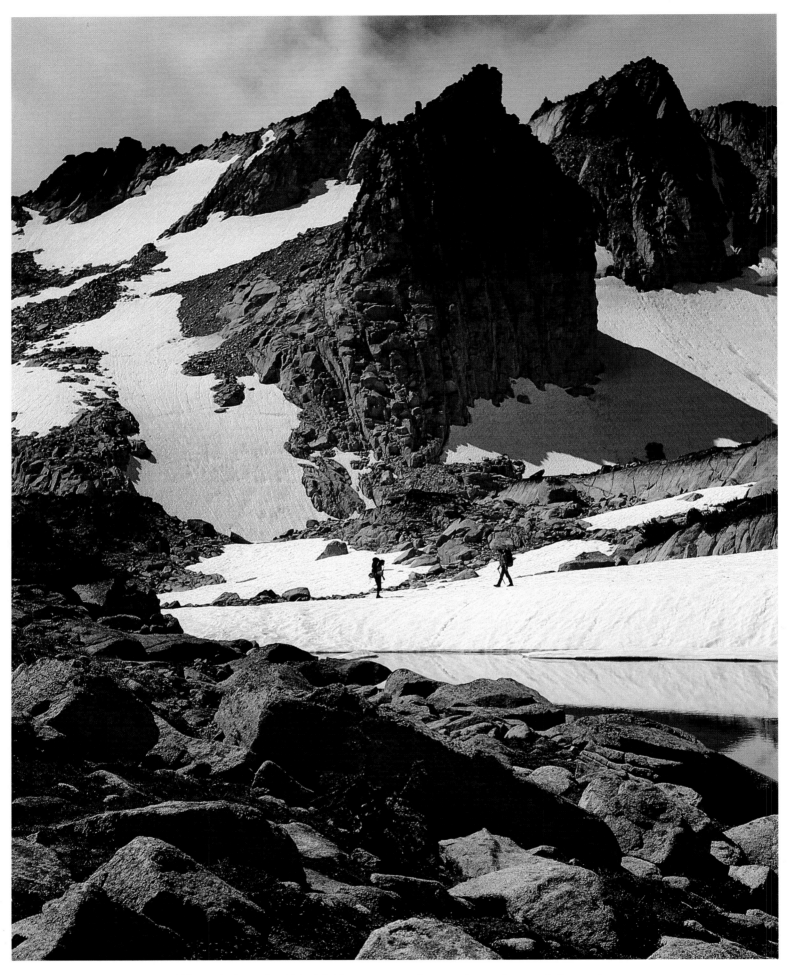

Hikers below the Witch's Tower, one of many imposing rock formations surrounding the Enchantment Lakes. The lake and crags bear a litany of names from Scandinavian folklore and the creative imagination of rock climbers. Their nomenclature includes Talisman, Rune, Viviane, and Bryn-hild lakes, Dragontail Peak, Little Annapurna, The Chessman, Excalibur Rock, Fantasia Tower, and the High Priest.

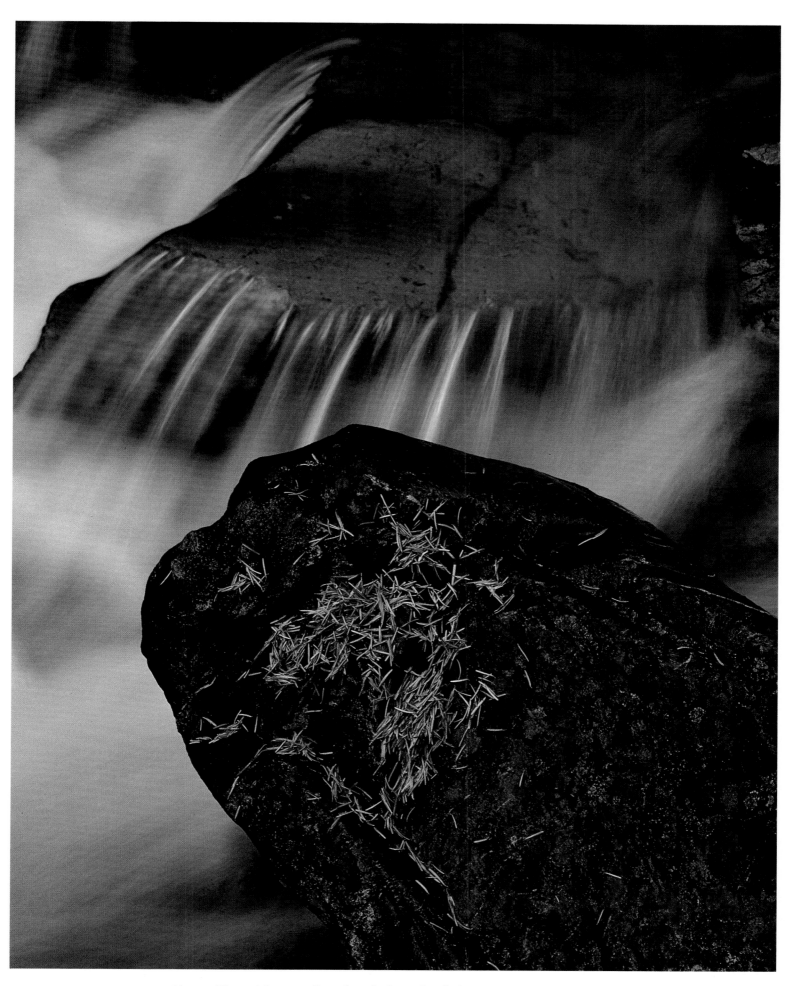

Above: The golden needles of a subalpine larch decorate a streamside rock. A deciduous evergreen native to the high eastern ridges of Washington and British Columbia, this rare tree has light green needles which turn a beauteous hue when autumn frosts begin. *Overleaf:* Fresh snow festoons granitic Mount Stuart in the Wenatchee Range. This monarch has been called "a dizzy horn of rock set in a field of snow."

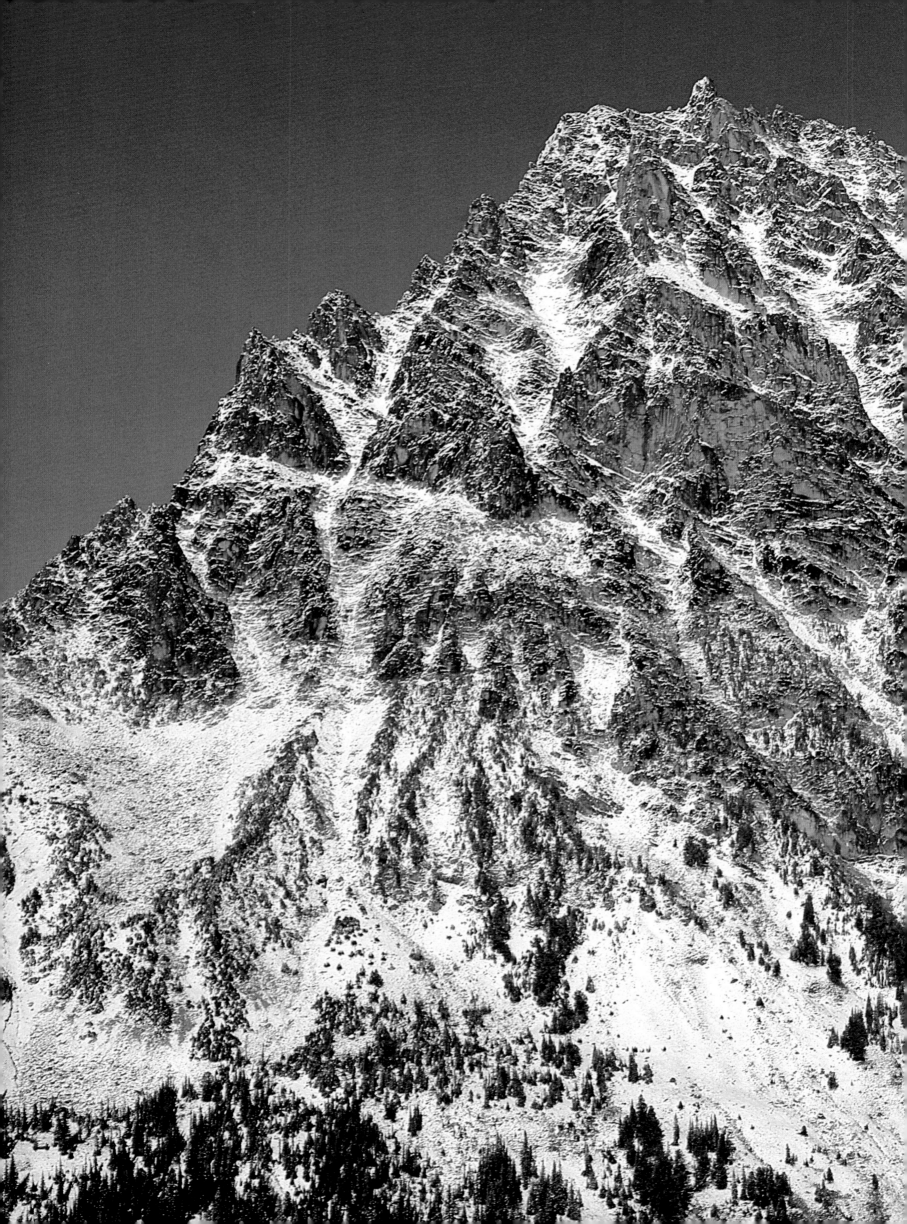

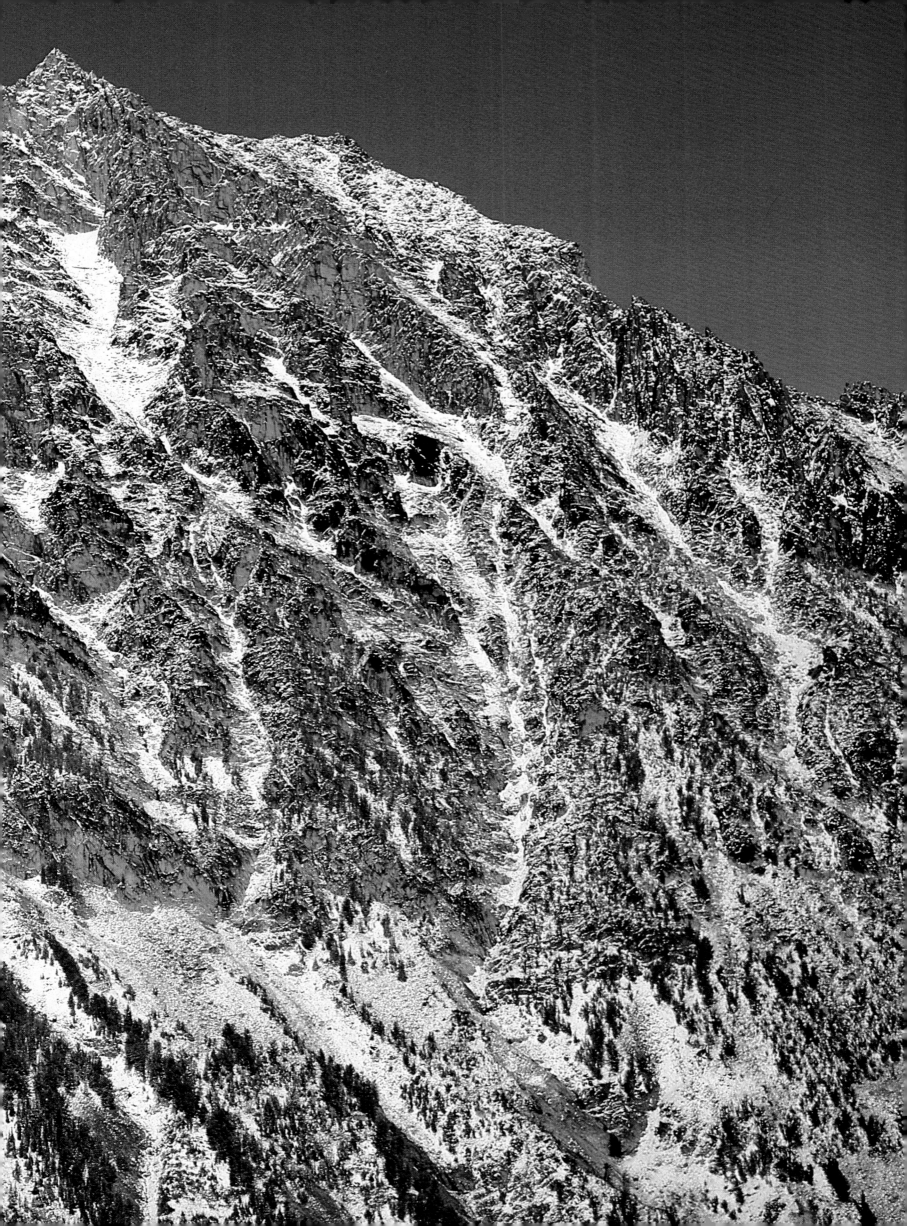

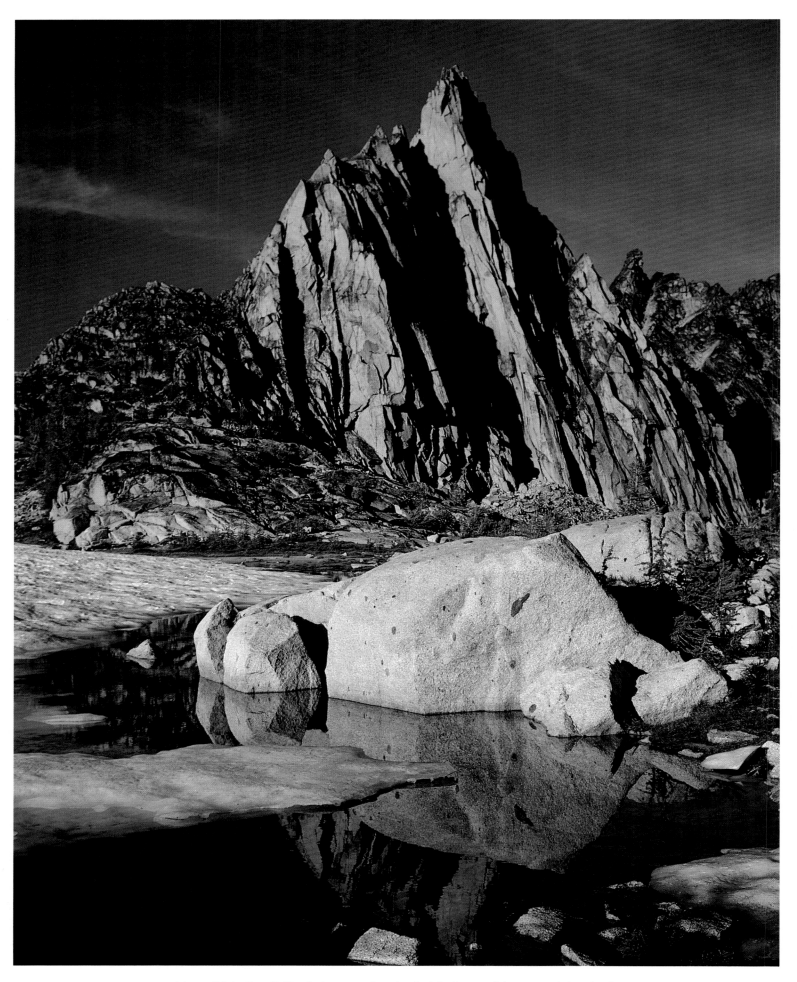

Monolithic Prusik Peak rises as a barrier behind one of the many lakes in the Enchantment group. While the granite appears indestructible, the high lakes, stunted krummholz trees, and delicate meadows are extremely fragile. Part of this picturesque region is called the Lost World Plateau. Despite its name, this is part of the real world man must protect.

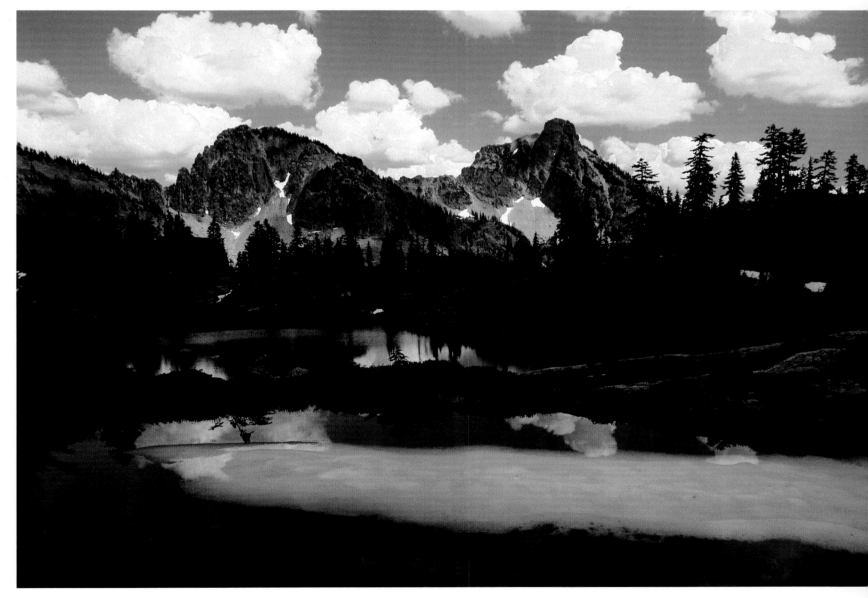

Above: Hibox Mountain, its whimsical name derived from the castle-shaped summit block, is seen behind Park Lakes. *Overleaf:* Black Peak sweeps in castellated majesty to nearly 9,000 feet near the North Cascades Highway at Rainy Pass. Until the advent of this thoroughfare, this area north of Lake Chelan was one of the most inaccessible in the Cascades; now it is a lovely vacationland.

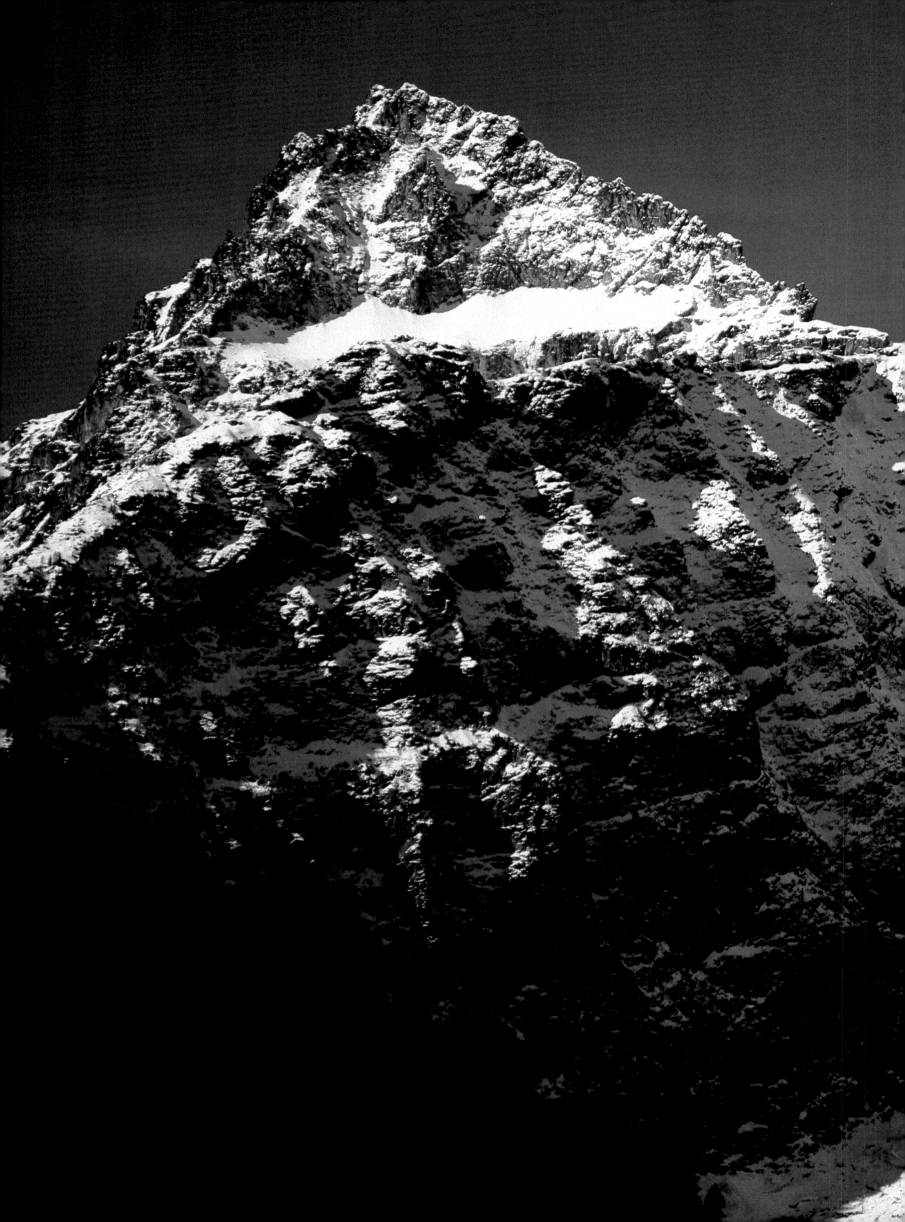

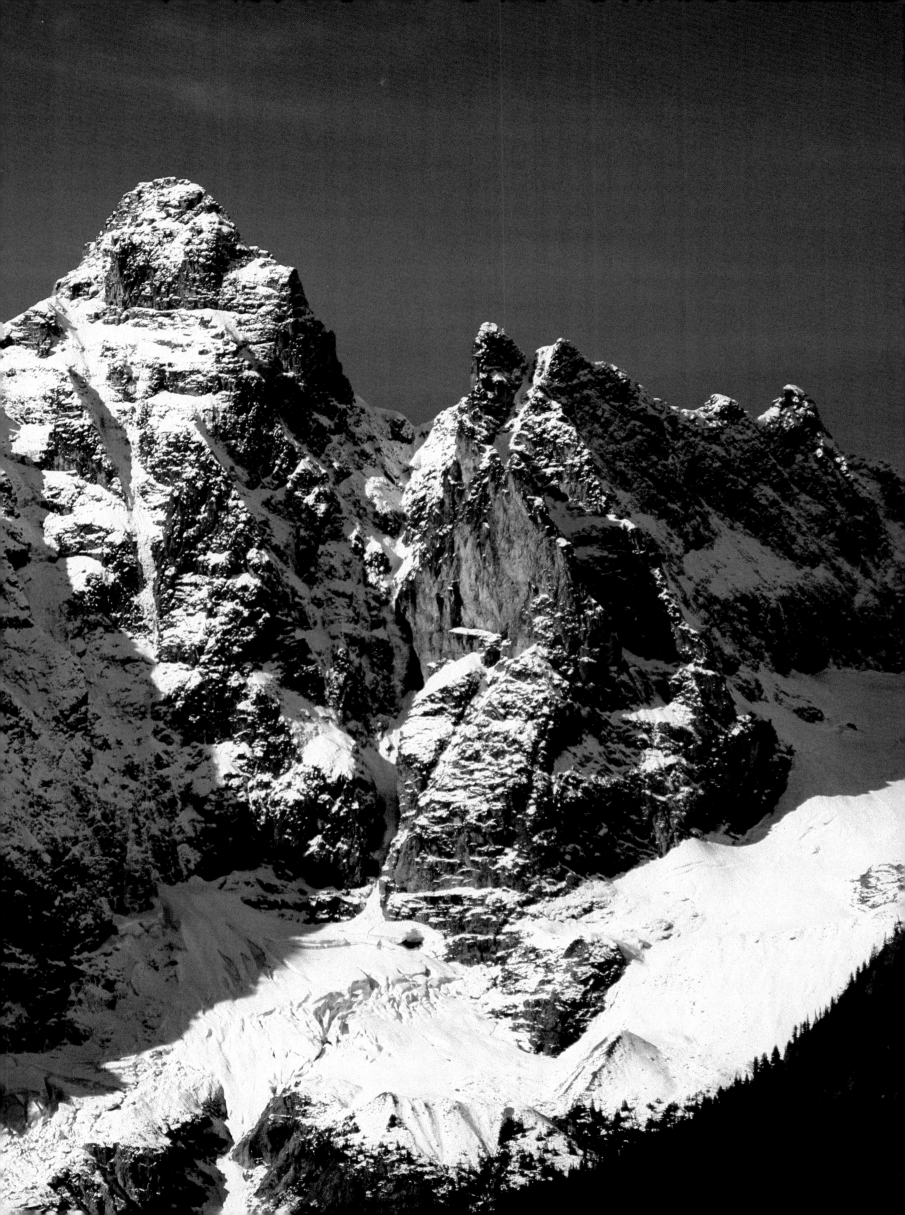

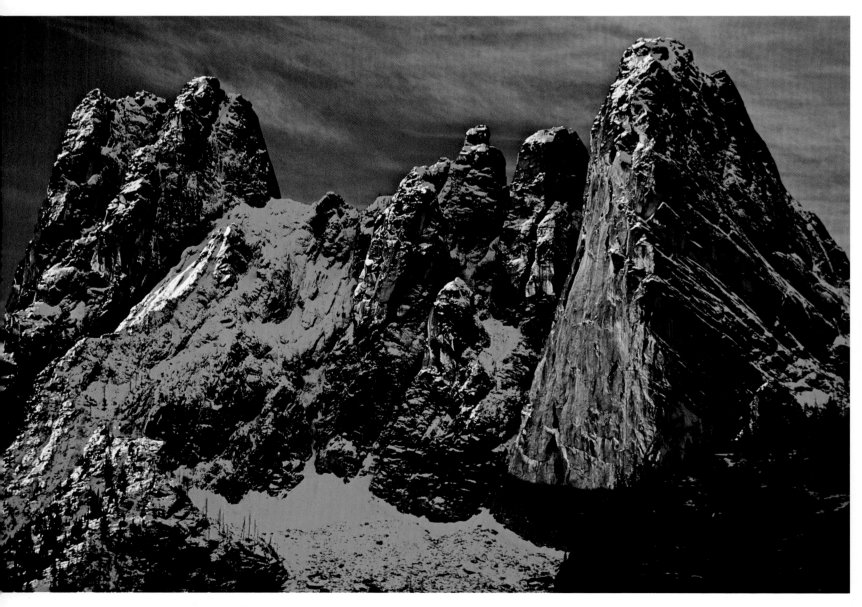

The image of sheer rock walls is nowhere more powerfully stated than in Liberty Bell—on the right—and the Early Winter Spires. Parts of the granite, amber-toned walls of ancient Golden Horn are too steep to hold the snows of an early autumn. Some of the challenging routes require more than one day to climb.

Above: Some compare Indian paintbrush to brushes draped in flaming paint. The petals of paintbrush are fixed into an elongate tube, open at the throat, which allows bees and hummingbirds access to nectar and encourages pollination. *Overleaf:* Light refracted through the ice caves of the Paradise Glacier on Mount Rainier creates an ethereal effect.

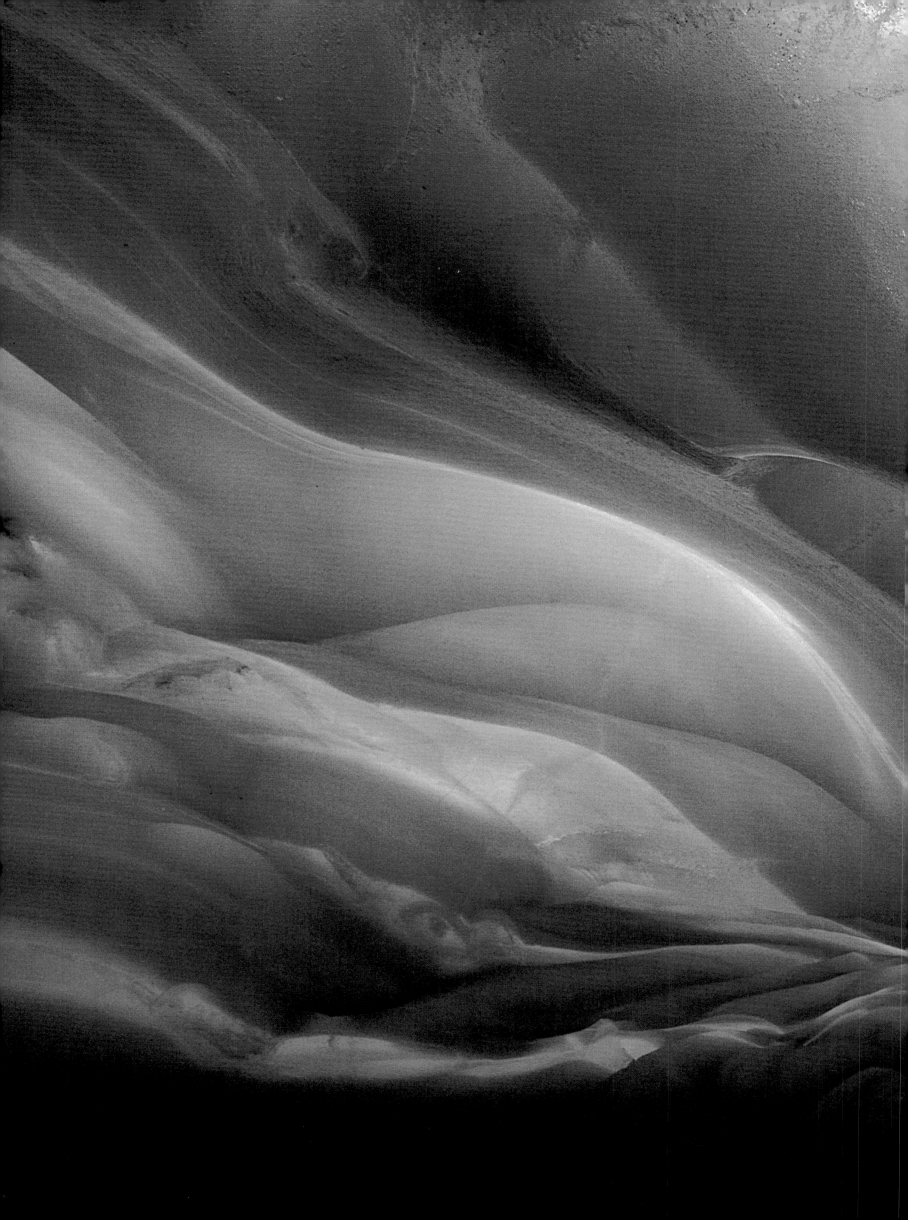

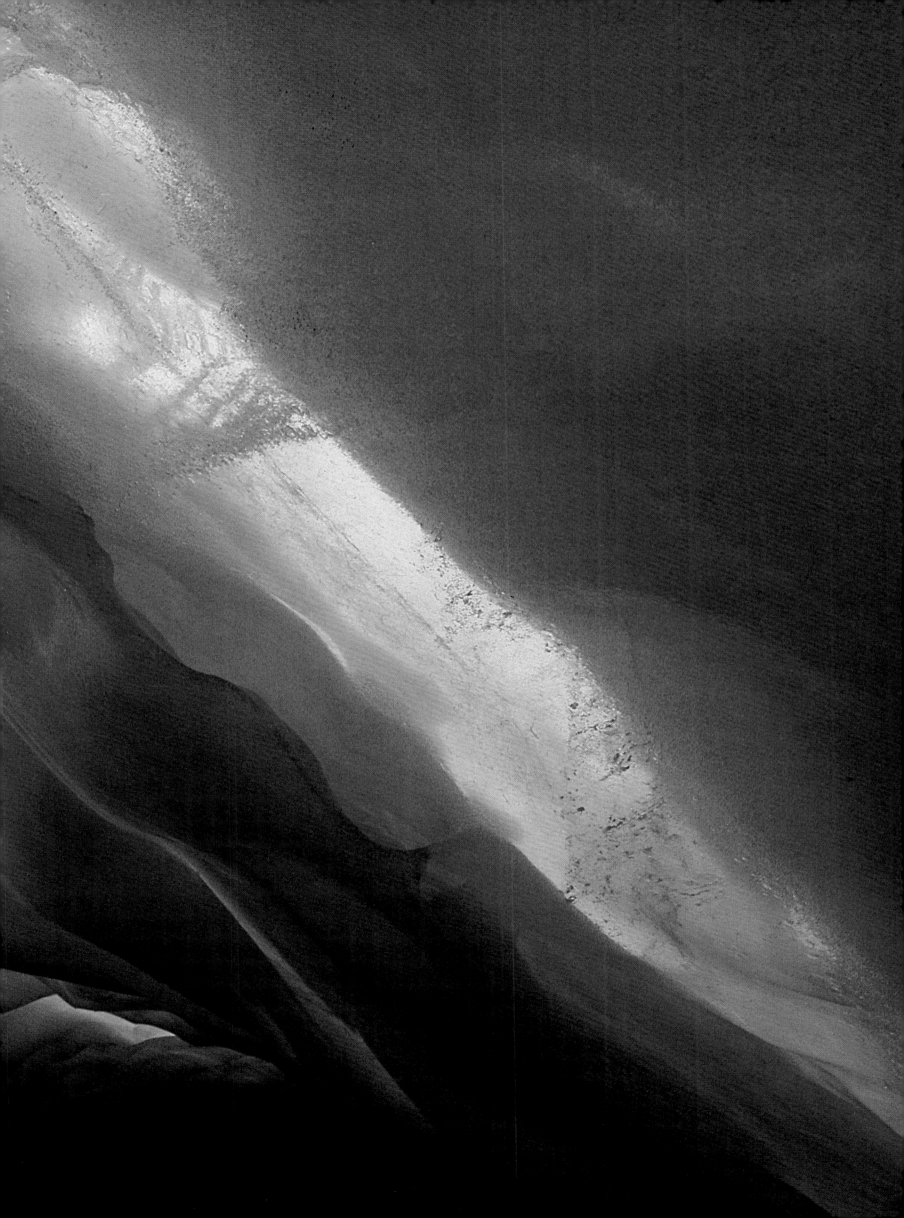

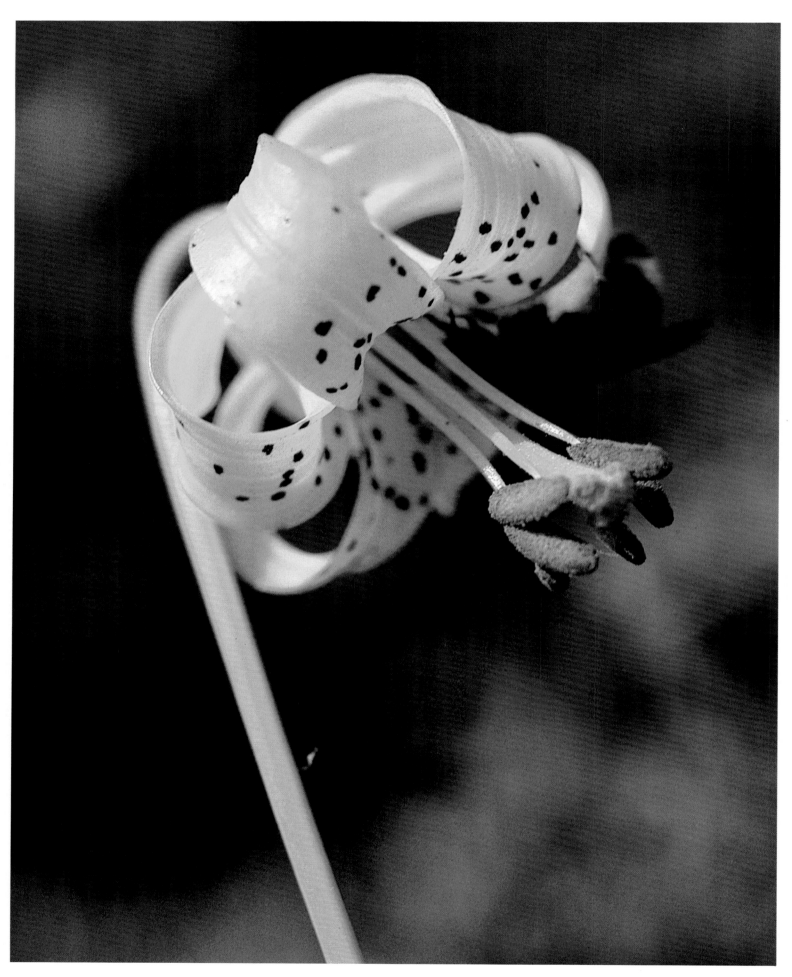

With showy orange flowers atop a leafy stem, the Columbia tiger lily blooms in high parklands from May to July and reminds us of Thoreau's conviction that "we can never have enough of nature." This brilliant lily is usually found with flowering penstemon, paintbrush, and columbine during the short summer season.

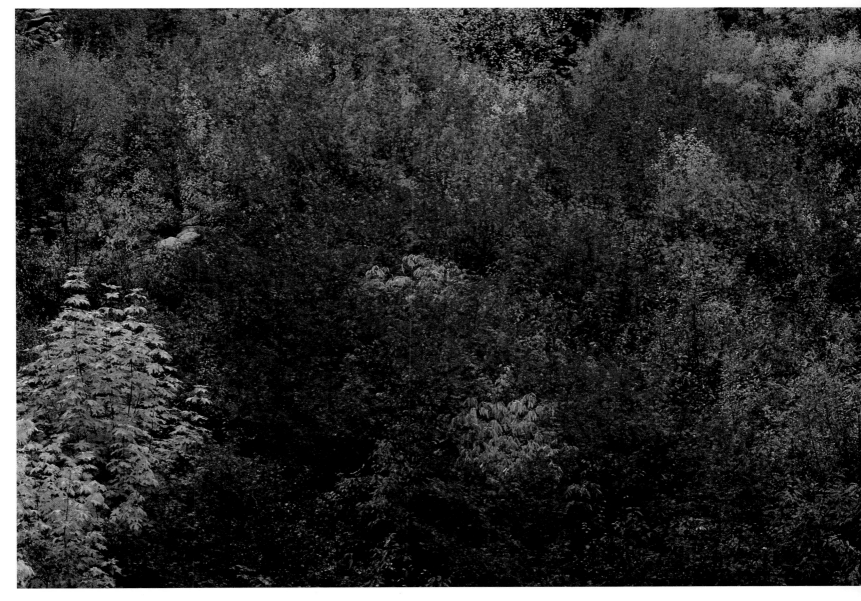

Tumwater Canyon becomes a pageant of flaming colors in autumn when the deciduous foliage of red alder, vine maple, and willow drape the steep, granitic canyon slopes. The Wenatchee River, which flows from the Cascade crest north of Stevens Pass, rushes through the winding gorge in a torrent to Leavenworth. To Indians Wenatchee meant "great opening out of the mountains."

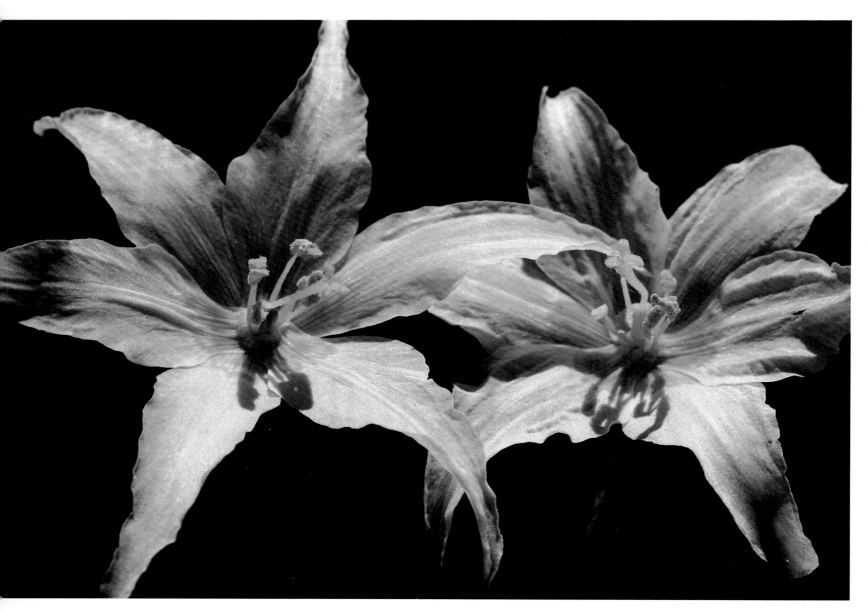

The remarkable avalanche lily, displaying from one to nine pure white flowers nearly three inches across, sometimes masses by the thousands in the high meadows to create a dazzling spectacle. Miraculously, its exquisite form also appears in thin, receding snowpatches. In nature's timetable, this lily blooms for only a few months.

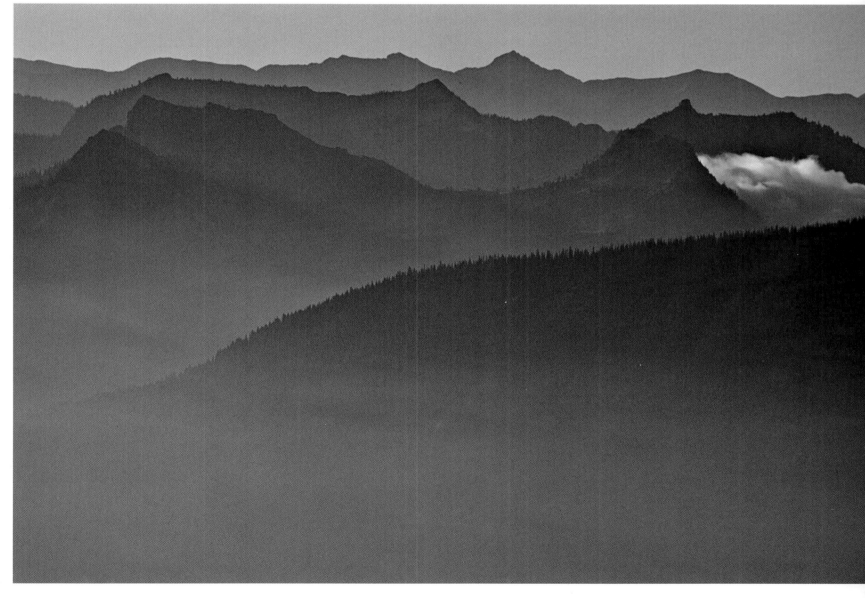

Looking east across the canyon of White River near Mount Rainier's Sunrise Park. The almost-level accordant ridges lying in the shadow of Rainier are much older than the great volcano. In this area, the range consists mainly of andesitic and basaltic lavas of the Tertiary age—later deformed and uplifted — and extensive outpourings of more recent Keechelus andesites.

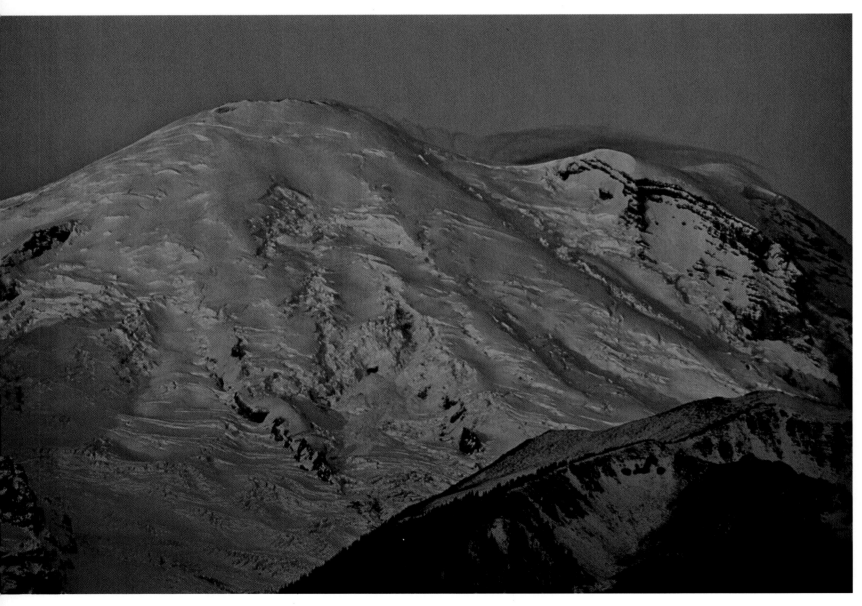

Above: Alpenglow tints Mount Rainier and Emmons Glacier, as seen from Sunrise Park. *Facing page:* A western larch is frosted after a cold night. *Overleaf:* The sun's rays gild the layer of stratus obscuring the valleys of Mount Rainier. Columbia Crest, Rainier's highest point, and Liberty Cap are visible above the tips of subalpine firs.

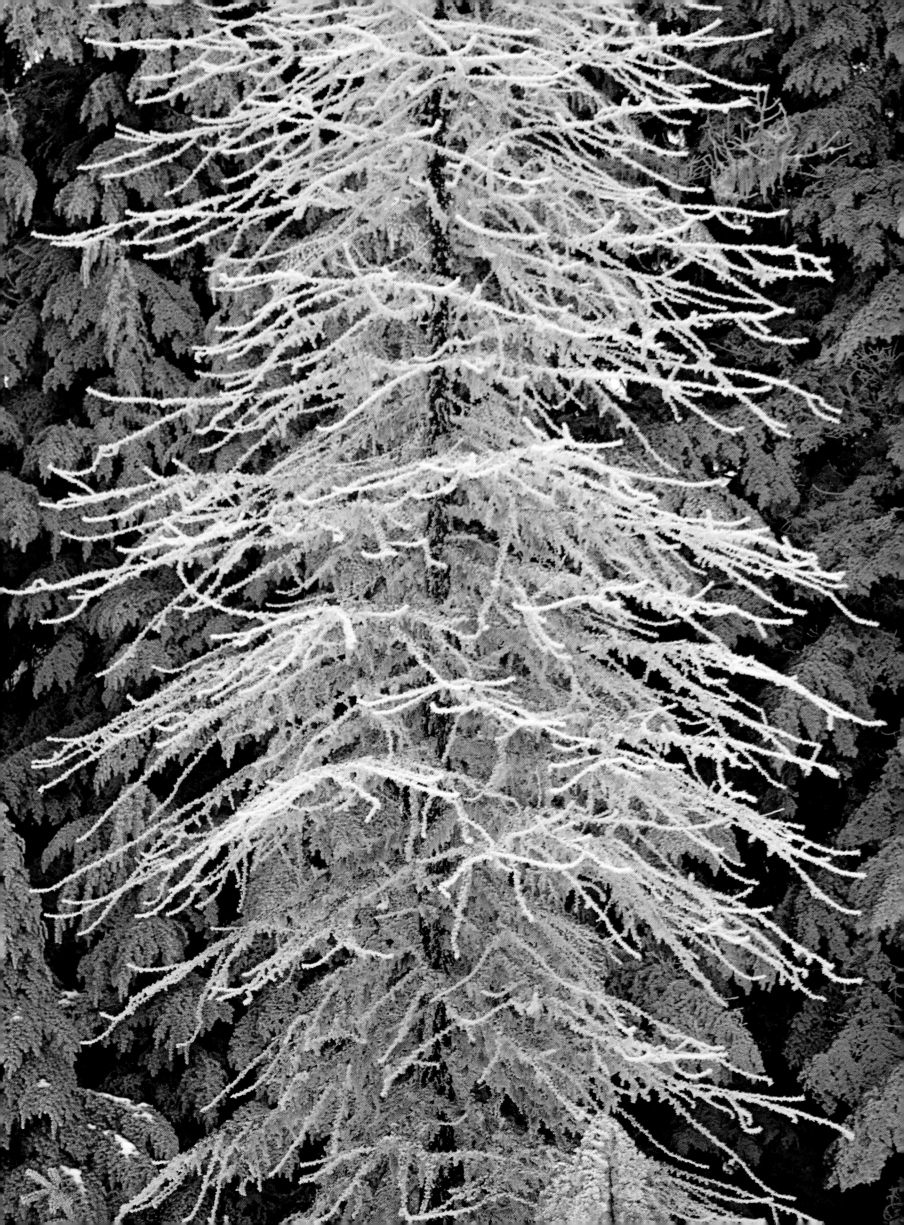

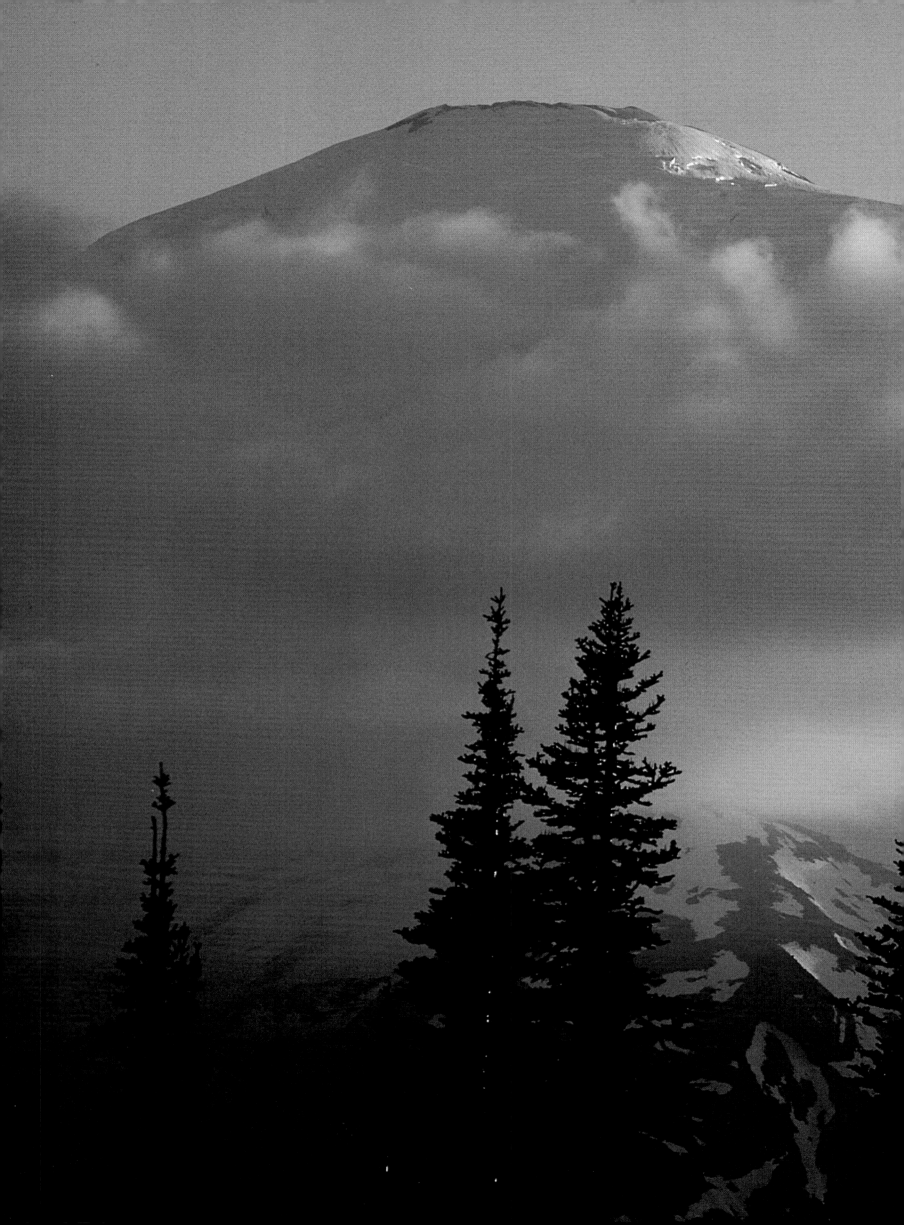

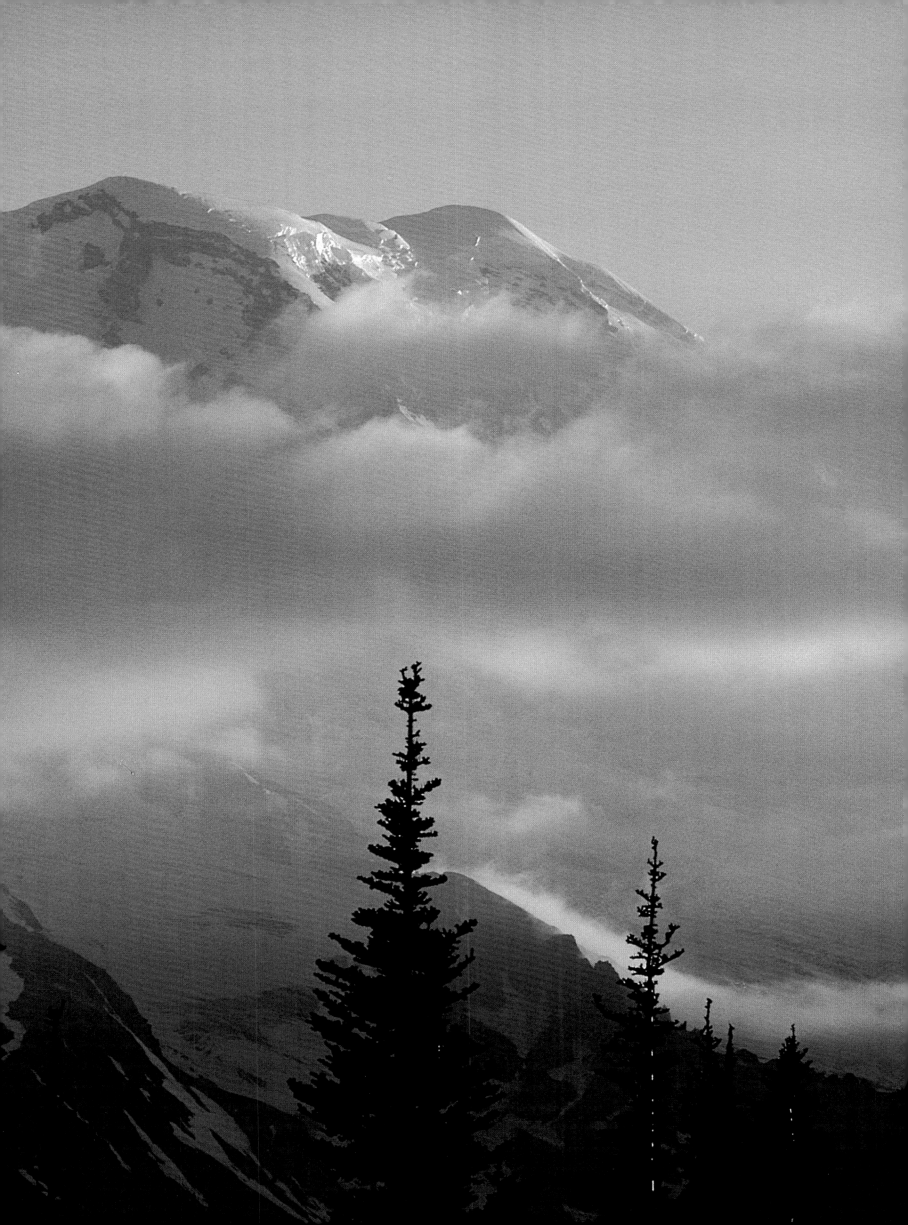

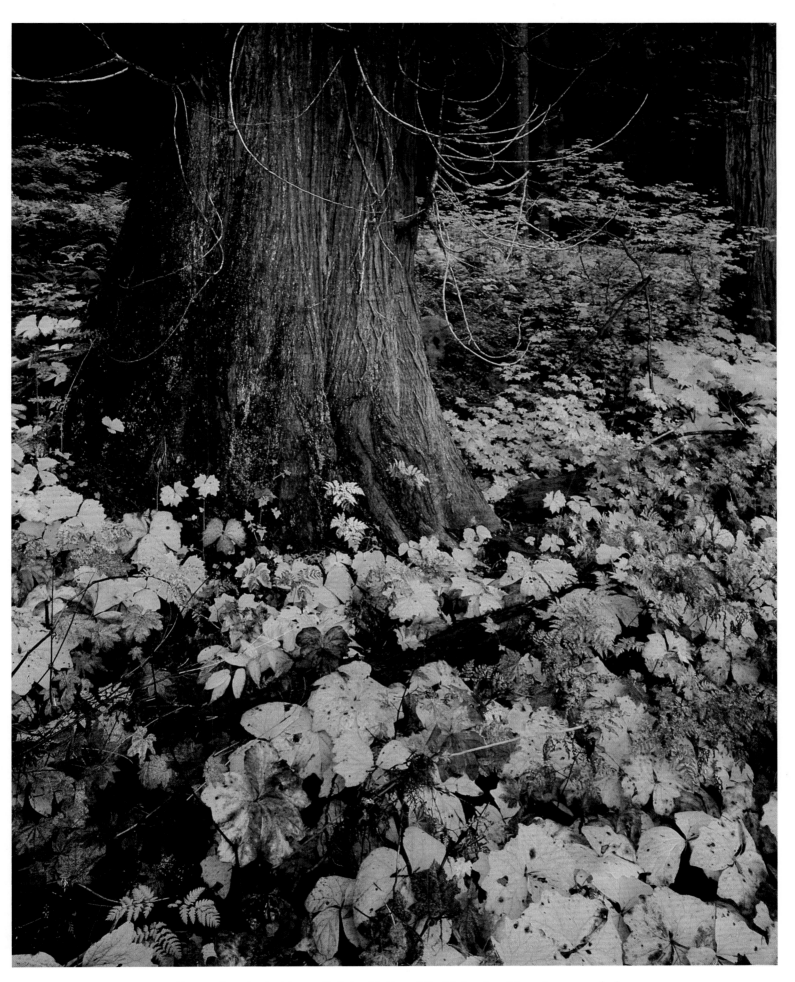

Above: A cedar in Mount Rainier National Park's lowland forest surrounded by a leafy undergrowth. Such trees are nourished by moisture through a long annual growth season. *Facing page:* The maidenhair fern, with its filmy light leaves, is the most loved of all ferns. *Overleaf:* The purple flowers of phlox in an alpine meadow cluster tightly.

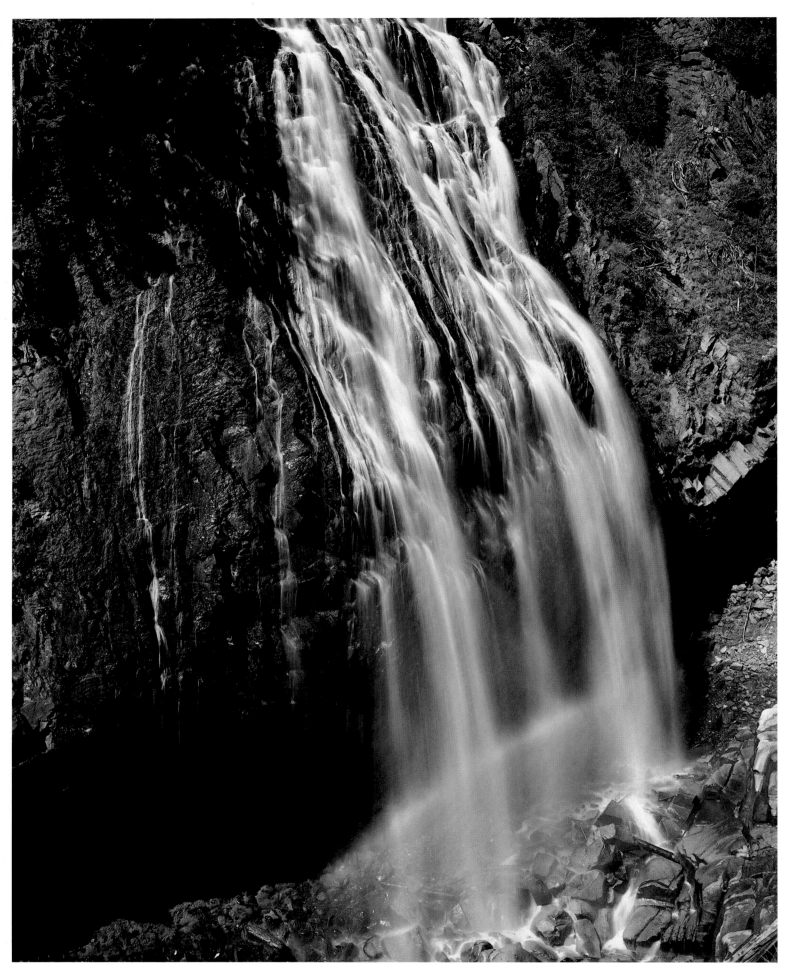

The most renowned waterfall on the slopes of Mount Rainier, Narada Falls. On August 24, 1893, Arthur F. Knight, a member of the Narada branch of the Theosophical Society of Tacoma noted: "These falls dropped about 200 feet and spread out fan shape, and we all went into ecstasies over them and decided to name them Narada Falls."

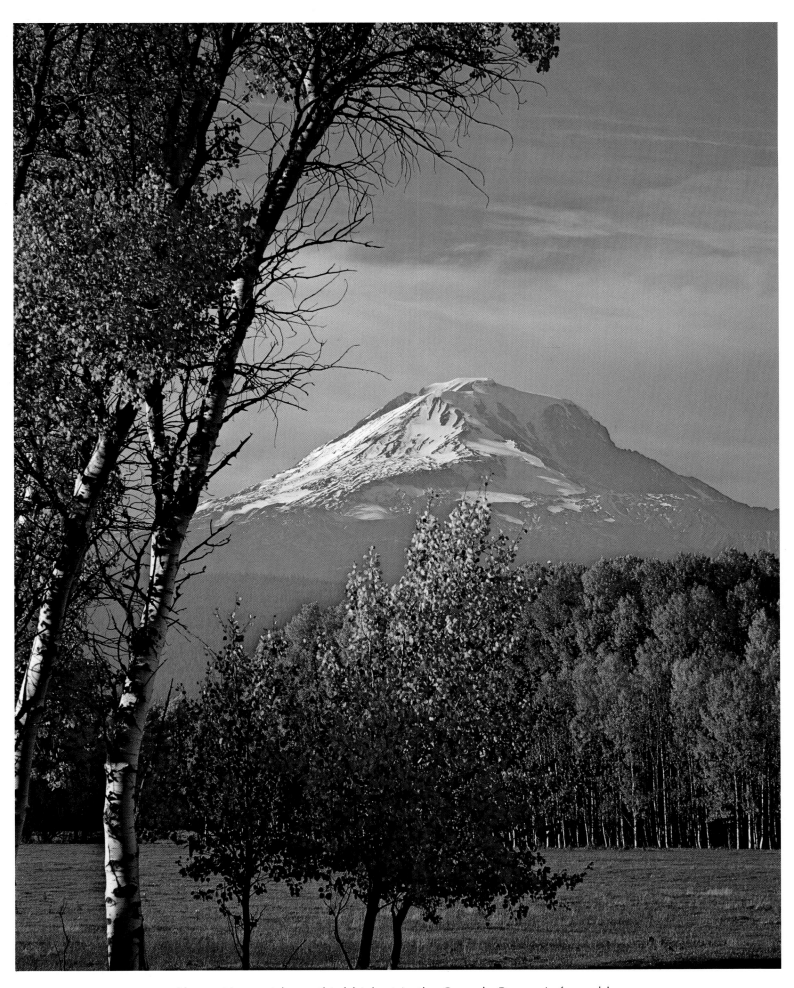

Above: Mount Adams, third highest in the Cascade Range, is framed by quaking aspen and black cottonwood. Bulky Adams, the Pah-to of Klickitat legends, was elongated by volcanic vents. *Overleaf:* Steam rises from the new crater of Mount St. Helens, the result of the greatest explosion the Cascades have known in historic times. Mount Hood is in the distance.

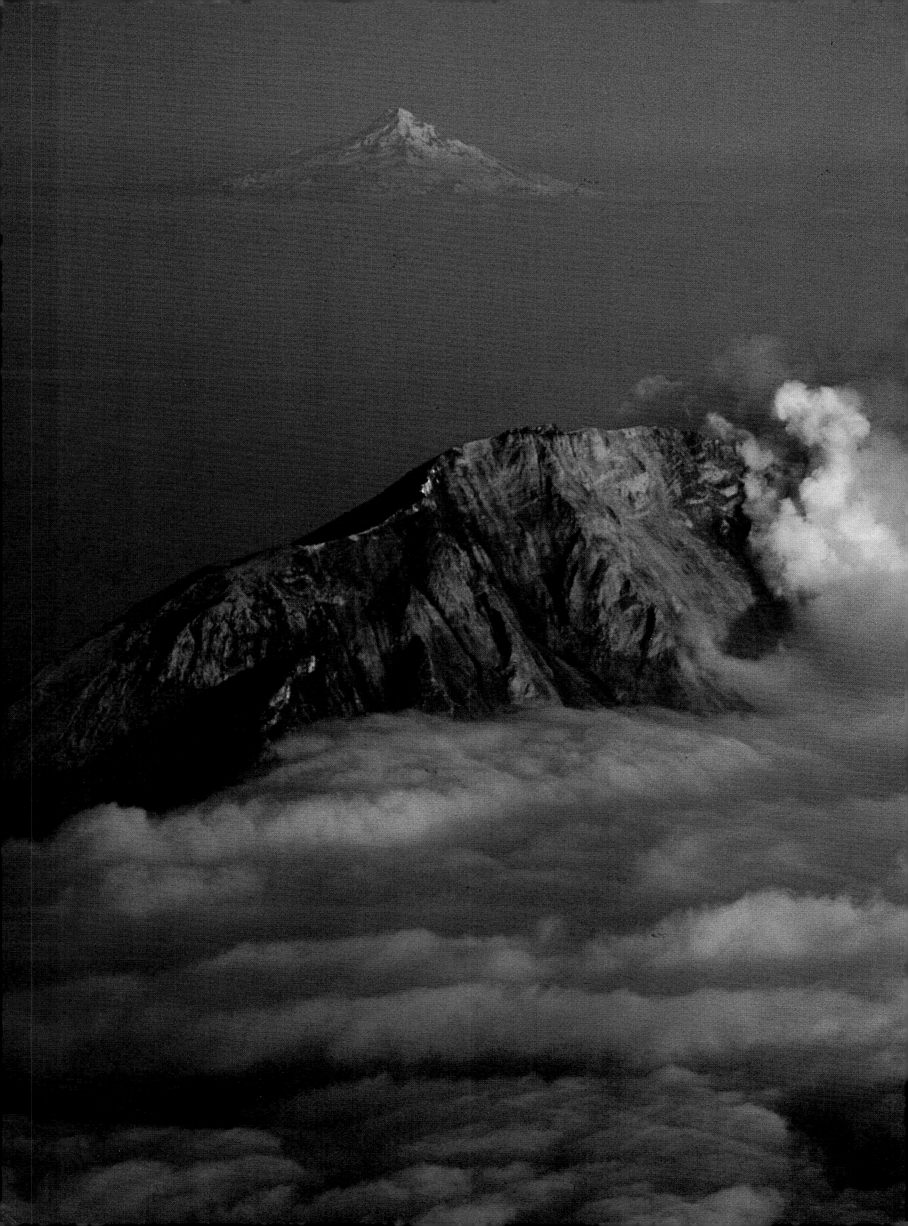

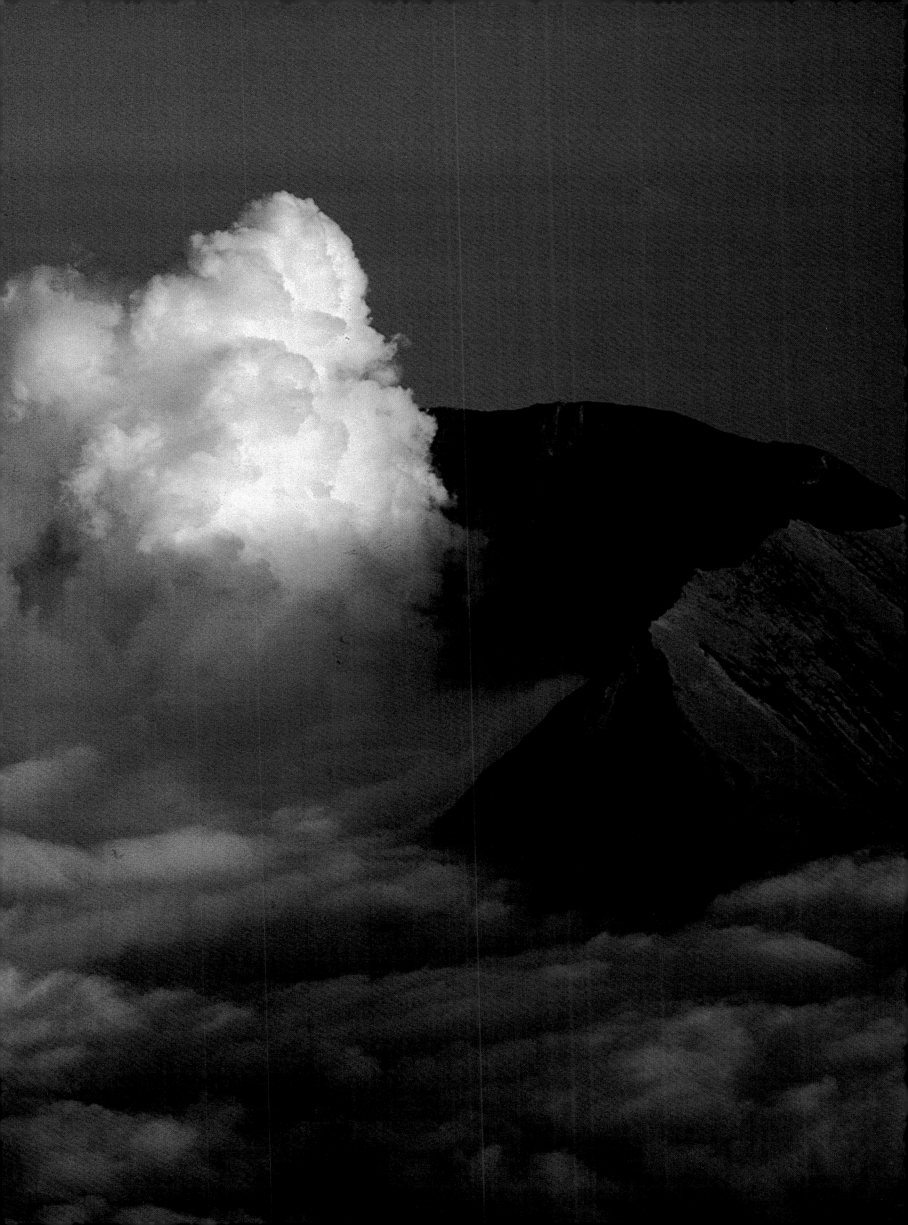

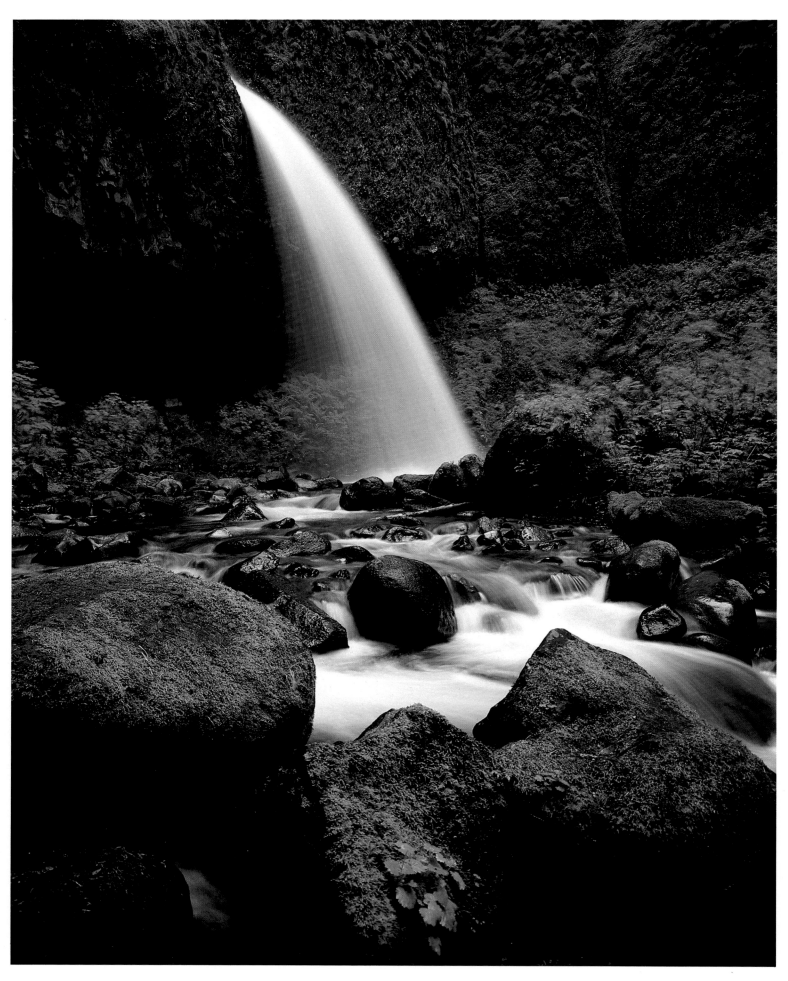

One of a series of magnificent waterfalls in the Columbia River Gorge, Upper Horsetail Falls drops from an overhanging cliff of basalt. A short trail from the Scenic Highway brings you behind the waterfall. The sequence of falls is partly a consequence of the Lake Missoula Ice Age floods, which carved the basalt into steep walls and left hanging valleys.

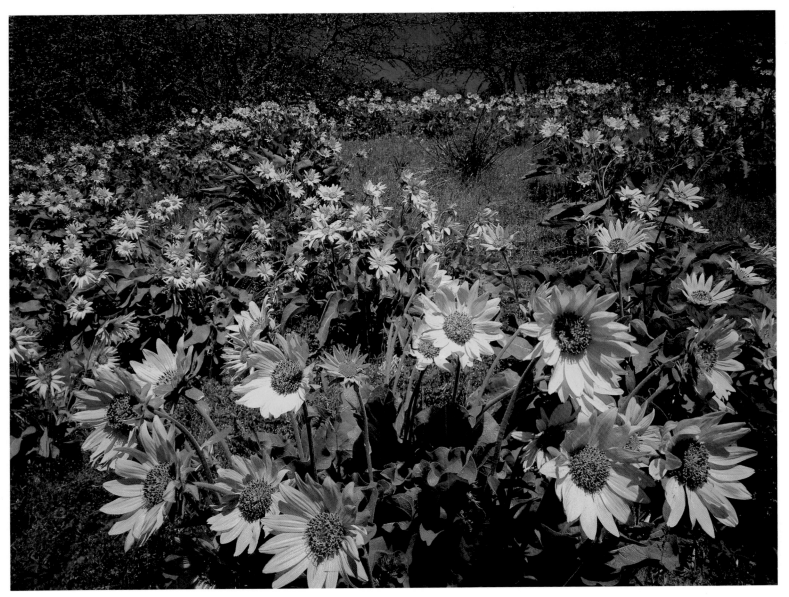

Arrowleaf balsamroot is confused with mule's ears and alpine sunflower. The balsamroot has an almost leafless stalk growing from a basal cluster of large leaves and extends one large, disklike, bright yellow flower head at its tip. Colorful plant populations inhabit sagebrush plains and dry, rocky slopes. Indians prepared medicine from the roots.

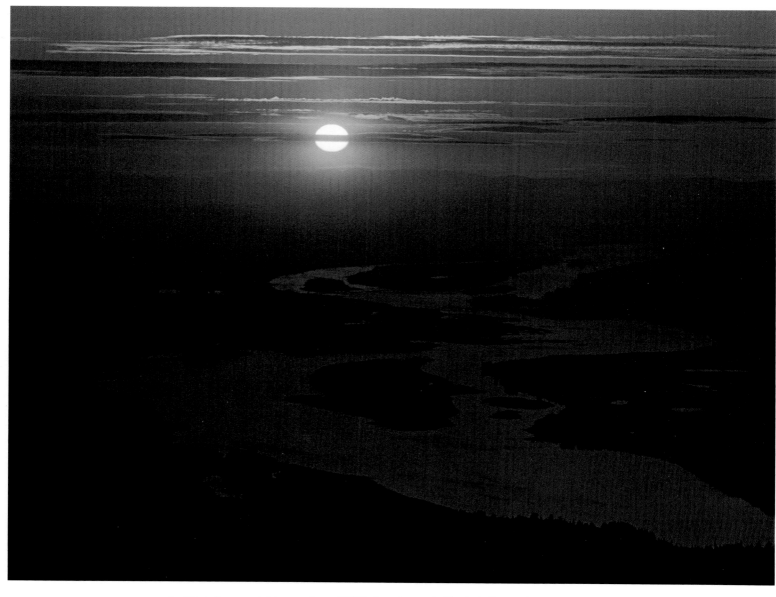

In October and November, 1805, Lewis and Clark followed the Columbia
River Gorge west in the direction of this blood-red sunset. They marveled at
the waterfalls that plunge from the forested cliffs of black basalt to join the
great river that carved this impressive canyon through the Cascade Range.

A farm along the Columbia River Gorge is fringed by a row of Lombardy poplars and lodgepole pines. In this vicinity, Captain William Clark wrote that Meriwether Lewis borrowed an Indian canoe, then "killed a Swan and Several Ducks, which made our number of fowls this evening 3 Swan, 8 brant and 5 Ducks, on which we made a Sumpteous supper."

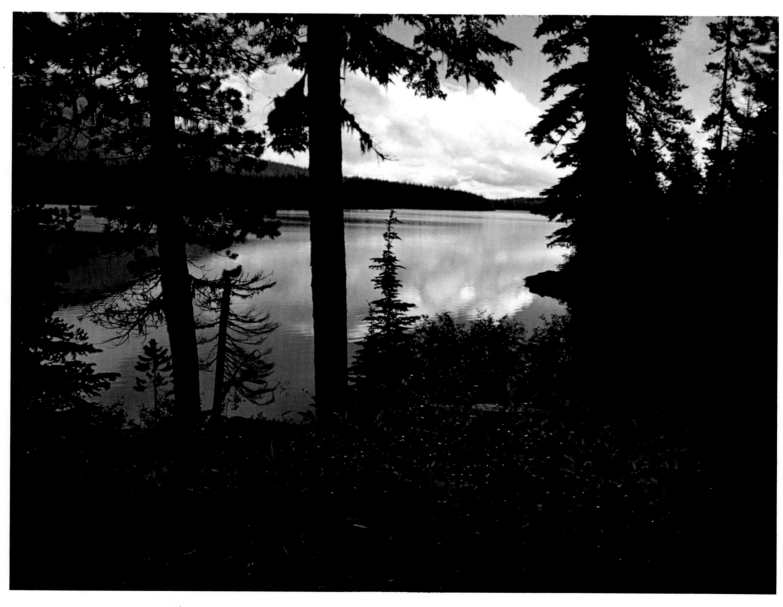

The pure, tranquil waters of Mount Hood National Forest's Olallie Lake are lined by evergreens, including western white pine and western hemlock. Located due south of Mount Hood, the pristine lake offers food and shelter to migratory waterfowl. Once, a large ice field buried this entire region.

Above: Twisted by the winds, the whitebark pine struggles to survive the harsh elements. A flexible tree especially adapted to withstand the alpine region's dryness, shallow soils, and fierce winds, the whitebark often spreads to counter winds. *Overleaf:* Thickening cirrus forms over the summit and south flank of Mount Hood. The mood of the mountain changes with the weather.

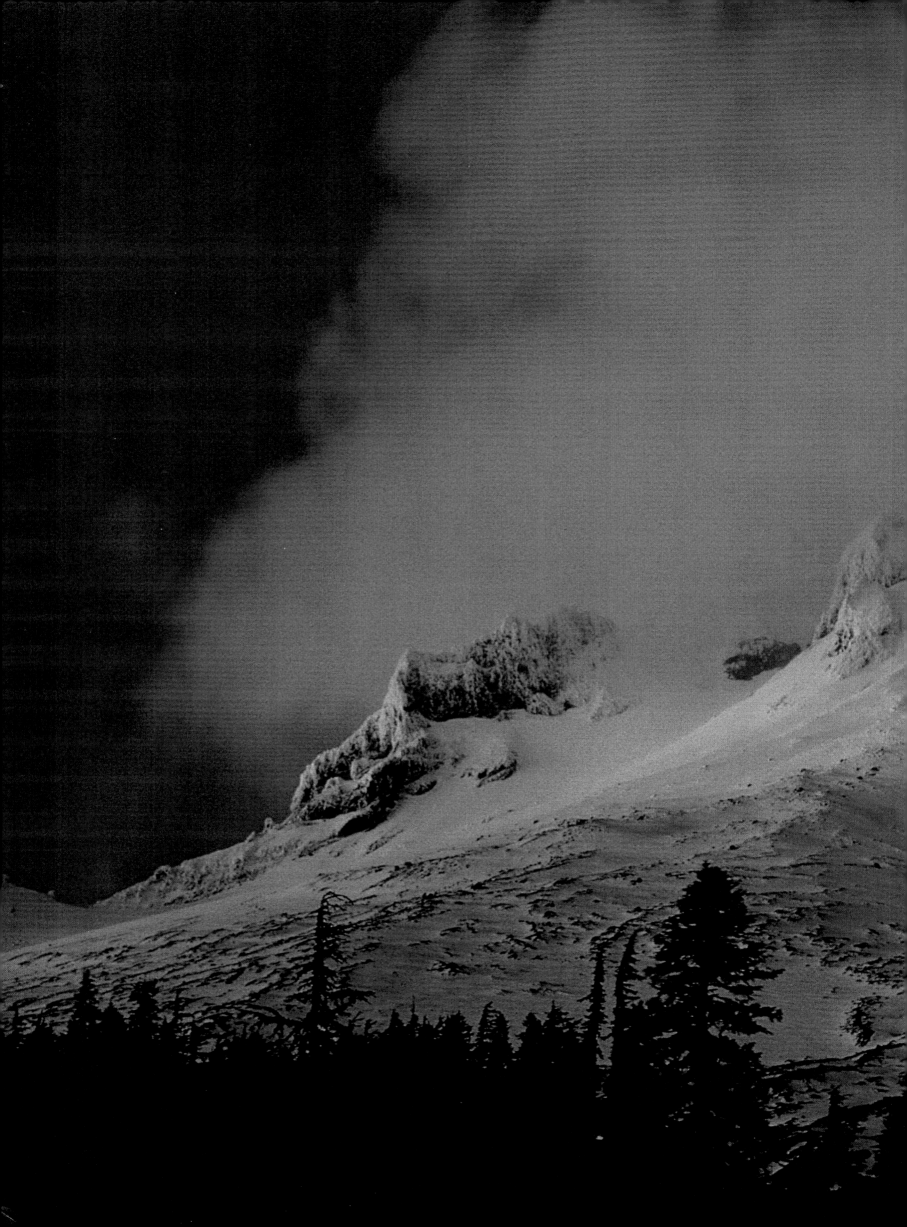

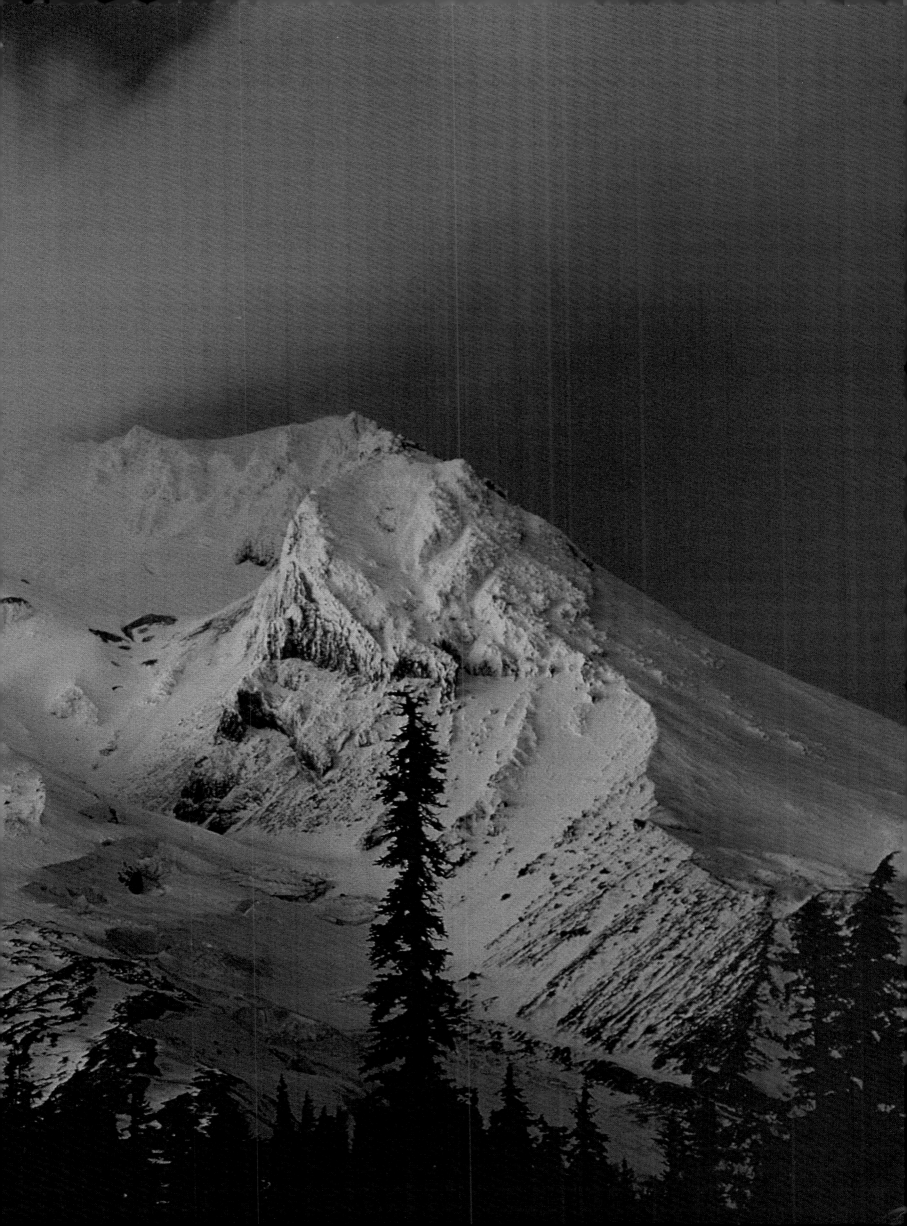

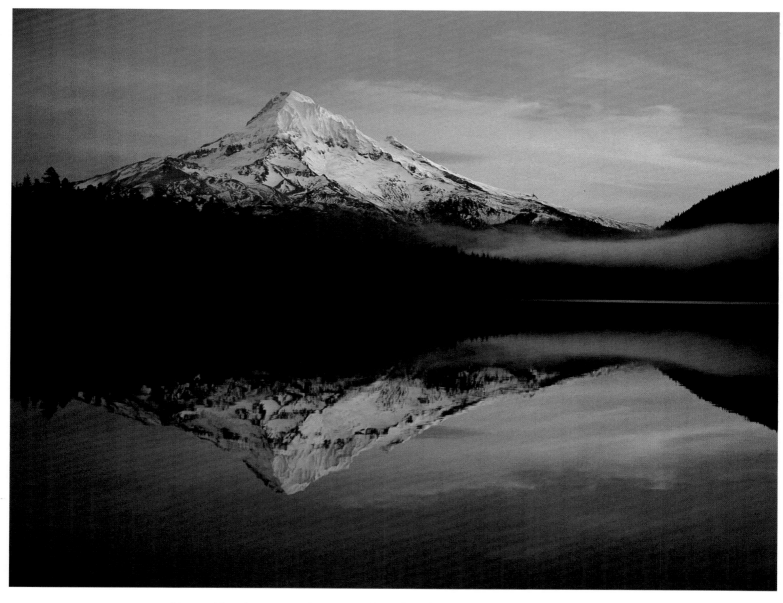

Mount Hood at sunset is mirrored in placid Lost Lake. In October of 1845, Oregon immigrant Joel Palmer described the lofty volcano: "I had never before looked upon a sight so nobly grand. We had previously seen only the top of it, but now we had a view of the whole mountain." Palmer then made a valiant, unsuccessful attempt to reach the summit alone.

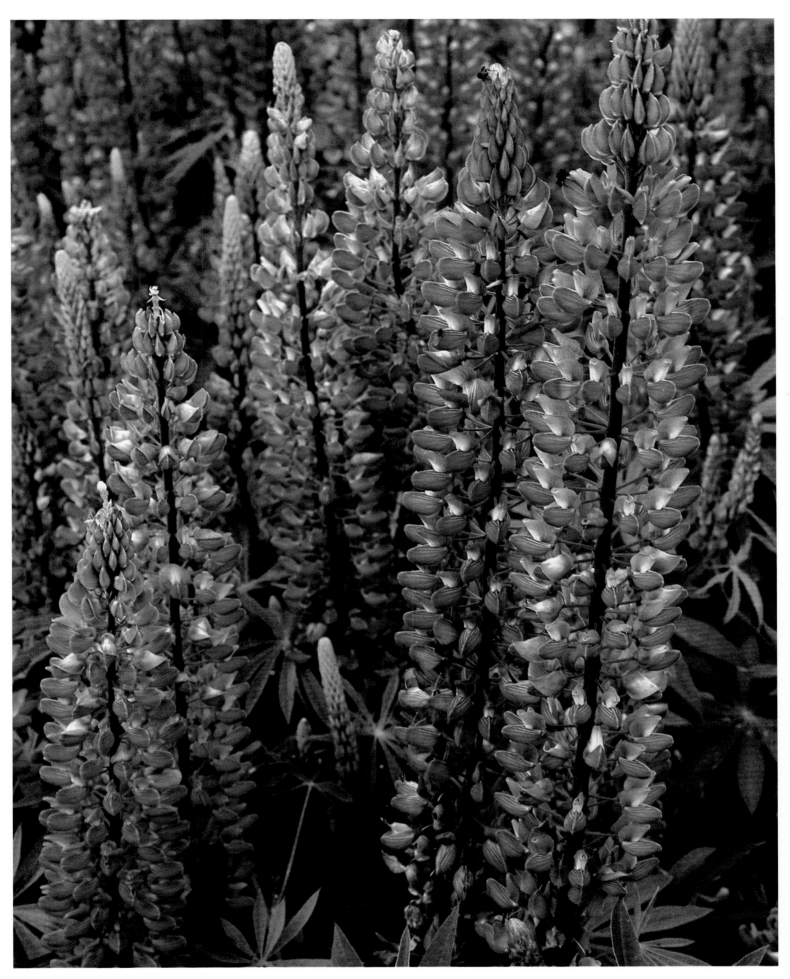

Above: A field of lupine purples the meadowlands. The lupine forms one of the larger genera or biological groups in the West and are easy to recognize: leaf blades divide into five or more segments and flowers hang in rows along the stem. *Overleaf:* Oregon's volcanos were built by alternating flows of lava and eruptions of pyroclastic debris. Consequently, the North and Middle Sisters rise impressively to over 10,000 feet in altitude.

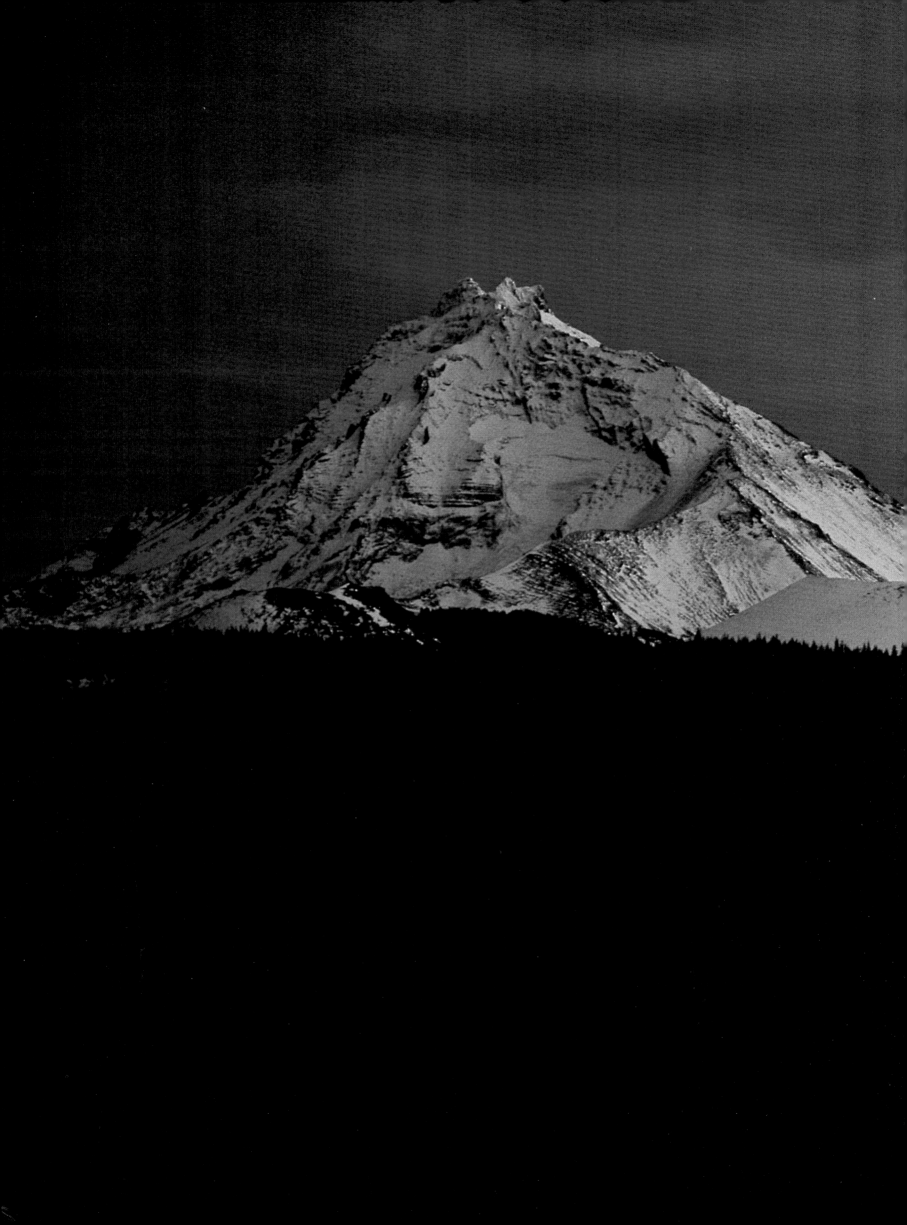

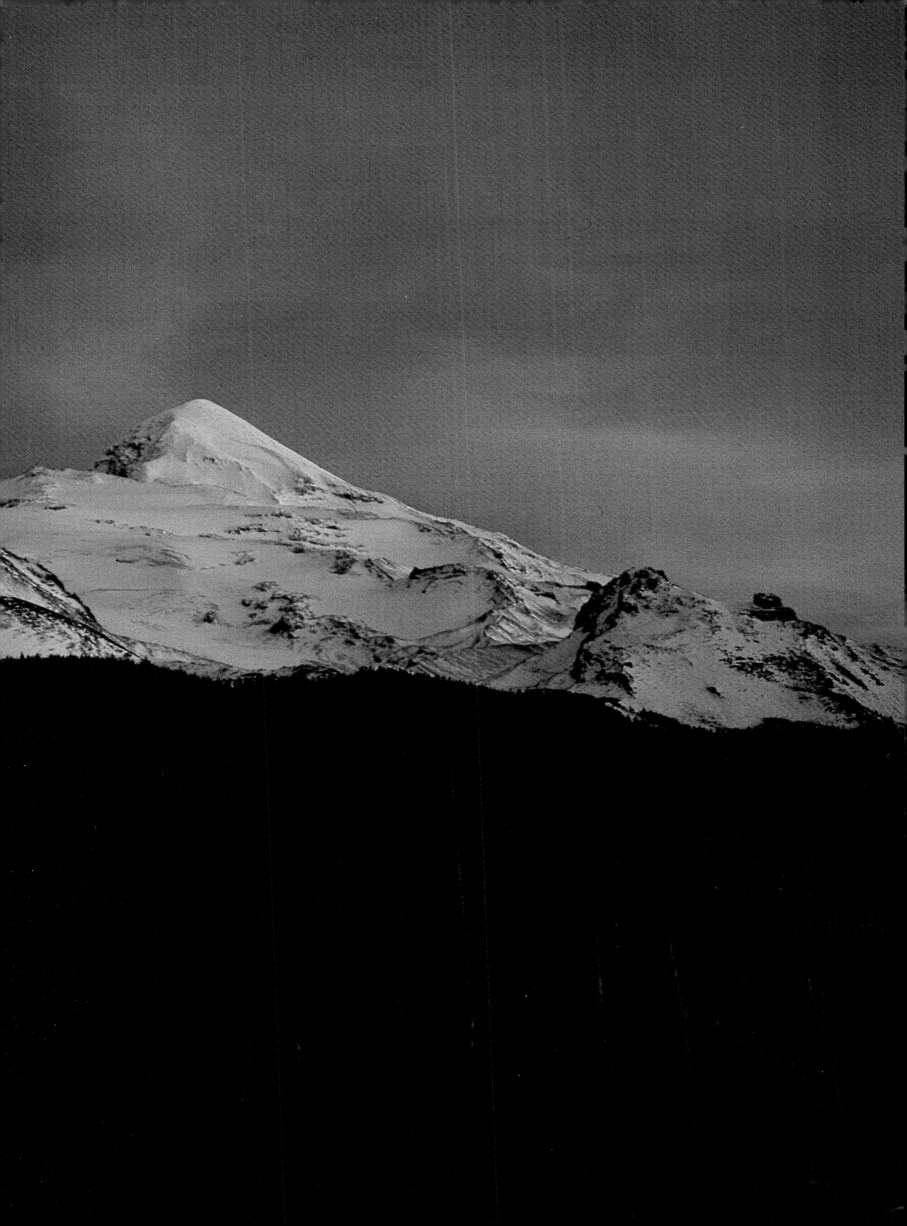

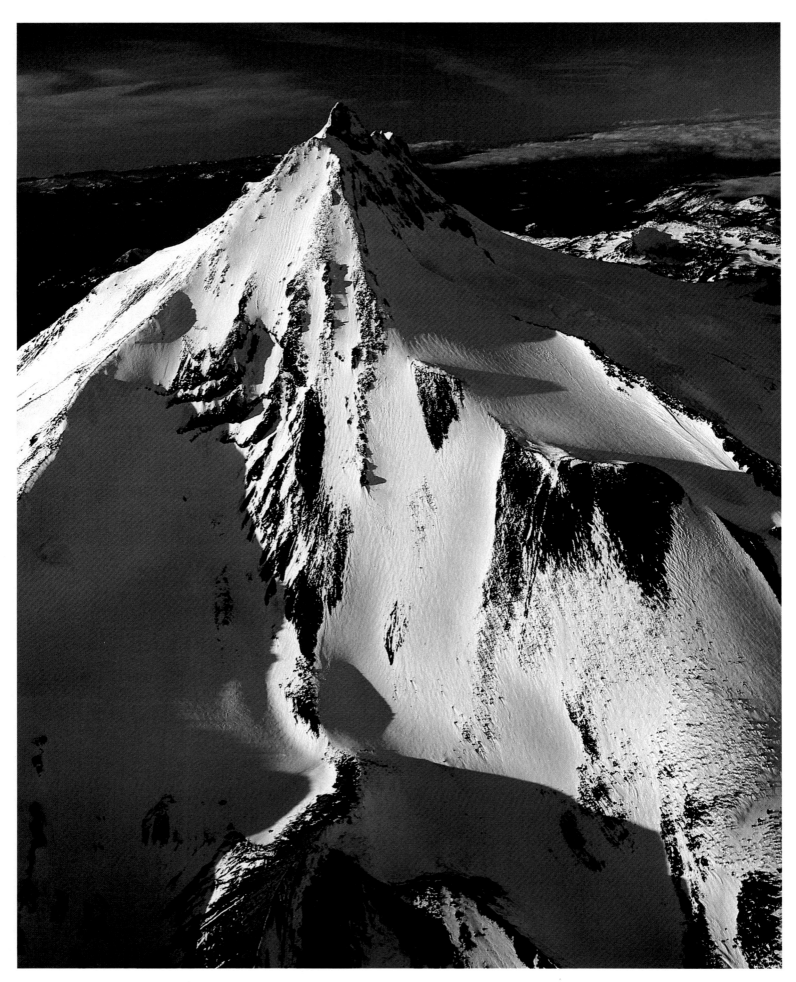

Above: Oregon's second highest peak, Mount Jefferson, from the air. The volcano was built far above a deeply dissected platform of older lavas and volcanic clastic rocks. Lewis and Clark named the mountain for the United States President who sent them West. *Right:* Proxy Falls, Willamette National Forest. *Overleaf:* South of Mount Jefferson, Three Fingered Jack stands in winter sunshine while a gale blows fresh snow off its ridges.

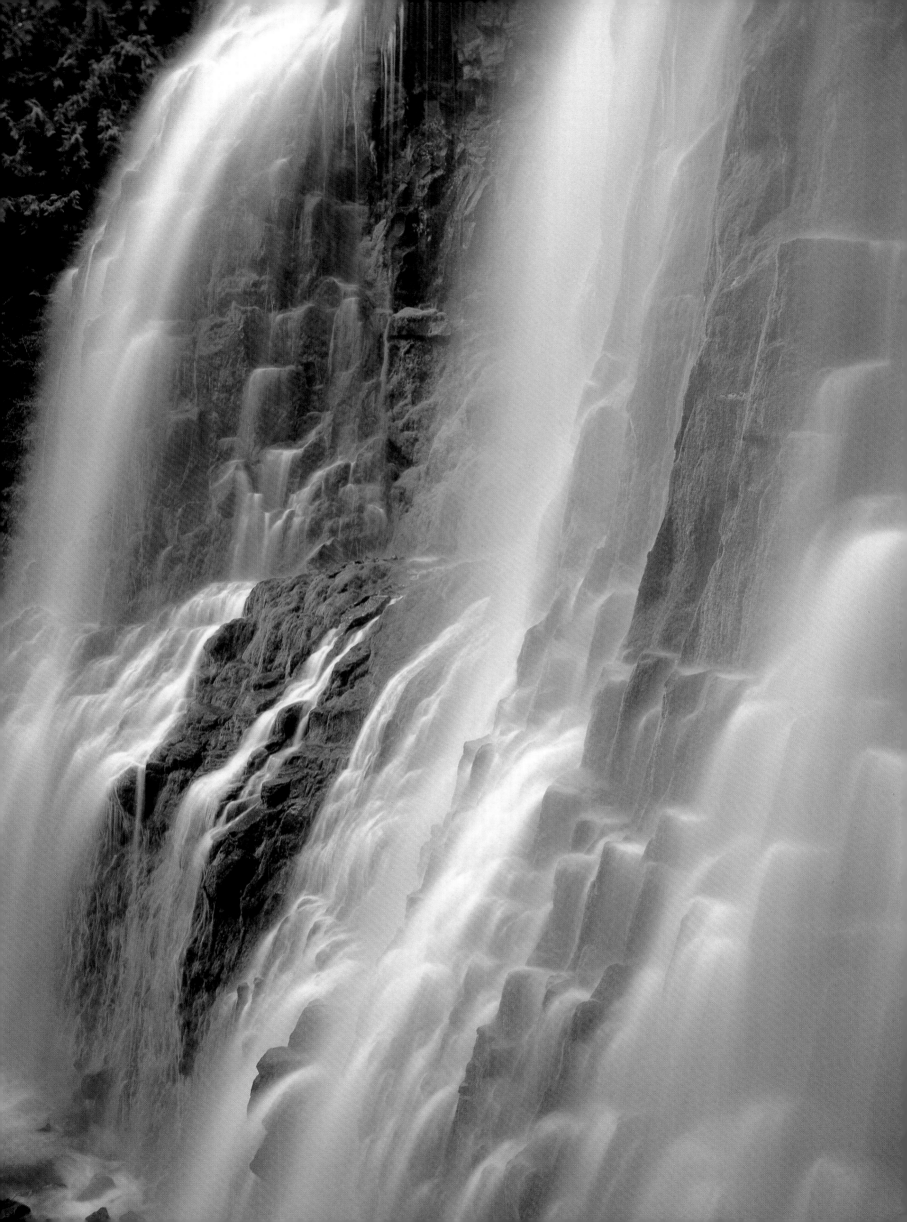

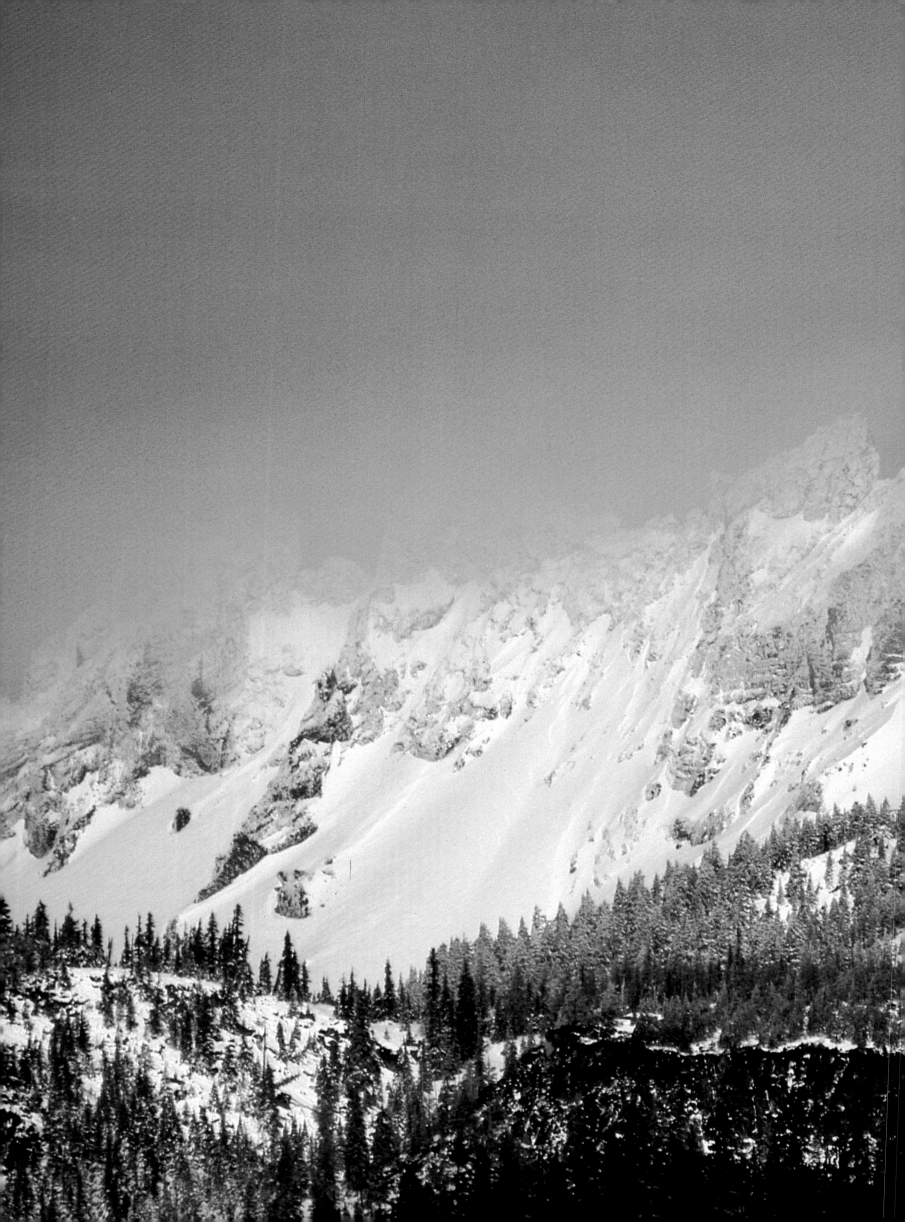

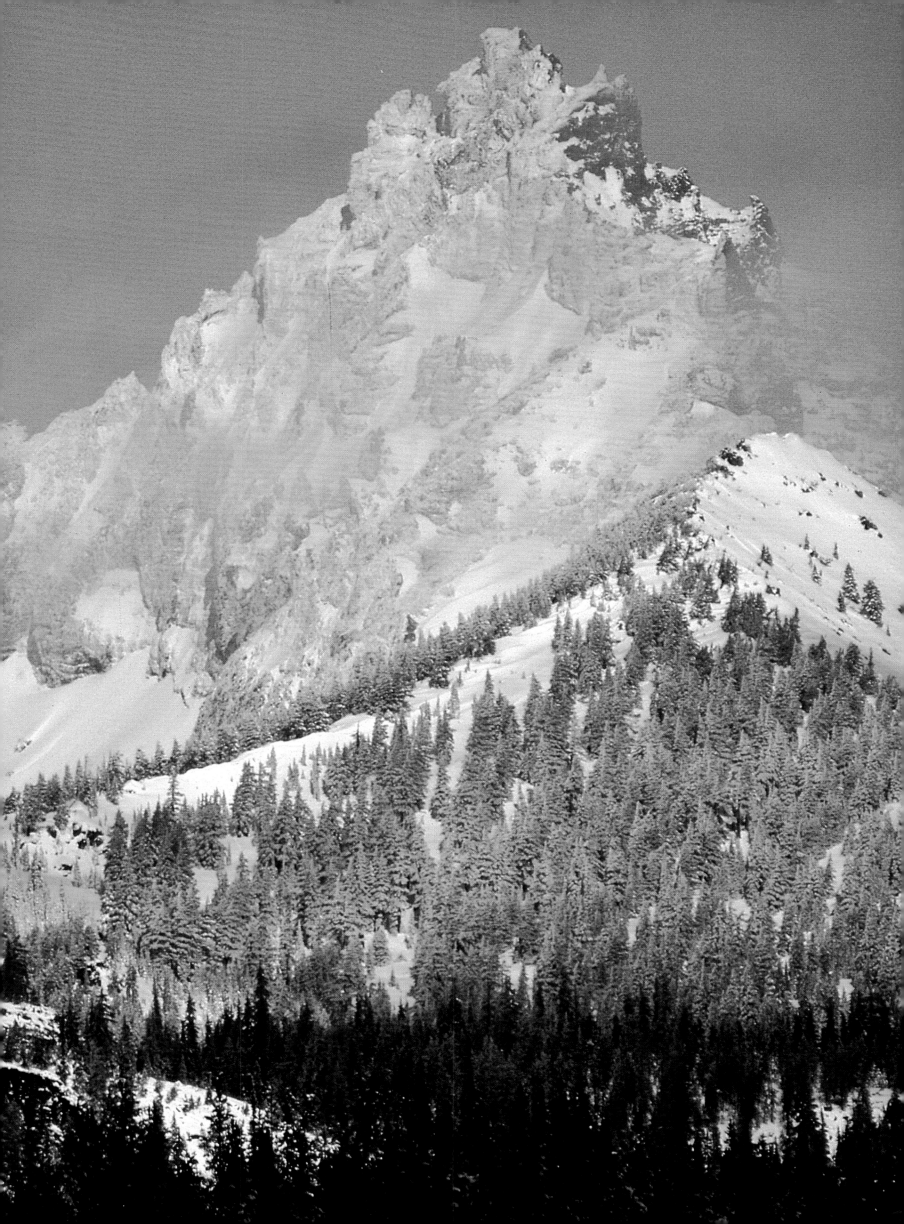

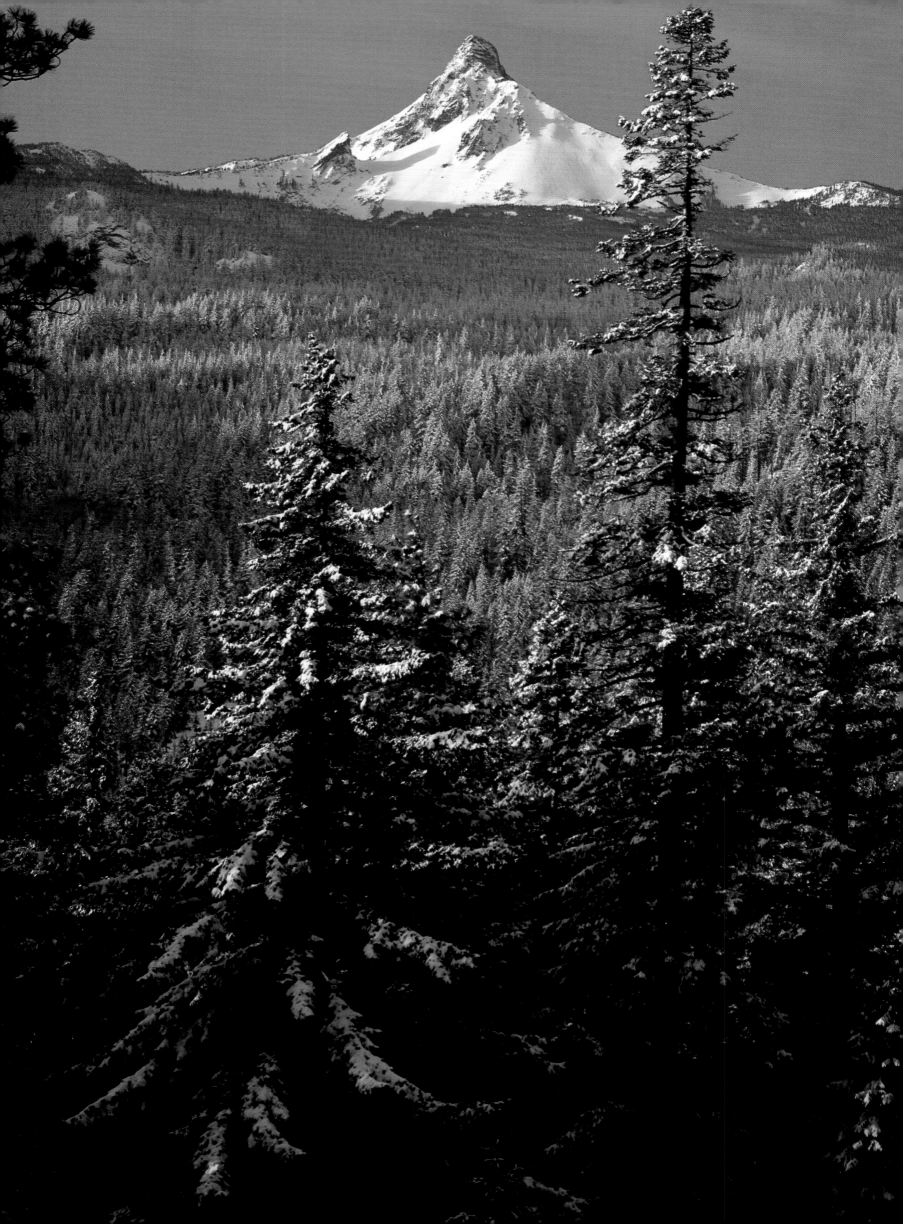

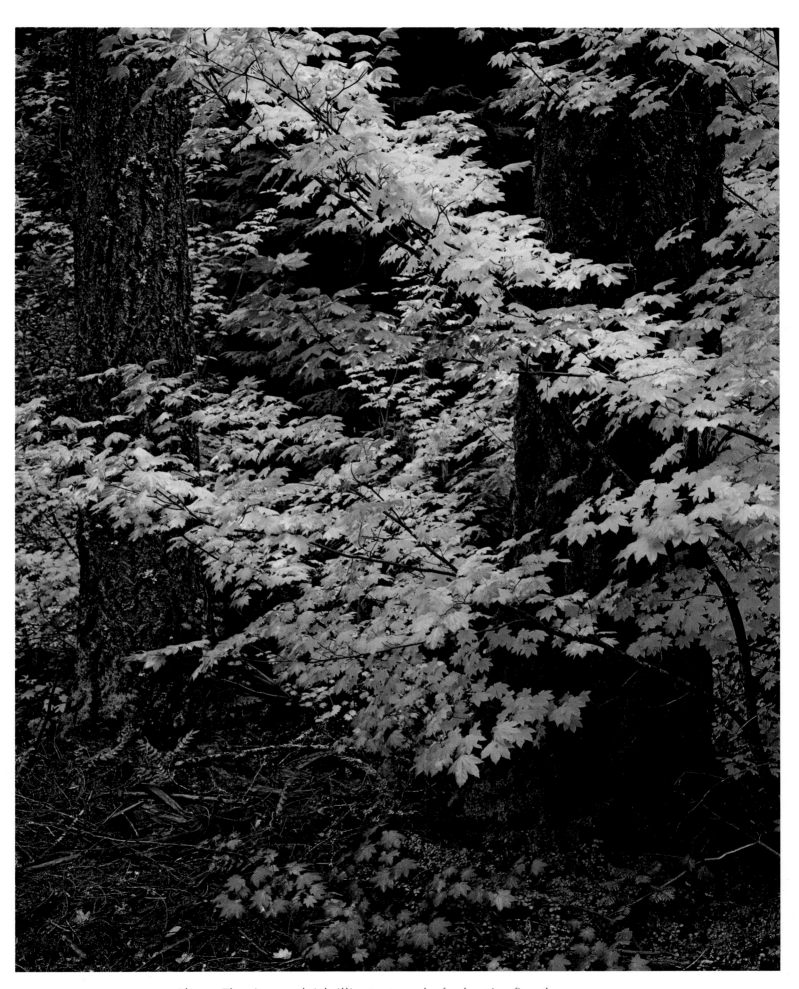

Above: The vine maple's brilliant autumn leaf coloration fires the evergreen forest below 4,500 feet with red and yellow tones. The maple, a deciduous tree with many supple stems, may attain a height of forty feet. *Facing page:* Mount Washington seen near Santiam Pass as the sun sparkles on snow-dusted forest. Erosion has revealed the old volcano's central pipe.

Vine maples become ornamental when foliage ripens to a rich scarlet. The thin leaves have blades about five inches wide and seven to nine lobes; reddish purple flowers appear with the leaves in spring, droop in clusters and turn into red, paired samaras—winged fruit. The vine maple is found in moist woods and near streams west of the Cascades from British Columbia to northern California.

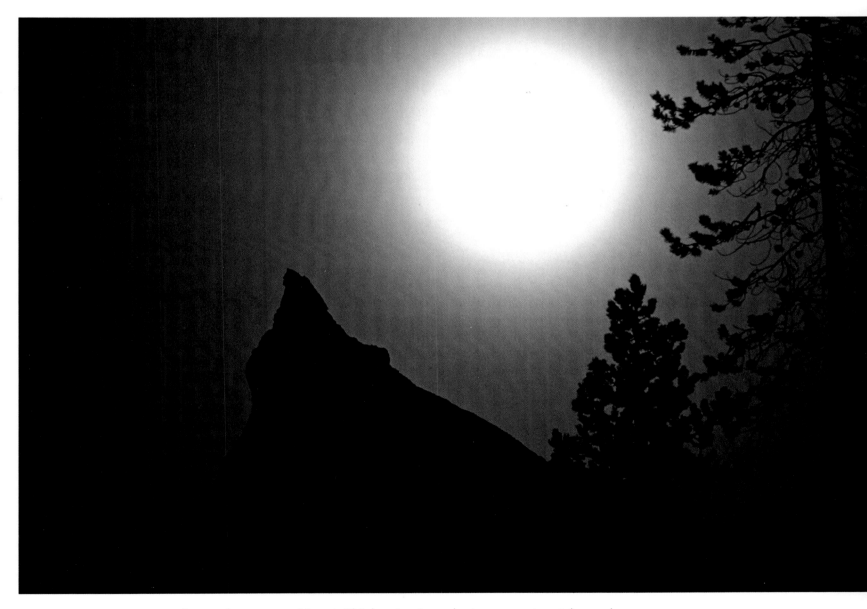

A moody specter, Mount Thielsen's pinnacle is a prominent lava plug known as the "lightning rod of the Cascades." One of the older Oregon volcanos, Thielsen was probably extinct before the last major Pleistocene glaciation. The volcano first produced fluid basalt streams that formed a broad shield, then its explosive eruptions built a large pyroclastic cone.

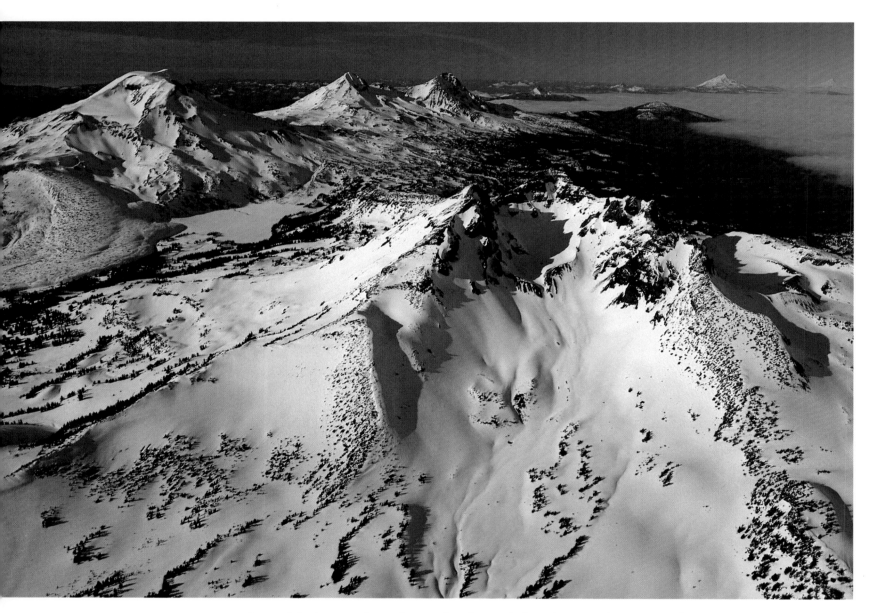

An aerial view northward over deeply eroded Broken Top focuses on the
Three Sisters, center of a magnificent wilderness playground. An immense
icefield once covered this region, merging with alpine glaciers descending
from the Sisters. Ice scoured the landscape and left troughs now filled by
picturesque mountain lakes. Like lonely sentinels, Mounts Jefferson and
Hood punctuate the far distance.

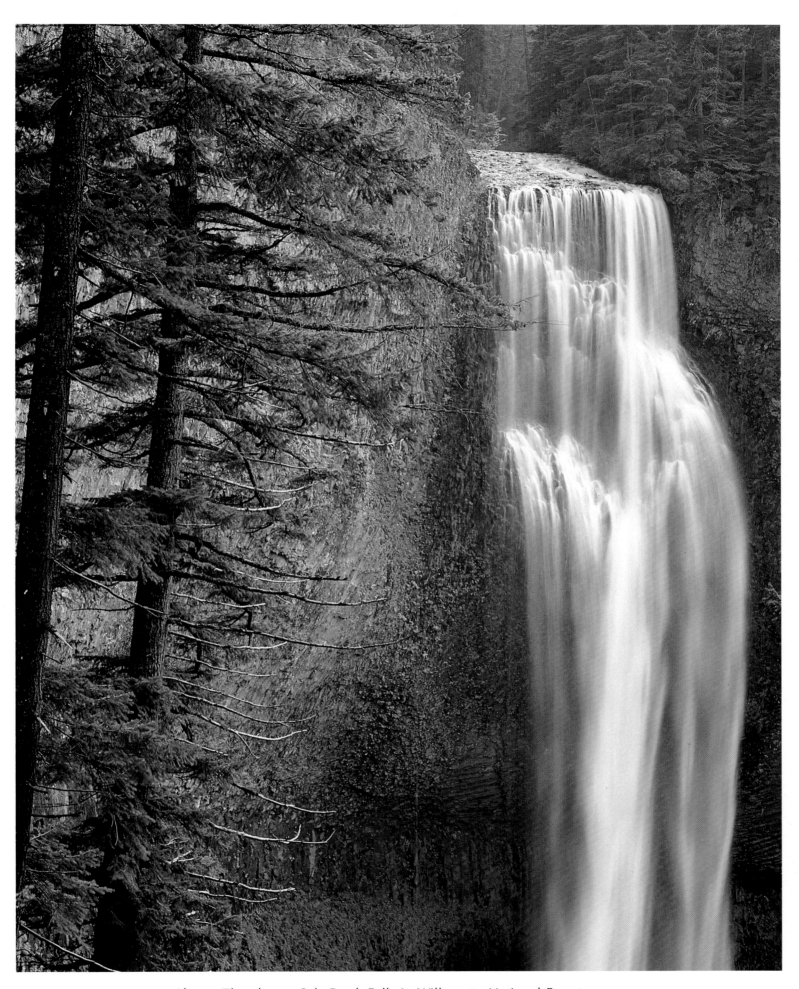

Above: Thunderous Salt Creek Falls in Willamette National Forest pours water 286 feet into a deep gorge. *Overleaf:* Winter snow on the caldera rim makes a dazzling contrast with the blue, gemlike waters of Crater Lake, Oregon's legacy of volcanic fire. A great peak, identified in geologic history as Mount Mazama, once towered here.

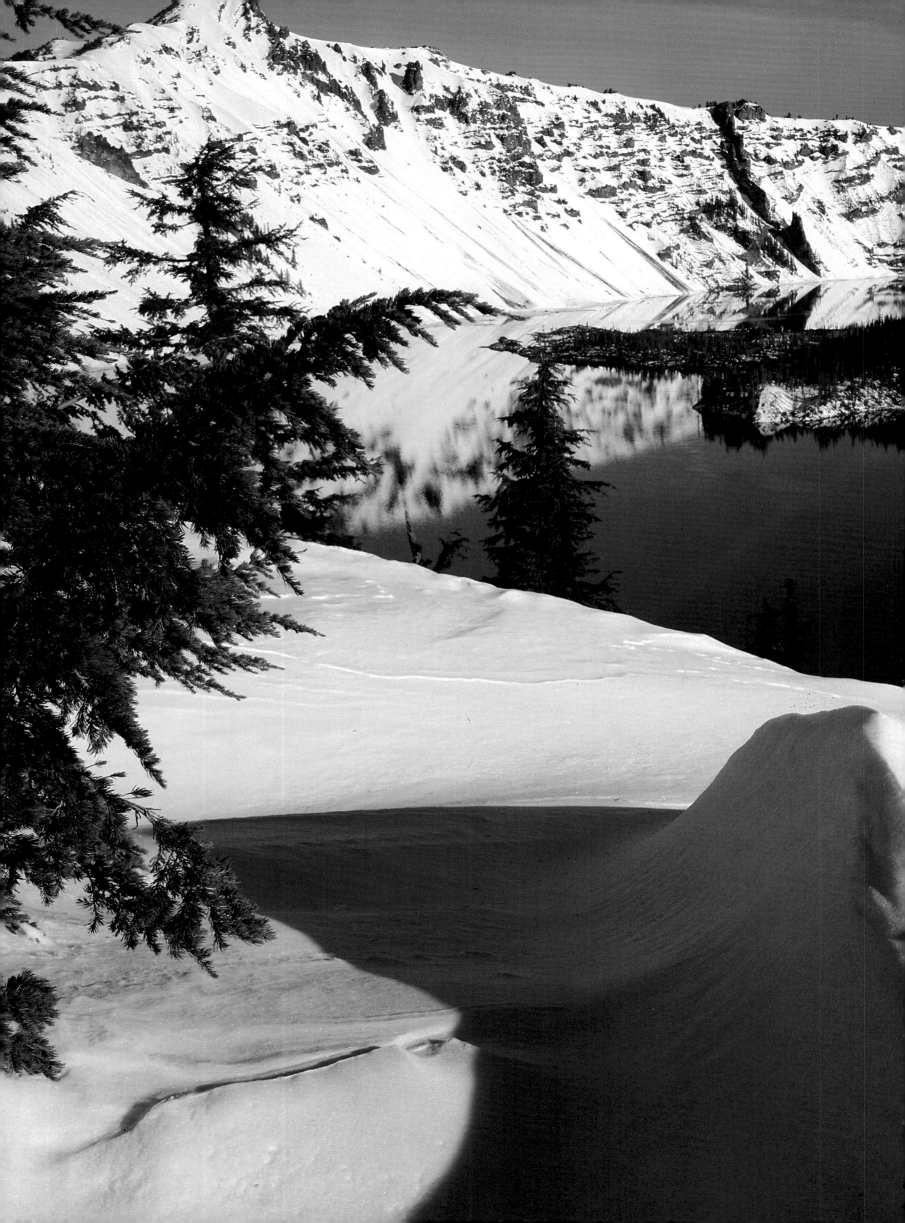

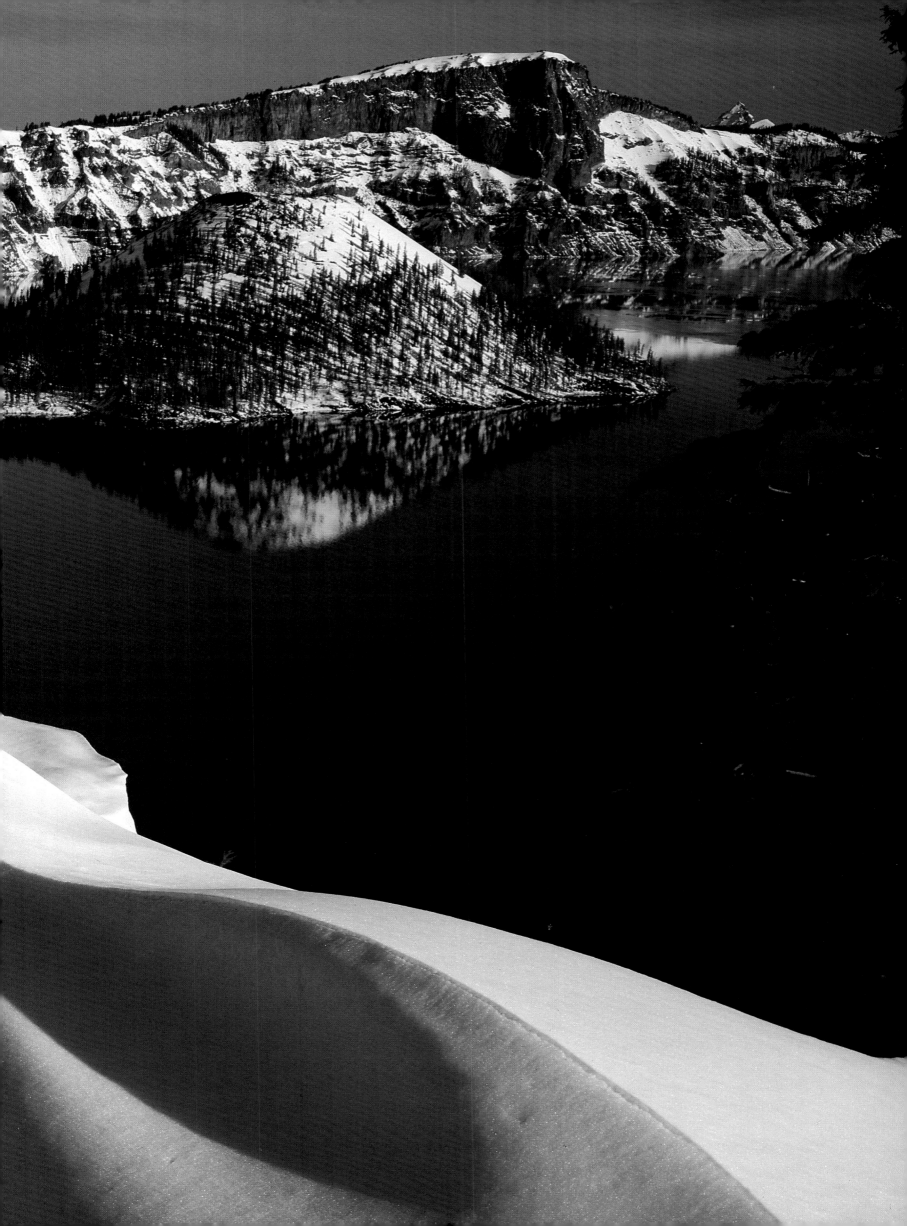

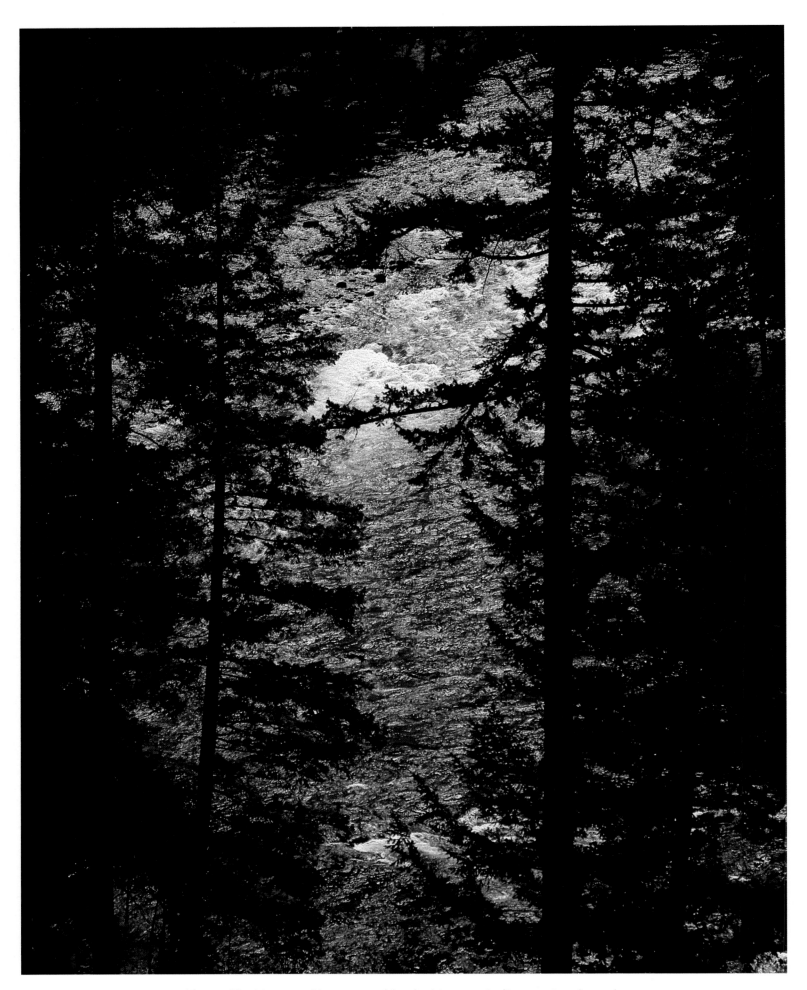

Above: The Umpqua River, named for the Umpqua Indians, twists through a forest of sugar pine, Douglas and white fir, hemlock, cedar, and rhododendron. *Facing page:* Oak leaves east of Lassen Peak in the Caribou Peak Wilderness, a vacationland informally known as the "Thousand Lakes Wilderness." *Overleaf:* Looking west across Klamath Lake. Symmetrical Mount McLoughlin looms on the far right.

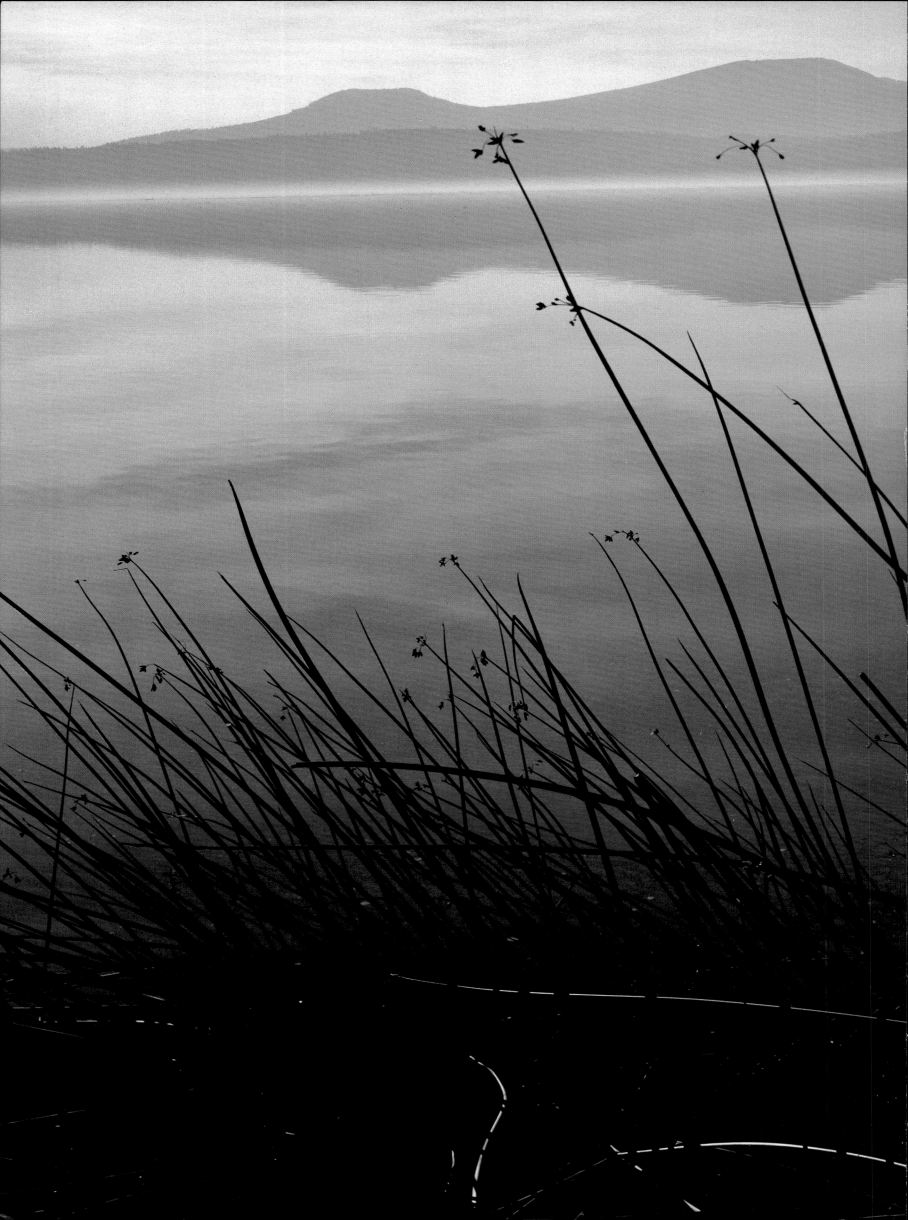

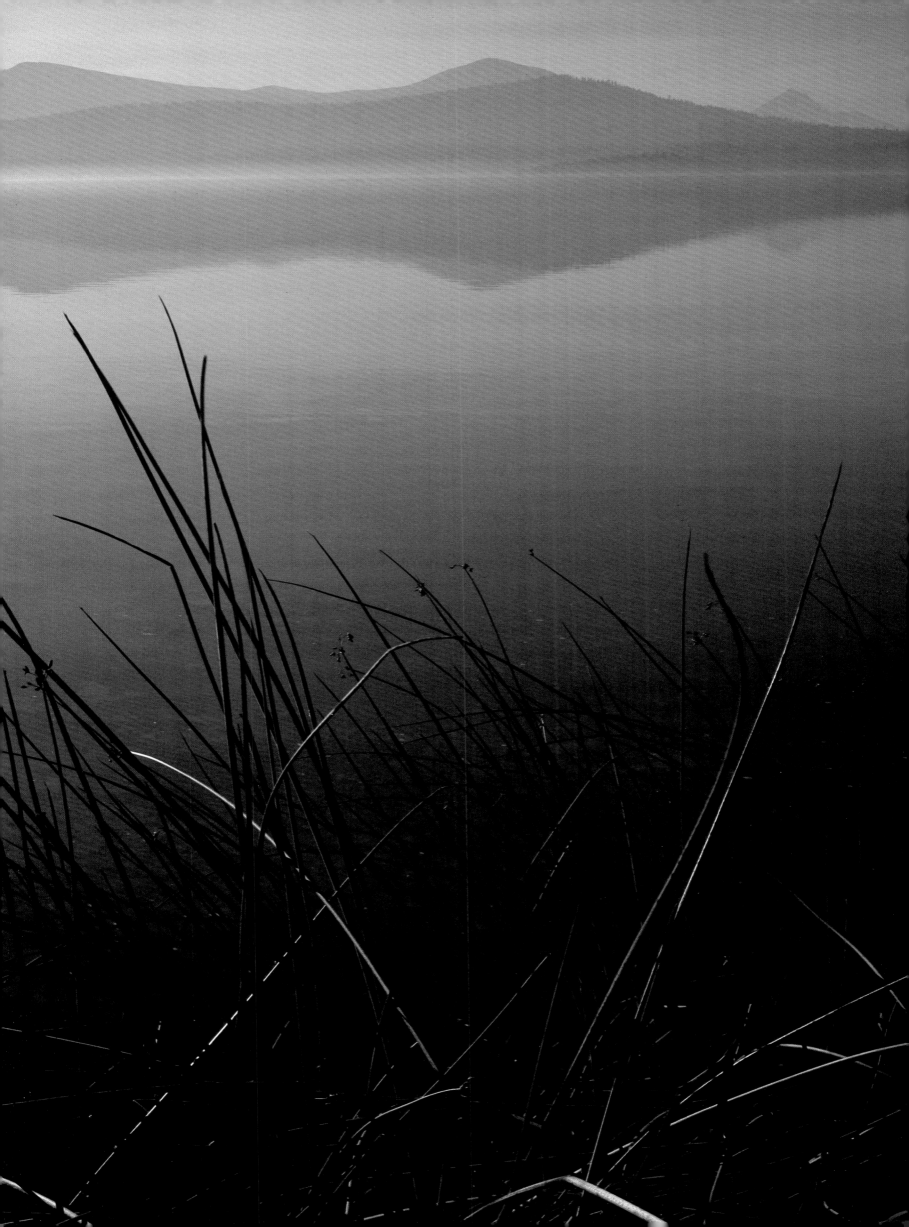

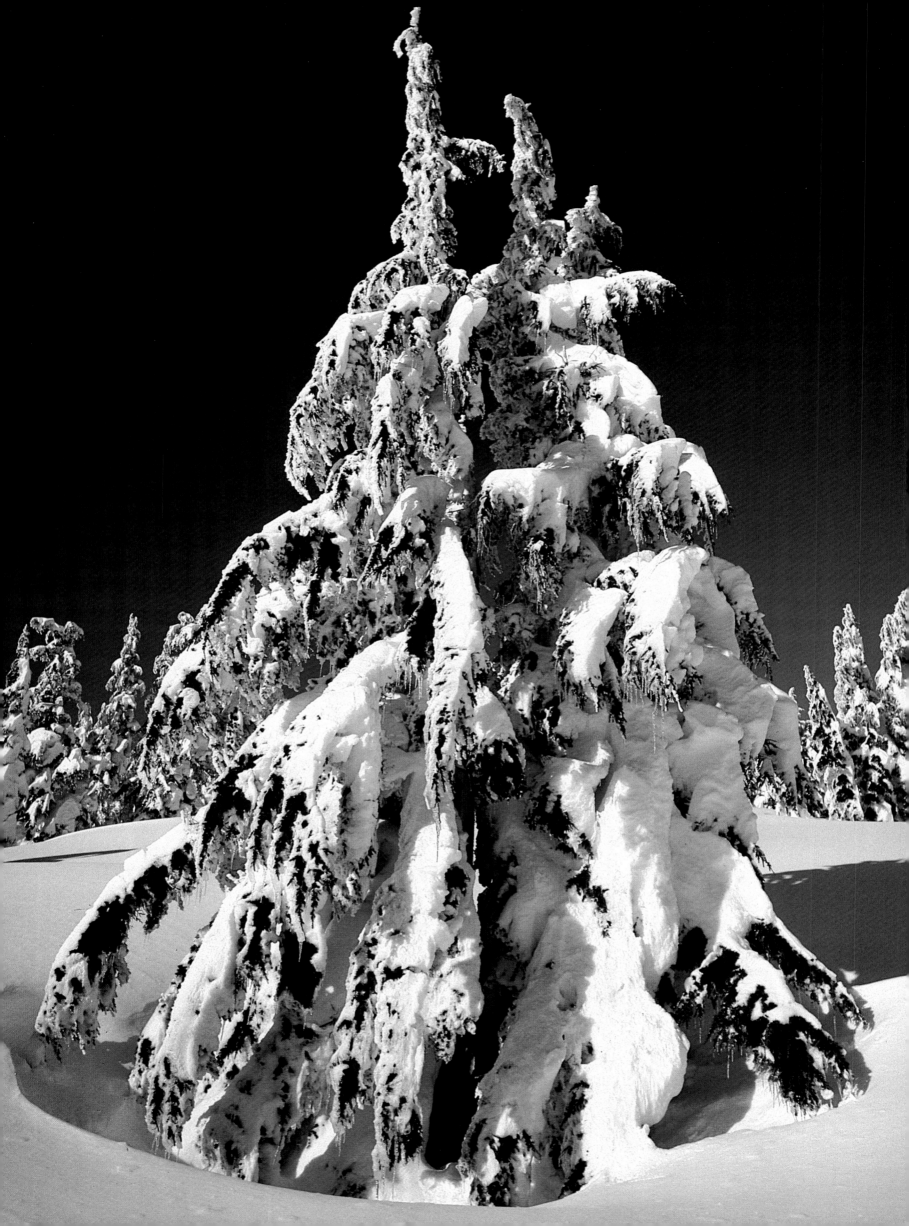

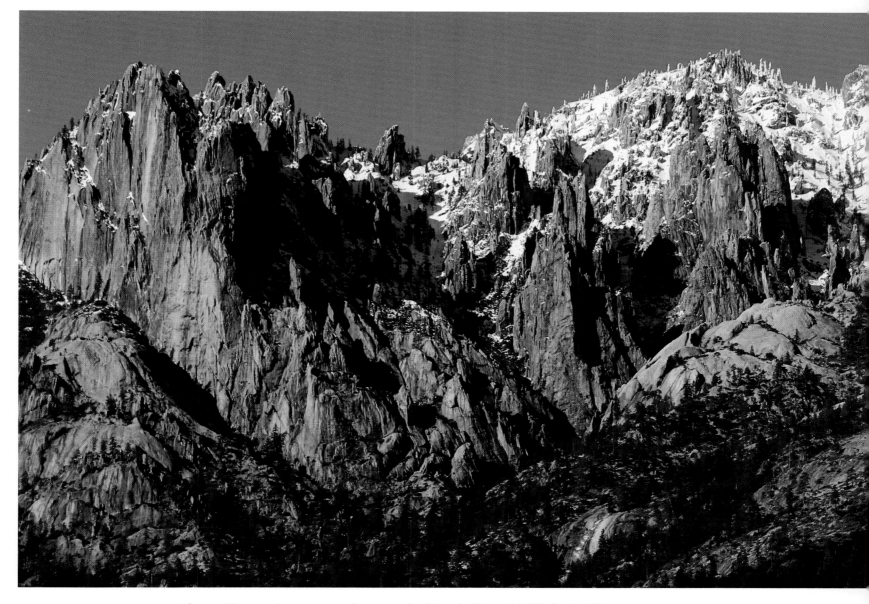

Above: Contrasting snow and gray rock of Castle Crags highlight the Trinity Mountains southwest of Mount Shasta. *Facing page:* A timberline mountain hemlock laden with midwinter snow. *Overleaf:* Alluring Mount Shasta once inspired Joaquin Miller to write it was "lonely as God and white as a winter moon." John Muir experienced a snowy gale on Shasta that "drove on night and day in hissing, blinding floods."

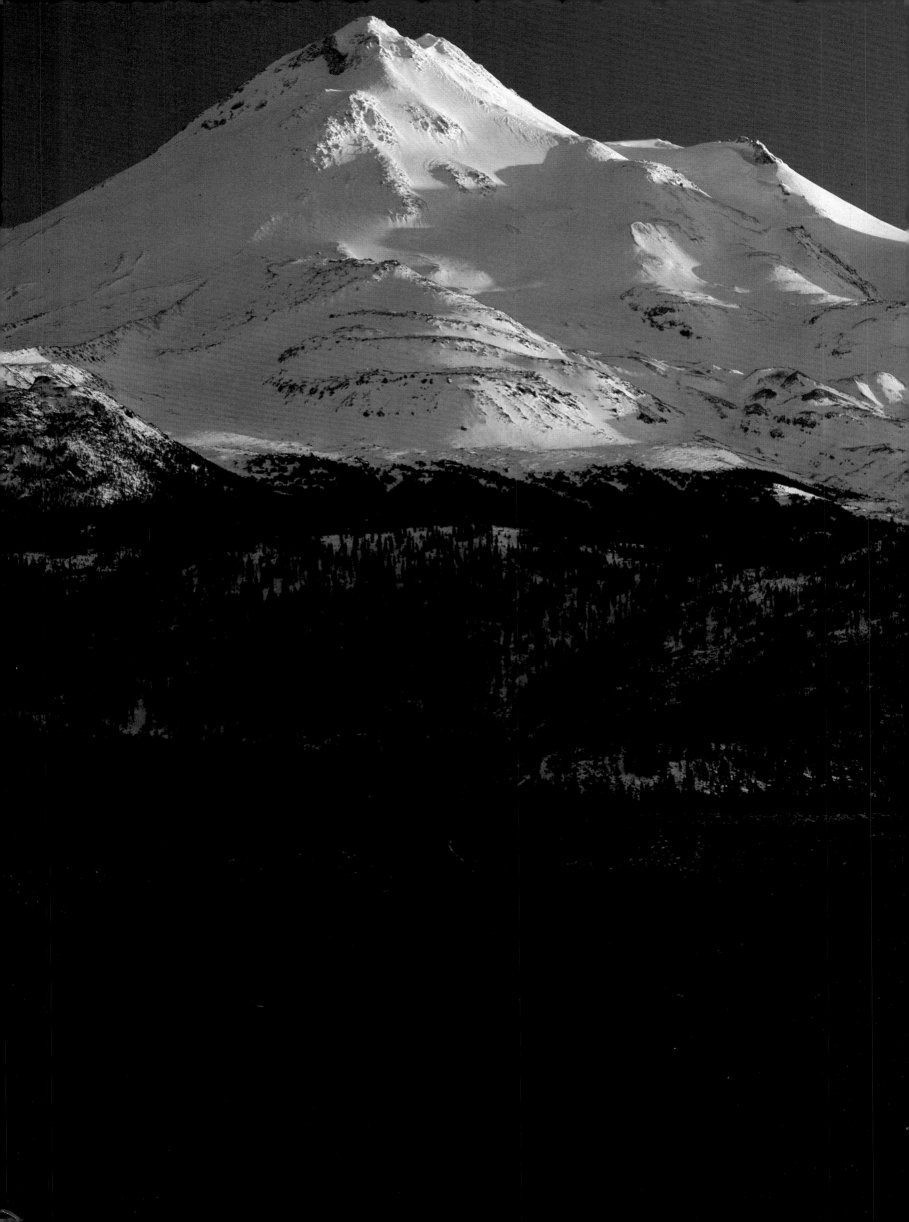

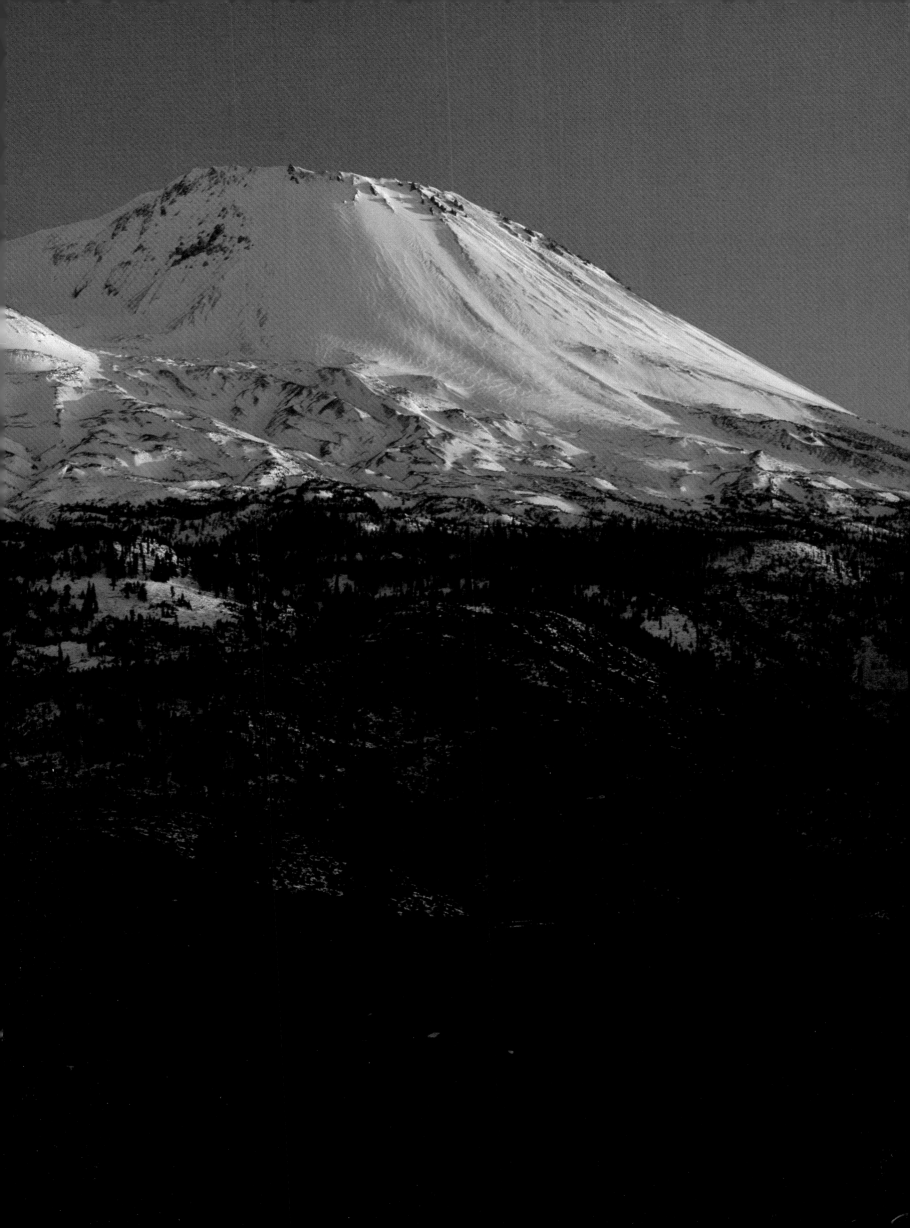

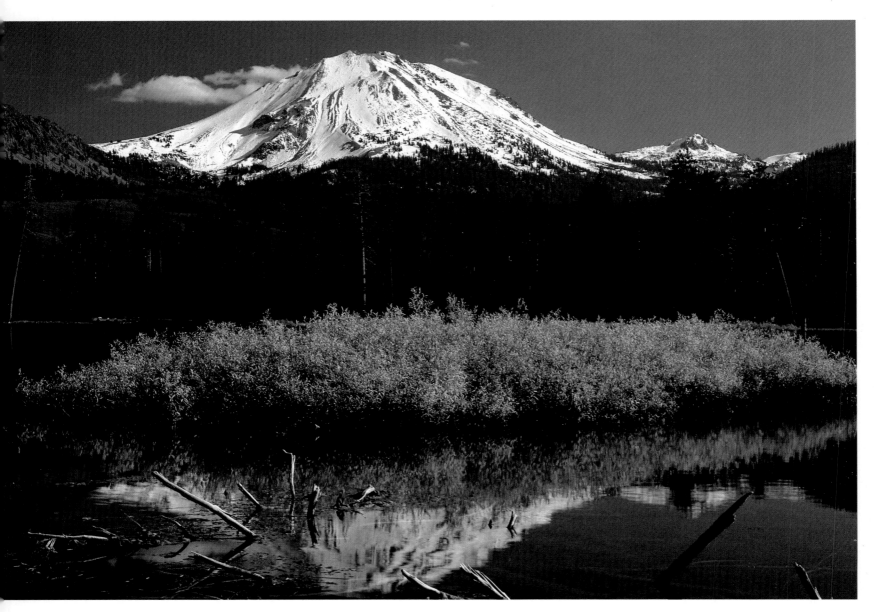

Autumn shrubbery enhances the stirring vista of California's Lassen Peak, the young volcano that anchors the southern Cascades. Lassen spent one year in explosive reawakening, then in spring, 1915 mushroomed ash clouds far into the skies. Too young for glaciers to have formed, Lassen is high enough to receive considerable snowfall.

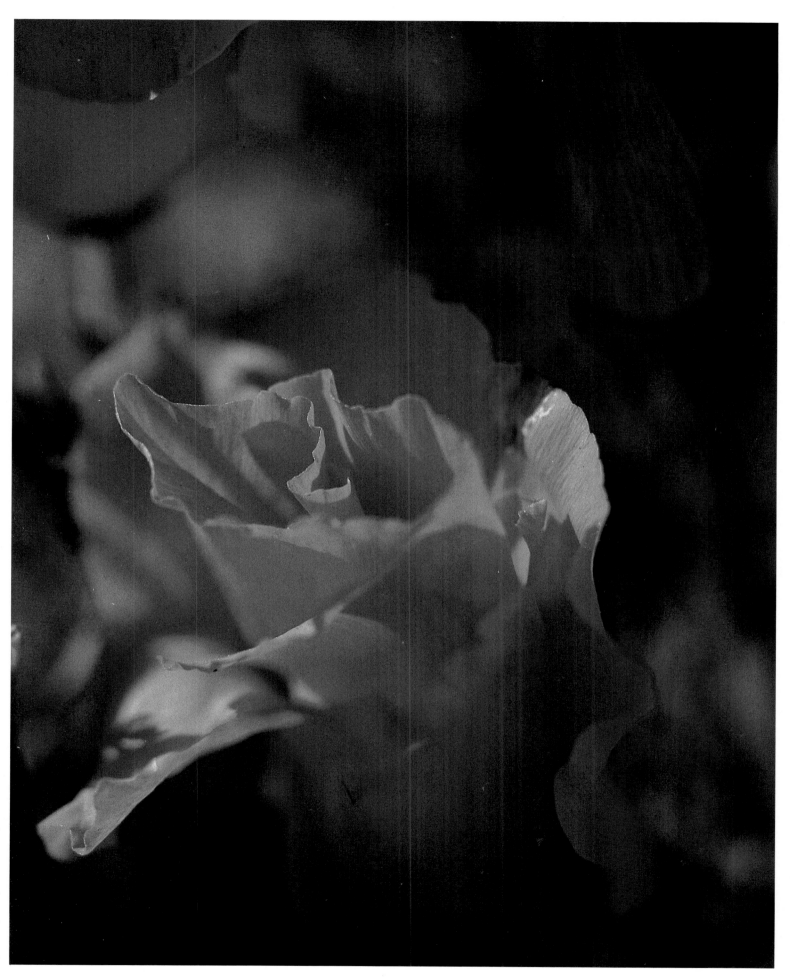

The California poppy, with its four fan-shaped, orange-yellow petals bright as sunlight, is usually found on open, grassy slopes. California Indians knew of the poppy's pain-killing properties and used juice from its fresh root to halt toothaches.

REFLECTIONS

The photography in this book represents only a small sampling of the intense beauty to be found throughout the Cascades. My life is a never-ending search to discover and record this beauty with my camera. I have found that the more I discover, the more I have yet to discover. By recording these impressions on film, it is hoped that I will play some small part in increasing man's awareness.

Each sunrise gives birth to a new adventure. Each sunset brings the memory of a day lost forever. How fortunate I am to have known these moments. I feel the urge to record all that is possible, but there is no end to the beauty that I see. In a thousand lifetimes I could not satisfy this thirst, but there is one thing I know: when the mountains call me, I will always return until I am no more.

Russell Lamb

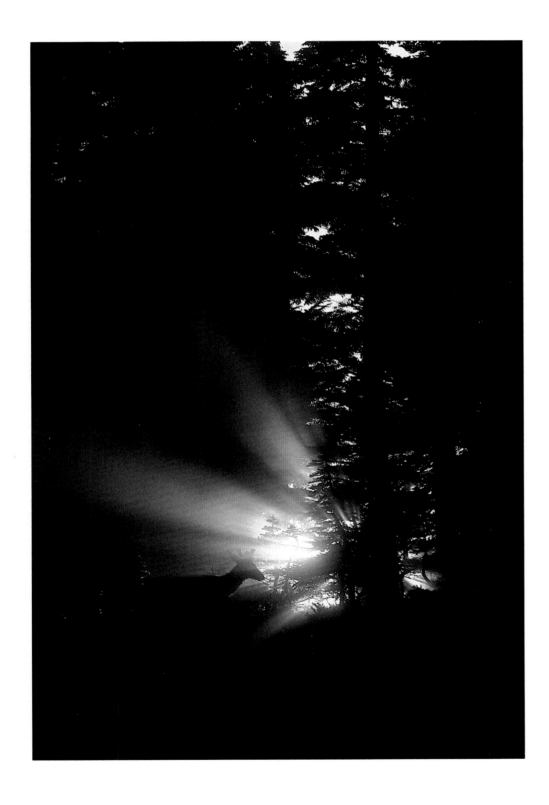